# The Cradle of Humanity

# The Cradle of Humanity
## *Prehistoric Art and Culture*

Georges Bataille

Edited and Introduced by Stuart Kendall

Translated by Michelle Kendall
and Stuart Kendall

ZONE BOOKS · NEW YORK

2005

ZONE BOOKS
1226 Prospect Avenue
Brooklyn, NY 11218

Distributed by The MIT Press, Cambridge, Massachusetts,
and London, England

Library of Congress Cataloging-in-Publication Data
Bataille, Georges, 1897–1962
    The cradle of humanity : prehistoric art and culture /
by Georges Bataille : edited and introduced by
Stuart Kendall ; translated by Michelle Kendall and
Stuart Kendall.
        p.   cm.
    Includes bibliographical references.
    ISBN 1-890951-55-2
    1. Art, prehistoric and science.  I. Kendall, Stuart.
    II. Title.

N5310.B382   2004
709'.01 — dc21                    2004051634

# Contents

# The Sediment of the Possible

Stuart Kendall

> What pleasure can there be in the sight of a mangled
> corpse, which can only horrify?
>
> — Saint Augustine, *Confessions* 10

Georges Bataille's writings and lectures on prehistoric art and culture span the thirty years between 1930 and the end of his life. In 1955, Editions Skira published his monograph *Prehistoric Painting: Lascaux; or, The Birth of Art* as the introduction to its lavishly illustrated series The Great Centuries of Painting, and two of Bataille's final works, his philosophical anthropology of eroticism, *Erotism: Death and Sensuality* (1957), and *The Tears of Eros* (1961), both draw heavily on examples from prehistoric art, religion, and culture.[1] The present volume collects all of Bataille's remaining essays, articles, reviews, and lectures on prehistoric art and culture, from his early review of Georges-Henri Luquet's *L'Art primitif*, published in *Documents* in 1930, to the extended essay of 1959 from which the title of this collection is derived.[2]

Despite the breadth and depth of Bataille's writings on prehistory, readers have thus far largely failed to engage with this aspect of his work. Among specialists in prehistory, readers of Bataille, and general readers — with the notable exception of

Steven Ungar's essay "Phantom Lascaux: Origin of the Work of Art" — the response to Bataille's writings on prehistory has been characterized by indifferent silence.[3] Perhaps this response is not entirely inappropriate. One purpose of the present collection is to break this silence by reasserting the place of prehistory in Bataille's thought. Toward that end, this introduction will elaborate several major themes consistently present in Bataille's treatment of prehistoric art and culture, both in this collection and in his corpus as a whole.[4]

Bataille himself betrayed a curious reticence on the topic. In *The Tears of Eros*, Part One of which is devoted to prehistory, he carefully and pointedly summarizes his previous statements about the images in the pit at Lascaux. In reference to his 1955 monograph, he confesses: "I forbade myself from giving a personal interpretation of this surprising scene. I restricted myself to relaying the interpretation of a German anthropologist."[5] Of his 1957 interpretation of the scene, given in *Erotism*, he is similarly critical, claiming that his interpretation was "excessively cautious ... I limited myself."[6] Bataille couches his self-criticism in startling terms: of restriction, limitation, and forbidden speech. He faults himself for failing to offer a "personal interpretation," though he is the writer who claimed in *Guilty*, "Nothing is more foreign to me than a personal mode of thought.... If I utter a word I bring into play the thought of *other people*."[7] Bataille laments forbidding himself a speech that he nevertheless denies.

It is a paradox, then, as so often in Bataille: at once the nearly obsessive will to know, to speak on a particular topic, and the refusal to do so, the refusal to offer a definitive interpretation, to close the topic once and for all. Reading this diverse corpus of essays, lectures, and reviews, of writings in philosophical anthropology and aesthetics, in the history of religions and sociology of the festival, one may feel as though Bataille were interminably,

eternally, circling the topic at hand, circling the scene in question, often the scene in the pit at Lascaux, without satisfying his own and our own desire for answers, as though he were deferring the definitive statement: speaking while waiting to speak.

Although Bataille began writing on prehistory in 1930 as part of the general corrosion of contemporary visual culture that he effected through the journal *Documents*, cave painting did not surface as a vehicle of his primary concerns until the early 1950s.[8] The moment of his turning to Lascaux is an interesting one. In 1949, Bataille published the first volume of a projected trilogy, *The Accursed Share*.[9] A year later, in 1950 and continuing in 1951, he drafted the trilogy's second volume, *The History of Eroticism*.[10] Dissatisfied with the text, he put it aside for three years, then rewrote it in 1954 and 1955 before finally publishing it under the title *Erotism*. Perhaps most significant among the differences between the two versions of the work is the turn to prehistory. In *The History of Eroticism*, Bataille couches his discussion of the passage from animal to man in pointedly abstract, philosophical, and logical terms. In *Erotism*, on the other hand, the passage is a properly historical one, a passage located in prehistory and visible, for Bataille, in the drama surrounding the creation of works of art.

Bataille's preference for philosophical over anthropological discourse in *The History of Eroticism* repeats the logic of his 1948 lecture on the history of religions. In that lecture, he tells his listeners: "In order to represent this outline [of the history of religions], I begin with animality.... I will represent forms successively in my presentation without precise concern for responding to a given historical succession. It is not a question, in the group of forms analyzed, of a succession that one could give as chronological, it is a question of logical succession that might coincide

with the succession of the facts."[11] Philosophy, as he says else-
where, grasps the "major aspects" of a given historical moment or
shift, but philosophical history, without the foundation of special-
ized anthropological detail, remains too general, is "nothing."[12]

Part Two of *The History of Eroticism* establishes the terms of
the debate and their initial faltering. This part of the text merely
reprints Bataille's review of Claude Lévi-Strauss's *Elementary
Structures of Kinship*, a review originally published under the title
"Incest and the Passage from Animal to Man."[13] In Bataille's read-
ing of Lévi-Strauss, incest marks the passage from animal to man
insofar as, beginning with incest, human beings regulate their
behavior by means of taboos, a phenomenon unknown in the ani-
mal world. The concept of the taboo, the interdiction, or royal
rule, though widely disseminated, may be traced in its most pop-
ular and developed forms to Sir James George Frazer's treatment
of it in *The Golden Bough* (1890–1915) and Sigmund Freud's elab-
oration of its role in human emotional life in *Totem and Taboo*
(1912). Both Frazer and Freud are among the *other people* who
speak in Bataille's discussion with Lévi-Strauss.

The problem, as Bataille sees it, with Lévi-Strauss's book is
the extent to which it evidences the "horror of philosophy that
dominates...the scholarly world."[14] Lévi-Strauss, in other words,
and in Bataille's reading, errs on the side of anthropology rather
than that of philosophy in his discussion of the passage from ani-
mal to man. This is to say not that he has neglected the demands
of philosophical abstraction entirely, merely that he has handled
them poorly: the meaning of his text remains too narrowly cir-
cumscribed by the individual examples he records. Yet Bataille
himself equivocates: "It is difficult, however, to deal with the pas-
sage from nature to culture while staying within the limits of the
science [philosophy] that isolates, that abstracts its views."[15] Any
adequate description of the passage from animal to man, in other

words, requires reference not just to the global view of totality provided by the abstraction of philosophical thought but also to the particular details of experience and history provided by anthropological discourse. For Bataille, "the change evidenced in the advent of man cannot be isolated from *all* that man's becoming is, from all that is involved if man and animality are set against one another in a laceration that exposes the whole of the divided being. In other words, we can grasp being only in history: in changes, passages from one state to another, not in the sequence of states. In speaking of nature, of culture, Lévi-Strauss has juxtaposed abstractions, whereas the passage from animal to man involves not just the formal states but the drama in which they opposed one another."[16] At stake in Bataille's interpretation is the question of approach, of disciplinary affiliation and limitation. Bataille, for his part, rejects neither philosophical abstraction nor anthropological specificity: in the complementary terms of his general economy, both discourses — and others, religious, biological, and so on — are required.[17] Bataille uses the word "drama" to designate both the moment under consideration and the form of his complementary style of description. Drama is no mere metaphor in Bataille's writing: it signals the tragic multi-vocality, the disciplinary and discursive pluralism, and the general economic style of his writing.

Bataille's dissatisfaction with the limitations of *The History of Eroticism*, then, can be attributed to the failure of the dramatic complementarity of the text, which errs on the side of philosophy in lieu of combining philosophical, anthropological, and other discourses. In rewriting the work, Bataille corrects this lacuna, and by then he is well prepared to do so. Between the two drafts, in late 1952, he had returned to the study of prehistoric art and culture.

The shift in discourses can be traced here. Bataille begins the

13

lecture published here as "A Visit to Lascaux" by telling his audience that his "lecture tonight will be of a philosophical nature." The following spring, however, he titles his review of *Four Hundred Centuries of Cave Art* (1952), Abbé Breuil's magisterial summa of prehistoric anthropology, "The Passage from Animal to Man and the Birth of Art." The passage remains the same, but Abbé Breuil and prehistory stand in for Lévi-Strauss and incest. In 1955, in his monograph on Lascaux, as we have seen, Bataille restricted his reading of the scene in the pit to relaying the interpretation of an anthropologist. In 1957, in *Erotism*, he offered his own interpretation of the scene (we will return to it), an interpretation that he later found excessively cautious but praiseworthy nonetheless, because it "replac[es] the magical (and utilitarian) [that is, anthropological] interpretation of the cave pictures . . . by a religious one."[18] By 1959, the discursive transformation had become still more complete. In "The Cradle of Humanity," he writes: "What we now conceive clearly is that the coming of humanity into the world was a drama in two acts. . . . Some tens of thousands of years ago, this small valley [the Vézère] was the theater of changes whose consequences are the origin of everything that followed." In "The Cradle of Humanity," Bataille conceives of the Vézère valley as a theater of changes in culture. The description of the theater is made possible through reference to the work of prehistorians; the action is fleshed out in terms set by philosophical discourse. The meaning of the passage consists in its value as drama, which is also to say, as experience.

For Bataille, Lascaux, and indeed the entire Vézère valley, stand in for the whole of prehistory as a historical period. In his terms, "The name Lascaux is the symbol of those ages which knew the passage from the human beast to the slender, sharp, and agile being that we are."[19] More broadly still, "prehistory is universal history par excellence."[20] "Prehistory" is, in fact, according to Bataille,

"the key to history."[21] These turns in his writing and thought cannot be overemphasized. Bataille does not think that Lascaux records the birth of art, only that Lascaux participates in the moment of that birth, a phrase in which the word "moment" may and almost certainly does refer to a period of tens of thousands of years. And this moment retains a preeminence among historical moments. Prehistory "possesses, from the outset, a planetary sense, not a regional one, and, from the first determination, the entire future of man is at stake."[22] Prehistory is universal history par excellence because it is not merely the history of the West; it is global in its sweep and implications.[23] As in his revision of political economy — his shift from a restricted economy to a general one — in Bataille's revision of historical economy he slips from the history of Western civilization to a mode of universal history that embraces the histories of the entire globe and indeed the cosmos. Bataille is significant as a historical thinker because he attempts to change the register of our historical thought: he shatters the Western paradigm and begins thinking the history of humanity on a scale vast enough to include geologic and even cosmic time.[24]

However vast his perspective, Bataille insists on the subjective ground of historical thought. Attentive to disciplinary and discursive locations, he also remains faithful to the contemporary and personal situation of his thought and of our encounter with prehistoric art. While attempting to discern the meanings and functions that the works possessed for their creators, he is equally attentive to the meanings these paintings possessed for their few modern "discoverers" and for the tourists who see the paintings only in the context of a crowd of other tourists. Living *after* the Fine-Art tradition, as we do, necessarily changes the situation in which such objects can be interpreted. Bataille goes so far as to say that prehistoric humanity "possessed a decisive virtue: a creative virtue which, today, is no longer necessary."[25]

By implicating himself and the subjective moment of his inter-
pretative act in the frame of the paintings, Bataille encounters the
images in a way that violates the terms of objective science. Partly
for this reason, his writing about prehistoric art and culture is a
writing about prehistoric art and *our* culture. Prehistory is the
beginning of a history that includes us; it is, he believes, our his-
tory, our culture. Prehistory is the key to history because it "an-
nounces the subject, the 'I,' it announces 'us.'"[26] The passage from
animal to man announces the birth of the subject, the birth of the
human community, the "we."

As noted above, Bataille's inquiry into the passage from animal to
man begins as an inquiry conducted in philosophical terms, terms
that Bataille borrows, in large part, from G.W.F. Hegel and, more
specifically, from Alexandre Kojève's interpretation of Hegel's
*Phenomenology of Spirit* (1807). Kojève developed his interpreta-
tion in a now-famous lecture course given at the Ecole des Hautes
Etudes in Paris from 1933 to 1939. Raymond Queneau later pub-
lished his notes from the course as *Introduction to the Reading of
Hegel* (1947). Bataille, for his part, audited the course for three of
its six years, and the residue of this listening can be heard through-
out his work.

Kojève summarizes the difference between animals and hu-
man beings in the following way:

Animal Desire . . . and the action that flows from it, negate, destroy
the natural given. By negating it, modifying it, making it its own, the
animal raises itself above this given. According to Hegel, the animal
realizes and reveals its *superiority* to plants by eating them. But by
feeding on plants, the animal *depends* on them and hence does not
manage truly to go beyond them. . . . The Animal raises itself above
the Nature that is negated in its animal Desire only to fall back into

16

it immediately by the satisfaction of this Desire.... To be *human*, man must act not for the sake of subjugating a *thing*, but for the sake of subjugating another *Desire* (for the thing). The man who desires a thing humanly acts not so much to possess the *thing* as to make another [human] *recognize* his *right* ... to that thing, to make another recognize him as the *owner* of the thing. And he does this — in the final analysis — in order to make the other recognize his *superiority* over the other. It is only Desire of such a *Recognition*, it is only Action that flows from such a Desire, that creates, realizes, and reveals a *human*, nonbiological I.[27]

Nevertheless, "human existence is possible only with an animal existence as its basis."[28]

Bataille readily adopted these terms and turns of thought as the foundation for his own. He writes: "Animality is immediacy or immanence."[29] It is indistinct, not different from the material continuum of the natural world. "Every animal is in the world like water in water."[30] Stronger animals — lions, tigers — are only "higher waves overturning other, weaker ones." But then, more obscurely, he writes, extending Hegel's terms in another direction: "The *apathy* that the gaze of the animal expresses after combat is essentially on the level of the world in which it moves like water in water."[31] Or again, along similar lines, in "The Cradle of Humanity": "Indifference is proper to the animal." These last two quotations suggest something of the enigmatic nature of Bataille's thought, of the means by which he will undermine Hegel by speaking in other voices.

When Bataille evokes the "apathy" of the animal gaze or the "indifference" proper to the animal, his words eschew the Hegelian quest for self-consciousness in favor of the apathy and indifference of the divine Marquis. For the Marquis de Sade, apathy accurately describes the state of nature, but it also describes the

ideal perspective or attitude of the libertine, the truly free individual (which is not to say "subject"). In *Justine*, Sade writes, "Such is the fatal apathy which better than anything else characterizes the true libertine soul: if he is merely carried away by passion's heat, limned with remorse will be his face when, calmed again, he beholds the baleful effects of delirium; but if his soul is utterly corrupt? Then such consequences will affright him not: he will observe them with as little trouble as regret, perhaps even with some of the emotion of those infamous lusts which produced them."[32] Enjoyment, for Sade, ecstasy, follows from one's *physical* desires, from nature's endowments, but apathy distinguishes the libertine from the beast.[33]

In a first moment, the libertine exists as a force of nature, a blind desire of the flesh. In a second, the libertine adopts a perspective of apathy in regard to that desire. The libertine soul circles itself, rejecting both his or her animal and human attributes in turn. Decisively, however, the libertine accepts his or her fate as a material being, a contingent being, prey to blind, animal impulses. Bataille follows Sade. He writes, "Beyond consent the convulsions of the flesh demand silence and the spirit's absence. The physical urge is curiously foreign to human life, loosed without reference to it so long as it remains silent and keeps away. The being yielding to that urge is human no longer but, like the beasts, a prey of blind forces in action, wallowing in blindness and oblivion."[34] Human no longer: prey of blind forces in action.

Eroticism "separates man from animals."[35] Animal desire simply seeks satisfaction. Human desire, in Hegelian — and Christian — terms, reduces desire to the realm of work. In this model, sexuality serves the goal of procreation. But the desires of the libertine exceed human desires by preceding them, by becoming animal, by denying sexuality a "goal" beyond the act itself. Eroticism is an affirmation of the instant, of the moment of voluptuous pleasure,

rather than of procreation, which remains simply a "happy" by-product of desire.[36]

Eroticism, again, is not animal desire: it is human desire surrendering itself to the animal desire that is its basis. In eroticism, the human being, shaped by the denial of its animal nature, reaches beyond itself in a second denial, though it cannot return to what it has rejected.[37] You can't go home again. Such is the wretchedness of our exile. As Pascal says: "Man is vile enough to bow down to beasts and even worship them."[38]

In the violence of eroticism, the "greedy I" reaches out for that which it has lost. For Bataille, this moment testifies to a still greater obscurity: "As soon as human beings give rein to animal nature, in some way we enter the world of transgression forming the synthesis between animal nature and humanity ... we enter a sacred world, a world of holy things."[39] Bataille's ruminations on the passage from animal to man proceed by denials and negations, rejections in turn of animal, self, and world, only to return him to his point of departure, his brute, contingent, material animality, an experience of existence as oblivion, of life lived like water in water. This new world of animality is animate, sacred, a world of holy things.

On October 31, 1939, the eminent Sade scholar Maurice Heine recorded a conversation with Bataille in his diary. During that conversation, Bataille admonished him: "You're wrong to adopt a moral point of view. I adopt that of an animal. I am not a man among men. I am an animal."[40] For Bataille, following Sade, experience is predicated on an impossible identification, that of man with the animal within. To experience the passage of animal to man is not to pass from animal to man at all.

This philosophical interpretation of the relationship between animality and humanity and the experience that Bataille, following

Sade and Pascal, derives from it, provide the foundation for his engagement with prehistoric art in general and with the scene in the pit at Lascaux in particular.

The central object of his fascination with prehistoric art and culture, the scene in the pit (also known as the shaft or the well) depicts three figures: a rhinoceros, a bison, and a humanoid figure with the head of a bird. Bataille describes this image, these figures, again and again in the pages that follow, always with an air of mystery, of enigmatic suspense. Why is the rhinoceros in flight? Why has the bison been depicted with such precision and the man so clumsily, with such reticence? Is it in fact a man? Is it not, rather, a half-human, half-bird hybrid creature? Is it a man wearing the mask of a bird? Is the bird-man in fact "falling" backward? Why is the man's sex erect? How is his fall related to the death of the bison? The bison is surely dying: his tail raised in anger, his entrails pour forth from his belly at the site of a wound caused by a spear or stick, the direction of which indicates that it has come from the bird-man.[41]

The prehistorians of Bataille's day — the Abbé Henri Breuil, Hans-Georg Bandi, Johannes Maringer, Hugo Obermaier, Raymond Lantier, to mention only the names that figure in the following text — interpreted cave paintings, including the scene in question, in terms of sympathetic magic, as elaborated by Frazer in *The Golden Bough*.[42] Along these lines, the then-accepted "utilitarian" or "functionalist" view held that cave paintings were thought to facilitate the work of the hunt. Prehistoric hunters attempted to provoke the actual appearance of their prey by painting apparitions of the animals on the cave walls. Painted arrows wounded the icons in anticipation of the actual hunt.[43]

Just as he accepted Hegel while supplanting his thought with a complementary thought of his own, borrowing from Sade, Bataille accepted the interpretation of these prehistorians. In his preface

to *Prehistoric Painting*, he acknowledges his "heavy indebtedness" to the specialists in prehistory, like Breuil, and writes: "With regard to archeological data, I have simply used what prehistorians have established at the price of an immense labor that has always called for patience — and often for genius."[44] In the texts collected here as well, his thought advances in conversation with the specialists in the field. He reviews their writings in *Critique* and relies on them, even as he attempts to push his own thought beyond what these specialists have been able to say about the caves.

In addition, the theories of sympathetic and contagious magic remain distinctly appealing to Bataille, not only as modes of description but also as modes of social action. For Bataille, the cosmos itself could be described in terms of energies, which he viewed as contagious. He also saw his own writing as a form of contagion: "At the moment when you read me, the contagion of my fever reaches you ... words, books, monuments, symbols, laughter are only so many paths of this contagion, of this passage."[45]

Magic, then, contagion, but also something else is at stake in the caves. After his initial refusal to speak on the topic — his recourse to the simple repetition of an anthropologist's interpretation in *Prehistoric Painting* — Bataille broke his silence and interpreted the scene as one of *murder* (the hunt is nevertheless murder) and *expiation*: a "shaman [is] expiating, through his own death, the murder of the bison. Expiation for the murder of animals killed in the hunt is a rule for many tribes of hunters."[46] He explains: "The act of killing invested the killer, hunter, or warrior with a sacramental character. In order to take their place once more in profane society, they had to be cleansed and purified, and this was the object of expiatory rituals."[47]

Several key elements of this interpretation stand out: the man is a shaman, perhaps wearing a bird mask; the scene recapitulates a scene of the hunt but in a sacrificial register; and the shaman

21

recognizes the death of the animal as having been caused by an act of murder requiring a purifying act of expiation. Before turning to the process of this expiation, we should remember that Bataille's evocation of the taboo on death and its corollary, the taboo on murder, participates in a larger complex of concerns within his thought, a complex of concerns that resonates uncomfortably with many of the darkest moments not only of prehistory but of the history of the twentieth century.

Indeed, ruminations on murder and death carry an awesome weight in the years during which Bataille is writing. As he observes in his 1955 lecture on prehistoric art, "Light is being shed on our birth at the very moment when the notion of our death appears to us." And the notion of our death is not just any notion of death; it is a historically new notion of absolute, total death, of atomic and ecological planetary disaster. The notion of absolute death is not only the death of an individual; it is the death of the human species as a whole and potentially the death of all life on this planet.[48]

The image of death in the 1950s, at the height of the Cold War, is an image of death after Hiroshima and Auschwitz.[49] Such an image is the ultimate challenge to a yes-saying thought inspired by Nietzsche's *gaya scienza*. It is an image with which Bataille struggles. Among his earliest plans for *La Somme athéologique*, he projected a volume titled *Le Monde nietzschéen d'Hiroshima* (The Nietzschean World of Hiroshima). But the affirmation proved too weighty for his pen, and the project remained embryonic.[50] Nevertheless, the image and the challenging affirmation remain: the reader of his notes for a film on Lascaux (see Appendix) cannot but observe the devastated landscapes described as somehow at once those of a pre- and a post-nuclear world.

Man's will to murder man, too, finds its echoes and origins in Bataille's vision of prehistory. His reflections on the disappear-

ance of the Neanderthal consistently recall the threat embodied by the name Auschwitz, that of the conscious and willful extermination of a species. It is significant that the disappearance of the Neanderthal does in fact represent the eradication of a biologically distinct, separate species, a project only *imagined* in the dark recesses of the anti-Semitic imagination.[51] Whether that eradication occurred by violence, evolutionary competition, or silent replacement remains unknown. For Bataille, however, the image of the *Homo sapiens* remains inseparable from the image of a being capable of exterminating his fellows to the last man.[52] "Like you and me, those responsible for Auschwitz had nostrils, mouths, voices, human intelligence; they could come together, have children: like the pyramids or the Acropolis, Auschwitz is a fact, a sign of man. The human image is inseparable, henceforth, from a gas chamber," he writes.[53]

For Bataille, the irony of the moment is inescapable and speaks to the ultimate, if rarely remembered, purpose of his oeuvre, namely, the necessity of finding an outlet other than thoughtless, random destruction for the consumption of excess energy, wealth, or resources (including human life).[54] "Our present world disparages man's longing for the marvelous...[and] when man's need for miracles is not satisfied," he says in his 1955 lecture, "it transforms itself into a passion for destruction." If cultures can be characterized by their most extravagant modes of expenditure, as Bataille claims, then our culture can be characterized by its weaponry of mass destruction.[55]

Here our culture takes its distance from prehistory. Whereas prehistoric and primitive cultures, in Bataille's reading, recognize the horror of murder and death as requiring apologetic expiation, contemporary culture all too often recognizes only the banality of evil: Western civilization is predicated on dispassionate, objective

professionalism even in matters of ultimate concern.[56] On the subject of the slaughterhouse, to take only this example, Bataille observed: "In our times . . . the slaughterhouse is cursed and quarantined like a plague-ridden ship. Now, the victims of this curse are neither butchers nor beasts, but those same good folk who countenance, by now, only their own unseemliness, an unseemliness commensurate with an unhealthy need of cleanliness, with irascible meanness, and boredom."[57] Nothing could be further from the Paleolithic imagination.

The Paleolithic imagination recognizes no such distinction between animals and men, save perhaps that animals possess skills and abilities, strengths, that human beings, in their fragility, their weakness, lack. Bataille repeatedly quotes the following passage from *Les Rites de chasse chez les peuples sibériens* by Eveline Lot-Falck, in which his vision of the rapport between hunter and hunted stands in clarified relief:

> Among hunting peoples, as among Siberians, man feels the most intimately linked to animals. Between the human species and the animal species, domination would have been unfathomable: they were essentially indistinguishable from each other. The hunter sees the animal, at the very minimum, as his equal. He sees it hunt, like him, for nourishment. . . . Like man, the beast possesses one or several souls and one language. . . . The bear could speak if he wanted, but he prefers not to, and the Yukaghir see this silence as proof of the bear's superiority over man. . . . "Wild game is like man, only more godlike," say the Navajo, and the phrase would not be out of place on a Siberian's lips. . . . The death of the animal depends, at least in part, on the animal itself. To be killed, he must have given his consent beforehand, which in a way makes him an accomplice to his own murder. The hunter therefore takes great care when dealing with the animal . . . anxious to establish the best possible relations with him.[58]

24

In this interpretation, the animal, if anything, exceeds man in power and dignity. The animal possesses all human skills and abilities as well as two essential abilities to which human beings can only aspire: the will to silence and the generosity of spirit to give of oneself even to the point of self-annihilation.

The silence of the beast thus testifies to its superiority over man: the animal instinctively chooses silence over speech. Bataille, for his part, wonders if he will be able to "let [his] thought slowly and slyly . . . devolve into silence?"[59] He admits, "I can't abide sentences. . . . Everything I've asserted, convictions I've expressed, it's all ridiculous and dead. I'm only silence, and the universe is silence. The world of words is laughable. Threats, violence, and the blandishments of power are part of *silence*. Deep complicity cannot be expressed in words. . . . Sovereignty does not speak."[60] Only a human being requires speech. Following Kojève again: "Man becomes conscious of himself at the moment when — for the 'first' time — he says 'I.' To understand man by understanding his 'origin' is, therefore, to understand the origin of the I revealed by speech."[61] The world itself, nature, is silent. Death is silent. The gods are silent. The realm of the sacred, the *mysterium tremendum*, cannot be captured in speech.

The prehistoric hunter, in Bataille's tale of the hunt, approaches his prey with dependence, devotion, and awe. The animal remains silent, simply submits, agrees to lay itself before the spear, the arrow, the blade. To kill the beast of prey is to violate the taboo on murder, to open the sphere of death. It is to reduce the once-dynamic animal to the status of a useful thing, an inert object, a foodstuff. And the animal has the power to suffer this humiliation, this reduction, willingly. The animal enters into complicity with its own murder. The animal here shares the fate of the Crucified.

Now, as in an ancient tragedy, the murderer recognizes himself as criminal, unclean, and he responds to a demand in excess of

his own animal needs (hunger and so on). In this response, he becomes someone else, other to himself, and takes his place as historically first in a long line of figures haunting the history of thought and the Bataillean corpus: the shaman here is the executioner who shares the fate of his victim.[62] He anticipates in his way all the others: Nietzsche's madman, Acephalus, Dionysus, Frazer's King of the Wood, the Freudian primal father — to offer up only a few names.

The shaman — painted priest and/or priest painter — stands in for the hunter, the executioner, the sacrificer who shares in the fate of his victim. Bataille indulges his fascination with this figure most intensely in the final pages of *Inner Experience*. There he reprints the text in which Nietzsche's madman announces the death of God, and in his gloss Bataille identifies with the agent of sacrifice. "The one who sacrifices is himself affected by the blow which he strikes...the one who sacrifices is in anguish before an incompleted world, incompletable and forever unintelligible, which destroys him, tears him apart (the world destroys itself, tears itself apart)."[63]

This figure, too, carries traces for Bataille of Frazer's King of the Wood, the priest of Nemi: that murderer who ascends his uneasy throne by slaying the previous priest-king; a king whose tenure comprises an uneasy wait for the priest-king who will one day slay him in turn. The King of the Wood gives human form to entropic tragedy: he is a figure who lives, who acts, only to bring himself another step closer to his own demise. In the final pages of *Guilty*, Bataille's identification with this criminal, too, is complete: he says simply but ecstatically, "I'm the King of the Wood."[64]

Finally, in this series, the tragedy of the wounded bison, of the cave bear, and of the King of the Wood is also that of Freudian man, threatened by dissolution from within, a subject in Thanatos. Further, this animal-god reflects the ambivalent figure of the

Freudian primal father, who is deified only in death, in and through an originary act of crime, of murder. The community, the band of brothers, conceives itself around this crime. For Bataille, the murdered bison stands in as an icon of a similarly primal slaughter.

At stake in the scene — and in this reading of the scene — is an impossible identification. To say that the shaman recognizes the divinity of the beast is to say that the shaman recognizes as sacred that which has been cast out of himself, that part of himself that he has rejected, that he now attempts to embrace: divinity and beast, high and low, spirit and flesh rejoined in an impossible identification. The shaman in the pit adopts the aspect — the mask — and point of view of an animal, once rejected, now divine, an impossible, tragic figure. In the scene in the pit, this impossible identification appears in the form of an impossible figuration, an image of the impossible: a disfigured bird-man falling, sex erect, beside a beautifully rendered bison, respected in attentive realism but dying, the life inside him pouring forth from his belly.

Images of cruelty are cruel images: they ask us to identify with our own annihilation. This impossible recognition remains the key to the ethics proposed by Bataille. We cannot steel ourselves to horror; we cannot hope to endure. Nor can we hope to share the burden of the pain of others. The impossible recognition of horror strips us of ourselves: images of dispossession dispossess us. Isolated from the pictured other, who we are not, and from ourselves, who we are no longer, we are lost in the embrace of our own mortal frailty.

Bataille reads prehistoric art as if he were reading one of his own books. Already in 1927 he claimed that "the world is purely parodic . . . that each thing seen is the parody of another, or is the same thing in a deceptive form."[65] In an act of self-fulfilling reversal, he deployed this interpretation of the world and its signs as an

aesthetic and intellectual credo, as an investigative tool, and as a meditational device. After the death of God, in the absence of transcendental truth, *incipit parodia*. However serious, however tragic his tone and topics, Bataille's writing proceeds by "contagion and mime"; it performs in the mode of dramatic mimicry.[66] His is a mobile thought, written in the voices and words of others.[67] He proceeds from affirmation to affirmation, and as each affirmation passes into silence, he discerns "the effect, in our human life, of the 'disappearance of the discursive real'" and draws a "senseless light from the description of these effects."[68] His goal is not the production of new affirmations, new facts, new knowledge. His writing aspires to the condition and experience of revelation: to capture in language that which cannot be expressed in words. His goal as a writer is the proliferation of silence.

Written ten years before his first visit to Lascaux, the final pages of *Inner Experience* wonder: "Is there a silence more stifling, more sound-proof, further beneath the earth? In the obscure unknown, breath fails. The sediment of possible agonies is sacrifice. If I have known how to produce the silence of others within me, *I am*, myself, Dionysus, *I am* the crucified. But I should forget my solitude."[69] Dionysus, the crucified, the madman, the shaman in the pit: silenced through an identification with that which does not speak, the death of the flesh, of the animal within. Bataille writes to produce the silence of others in himself. He writes toward an impossible identification, an identification with the impossible.

But what would it be to forget, in the silence and isolation of the cave, one's solitude? Can there be, today, a community of the cave?

Even a cursory survey of contemporary writings in prehistory — and it should be remembered that the most recent of the texts collected here is over forty years old — reveals a methodological

crisis in the field. A methodological crisis signals not only dis-
agreement over the method that should be used to frame under-
standing in a particular area but also a degree of confusion as to
the goal of the inquiry itself. Exactly how and toward what end
should researchers in prehistory proceed?

According to David Lewis-Williams, "Many researchers, espe-
cially those in France and Spain, believe that still more 'facts' are
required before we can 'theorize.'"[70] While this is understandable
given the rapidity with which techniques of information gather-
ing within paleontology have recently advanced, it has led to a
situation in which many researchers today "distance themselves
from the explainers and concentrate on data collection."[71] Paul G.
Bahn, in the preface to his book *Journey Through the Ice Age*
(1997), tells his reader that he will offer a "survey of past and cur-
rent theories about the art rather than promote a single favorite
interpretation." According to Bahn, "It will be some time before
another comprehensive volume [like André Leroi-Gourhan's
*Treasures of Prehistoric Art* (1967)] can appear — if indeed such a
thing is desirable."[72] Among the proliferating facts about prehistory,
the prehistorians, it would seem, tend toward silence, at least in
regard to the meaning of the data they report. (Is this the silence
sought by Bataille?) For contemporary prehistorians, attempting
a totalizing or unified vision of culture, to repeat Bahn's senti-
ments, may no longer even be desirable. Is this the residue of the
"horror of philosophy" that Bataille observed in 1951? Is there an
alternative?

Sharing Bataille's sentiments, Weston La Barre, in his book
*The Human Animal* (1954), wrote with enthusiasm: "Our knowl-
edge of the parts [of the world] has now reached a stage when we
can begin to seek a 'holistic' understanding of larger wholes. . . .
Science too is discovering that there is only 'one world.'"[73] In
anticipation of this unifying vision of culture and culture studies,

La Barre proposed a new methodology, for which he coined the names "anthropological holism" and the "ethology of culture." In La Barre, biology, primatology, physical anthropology, sociology, linguistics, analytic psychology, and comparative studies in religion and the humanities might fruitfully be combined in a single discourse of cultural understanding, and his is only one, however rare, example.

Prehistorians, of course, like all scientists and philosophers, specialize. For La Barre, as for Bataille, the specialist's insights lack value if they cannot be integrated into a larger, organized whole, if they cannot be situated against a broad horizon of value or concern. "The fatal tendency of specialists," Bataille observes, is that "the specialist often forgets that he is not writing for specialists ... that, if he himself has a meaning, it is to the extent that there is in him, beyond his specialty, a general interest in understanding."[74] The specialist, in other words, must write, think, and work with this general understanding in mind. This is not to say that the specialist must always write for the general reader. Rather, it is to say that the specialist's work is supported and sustained by a general vision of totality, the fulfillment of which must remain the goal of thought. (The disappearance of the educated general reader should also be noted at this point. However phantasmic, such individuals once served a function in the marketing of cultural information.[75])

Georges Bataille's ambition, as he tells us, "is a *sovereign* existence, free from all limited research."[76] His diverse inquiries trace the limits of man: those actions or activities in which human beings encounter that which they are not and recognize that which they are. He writes — for an educated general reader — on art, eroticism, laughter, death, poetry, play, the sacred. "I have sacrificed everything," he writes, "to the search for a perspective which reveals the unity of the human spirit."[77]

In *The Tears of Eros*, his final word on the subject of prehistoric art and culture, Bataille at first suggests that he will solve the enigma of the scene in the pit at Lascaux. Later he claims that the enigma *cannot* be solved; it can only be clarified as the sign of a "paradoxical accord." The image of man and/as beast exists as an irreconcilable combination of eroticism and death, identification and displacement, affirmation and negation. The scene, in Bataille's reading, has been "contrived to guarantee disorder in our thinking."[78] Our experience of this disorder is the substance of its meaning.

Bataille does not offer a final interpretation of the scene in the sense of a definitive explanation or affirmation of its meaning. This is not only because such an interpretation would be inadvisable in the absence of additional information on the cultural context of the painting's composition. Rather, Bataille *stages* a hermeneutics of incommensurability. He forcefully asks a question for which there can be no adequate answer. His writing on prehistoric art and culture offers an experience of disorder designed to restore our capacity for the state of wonder. Bataille writes to satisfy our longing for the marvelous.

In *The Tears of Eros*, his final word on the subject of prehistoric art and culture, Bataille at first suggests that he will solve the enigma of the scene in the pit at Lascaux. Later he claims that the enigma cannot be solved; it can only be clarified as the sign of a "paradoxical accord." The image of man and/as beast exists as an irreconcilable combination of eroticism and death, identification and displacement, affirmation and negation. The scene, in Bataille's reading, has been "contrived to guarantee disorder in our thinking."[5] Our experience of this disorder is the substance of its meaning.

Bataille does not offer a final interpretation of the scene in the sense of a definitive explanation or affirmation of its meaning. This is not only because such an interpretation would be inadvisable in the absence of additional information on the cultural context of the painting's composition. Rather, Bataille stages a hermeneutics of incommensurability. He forcefully asks a question for which there can be no adequate answer. His writing on prehistoric art and culture offers an experience of disorder designed to restore our capacity for the state of wonder. Bataille writes to satisfy our longing for the marvelous.

The following texts, drawn from a period of nearly thirty years, include essays and reviews published by Bataille in magazines and journals (see the notes for specific publication information). But these texts also include lectures, less polished essays, and other manuscript materials that were published only after Bataille's death. In keeping with the format of Bataille's *Oeuvres complètes*, the Gallimard editorial apparatus often supplements the texts with alternate and additional materials that indicate the difference between Bataille's manuscripts and his published texts as well as between various drafts of particular texts. In this translation, we have included only a portion of these alternate and additional materials (which are typically brief alternate word or line readings) in our notes. Our goal in this regard has been to carry over those materials that shed clear light on Bataille's process of manuscript revision or that suggest something of the cautious nature of his thought on the matters discussed here.

CHAPTER ONE

# Primitive Art

"The classical art of civilized adults," concludes Georges-Henri Luquet in the volume he recently devoted to the subject of "primitive art,"

> is not, as aesthetics has long believed, the only possible form of figurative art. In fact, there is another that is characterized by conflicting trends. It can be found among both children and adults, even among professionals, in numerous and varied human areas, about which prehistory, history, and ethnography have informed us. These artistic works, whose common characteristic is their opposition to the works of civilized adults, can legitimately be united into a single genre, suited by the name primitive art. To account for the age of the artists, we might delineate two types within this genre, children's art and the primitive art of adults, though these two types present exactly the same characteristics.[1]

In our day, it is at first difficult to maintain such bold propositions. A division of art forms into two fundamentally opposed categories risks appearing even more arbitrary than the comparison of children and savages made in contemporary thrillers. An expression like "ontogeny repeats phylogeny" no longer seems to

cover all the problems presented by the study of evolution.[2] However, we must recognize that Luquet's assertions proceed not from an arbitrarily placed faith in a now-discarded formula but from the analysis of a great number of facts.

From the minutely detailed observation of children, Luquet believed himself able to re-create the "genesis of figurative art" in the remote era of the Aurignacians. He writes, "The observation of actual, present-day children seems to establish . . . that heredity, suggestions, and example exercise no notable influence and that each of our children reinvents figurative drawing for himself as if he were the very first artist." At the same time, the author must recognize that the child from the outset finds himself in the presence of figurative representations to which he generally attributes the same reality as he does to objects that are present. But a factor independent of the will to figuration can easily be determined: children in particular (and here I am supposing it would also be necessary to include grown-ups in certain cases) willfully plunge their fingers into coloring materials, into containers of paint, for example, so as to leave traces of their passage while dragging their fingers across walls or doors. Such marks only "seem to be able to be explained as mechanical assertions of their author's personality." And in that capacity, Luquet associates them with one of the rare means that children have of asserting their personality, the destruction of objects, the exploits of "butter-fingered children," an association to which we will return later.

Luquet's analysis is unquestionably very satisfying. Children's drawings, considered in their most elementary form, have nothing to do with the figurative representations with which they are already familiar and which grown-ups alone, they assume, are capable of making. But the scribbles with which they persist in covering the blank page (at the beginning of these practices and without any premeditation) can by chance suggest resemblances

to them, most of the time very arbitrarily. Three crossed sticks are interpreted as a windmill, a broken line as a whip with its cord, and so on. The resemblance is sometimes slightly accentuated with a few simple additions, such as an eye for a bear, a beak for a bird. Later, these "fortuitous drawings" can be willfully repeated.

Luquet then cites the rather formless drawings from the beginning of the Aurignacian that seem to be the result of the "dragging of fingers." They are sometimes muddled, lines crisscrossing in all directions, sometimes forming rather uniform assemblages of straight parallel lines, whether horizontal or vertical; additionally, "analogous arrangements but with longer, more sinuous, more complicated lines ... more likely furnish the occasion for a figurative interpretation. In this way, we come to the still completely rough but already recognizable drawings of animals from Clotilde de Santa Isabel, from Quintanal, from Hornos, and to those, a little less imperfect, from Gargas, all of them still drawn on clay but with a single finger, and in regard to which it seems difficult to consider their resemblance as simply accidental and not premeditated."

Nevertheless, the author of *L'Art primitif* thinks it necessary to add a complementary hypothesis to this interpretation. "It is moreover possible," he says, "that in the case of the Aurignacians as in the case of our children, artistic creation has from the very beginning not consisted in the execution of an entire figure on a completely blank surface, but was initially limited to the physically easier and in particular psychologically simpler activity of intentionally completing a resemblance which the artist noted and judged imperfect in the pictures that were not his work. The child perfects, in this way, not only his fortuitous drawings but also unrelated productions and even natural accidents."

Luquet cites a number of representations dating from the Aurignacian period that surely are the result of this kind of activity.

Until now, this explanation bore on the genesis and not the constituent elements of "primitive art." Now, with the intention of permitting his analysis to bear on these elements, Luquet poses with emphasis the following general definition.

*Primitive art*, we must believe, *is the art that in the depiction of forms, whatever the age or the milieu of the artist, is guided by the same conception of figurative art and consequently of resemblance as that of our children, when they draw in their own way and by means of which they oppose themselves to adults before they become adults.*

"An image is a good likeness for the adult when it reproduces *what the adult's eye sees*, and for the primitive when it translates *what his mind knows*. We will express at once the common characteristic and the distinguishing characteristic of these two kinds of figurative art, calling the first a *visual realism* and the second an *intellectual realism*." In intellectual realism, "the drawing contains elements of the model that are not seen but that the artist judges indispensable; conversely, the artist neglects elements of the model that are blindingly obvious but devoid of interest for the artist."

Across nearly two hundred pages, Luquet gathers a considerable number of examples, borrowed from the arts of children or primitive peoples, from so-called popular arts (Epinal imagery, graffiti, and so on), sometimes even from prehistoric arts. In this way, he shows that these different categories of art have common traits, such as the representation of two eyes or two ears in a profile; the displacement of the legs, the horns, or the ears in width; the transparency of the sea, of a house, or of an egg, permitting the fish, the occupants, or a bird on the inside to be seen; the dynamic grouping in a figurative representation of elements that show a succession in time.

It seems undeniable to me that this conception of intellectual

realism is not nearly as interesting as the analysis of origins. Luquet is content to quickly eliminate the difficulties that would result from an examination of sculpted objects.

"In sculpture or three-dimensional art," he says, "the two kinds of realism (intellectual and visual) most often produce similar effects, with the result that it is ordinarily impossible to decide if a sculpture comes from one or the other." It would be simpler to recognize that a category like Luquet's intellectual realism can be used to classify different pieces of graphic art but is *essentially* inapplicable to sculpture. There can be no question of a sculpted object showing two eyes on a face in profile! Transparency is impossible, and the grouping of elements showing successive moments can only arise in quite exceptional cases. And yet it is hardly useful to underline that a general concept, as far as figurative art is concerned, lacks any interest if it does not envision all of the facts.

I will add that it is a shame that the author eliminated a question that is undoubtedly no less important.

In *L'Art et la religion des hommes fossiles* (1926), Luquet himself acknowledged that the art of the Reindeer Age, although it displays some characteristics that correspond to intellectual realism, falls incontestably under the heading of visual realism. The representations of animals of this epoch are sufficiently well known for it to be necessary to insist on this point. It seems, therefore, that the Aurignacians passed more or less without transition from the phase of genesis to the phase represented by the art of civilized peoples. Thus the first humans who made what we now call works of art would have overlooked primitive art.

Or at least so it might appear, if one sticks to Luquet's theory. If we pass from these eruditely elaborated conceptions to a much cruder perspective — according to which the art that is called primitive only through an abuse of the term would simply be

characterized by the *alteration* of presented forms — such an art existed with extremely accentuated characteristics from the very beginning, *but this crude and deforming art was reserved for the representation of the human form.*[3] To tell the truth, I am surprised that anyone interested in defining a kind of art opposed to traditional European art is not immediately drawn to such an evident, even shocking duality at the beginning of figurative representation. Reindeer, bison, and horses are shown with a meticulousness so perfect that if we had similarly scrupulous pictures of men themselves, the remotest period of human development would cease to be the most inaccessible. But the drawings and sculptures that represent the Aurignacians are nearly all formless and *much less human* than those that represent animals; others, like the Hottentot Venus, are shameless caricatures of the human form. The opposition is the same during the Magdalenian period.

It is evidently regrettable that this *willful* alteration of forms passes through Luquet's definitions.

I do not claim to be able to account for this categorical duality entirely. I do not think that it is much more mysterious than any other duality, but for the moment I will limit myself to indicating ways to access the problem it poses.

Whatever impasse Luquet seems to have written himself into, his work supplies, in my opinion, important data, at least when it concerns the origin of figurative representation. Dirtied hands gliding across walls or the scribbles in which he sees the origin of childhood drawing are not only "mechanical assertions of their author's personality." Without sufficiently insisting on this point, Luquet connects these gestures to the destruction of objects by children. It is extremely important to observe that in these different cases, it is always a question of the alteration of objects, whether the object is a wall, a sheet of paper, or a toy. Personally, I remember having practiced such scribblings: I spent an entire class

coloring the suit of the classmate in front of me with my pen. Today I am unable to betray the feeling that inspired me. The scandal that ensued interrupted a beatitude in the *worst* taste. Later, I practiced drawing in a less formless way, ceaselessly inventing more or less comical profiles, and this was not just anytime or on just any piece of paper. Sometimes I was supposed to have written an assignment in my copybook; sometimes I was supposed to have written the professor's dictation in a notebook. I do not doubt for an instant that I rediscovered the natural conditions of graphic art in this way. It is first of all a question of *altering* what one has at hand. During childhood, we are content to smear sloppily the first available piece of paper. It is possible, however, to become more demanding afterward. I can think of no better example than that of Abyssinian children, some of whose graffiti is published here (figure 1).[4] The Abyssinian children touched by graphomania draw with charcoal on the columns or doors of churches. Each time they are caught in the act, they are beaten, but the lower parts of the churches are covered with their bizarre rantings.[5]

The principal *alteration* is not that which the ground for the drawing undergoes. The drawing itself is crafted and enriched in various ways while accentuating the deformation of the represented object. This development is easy to follow in scribbling. From a few bizarre lines, chance unleashes a visual resemblance that can be fixed through repetition. This stage represents the second degree of *alteration*; in other words, the destroyed object (the paper or the wall) is altered to such a point that it is transformed into a new object — a horse, a head, a man. Finally, through repetition, this new object is itself altered through a series of deformations. Art, since undeniably there is art, proceeds in this way by successive destructions. Insofar as it liberates *libidinal* instincts, these instincts are sadistic.

However, another outcome is offered to figurative representa-

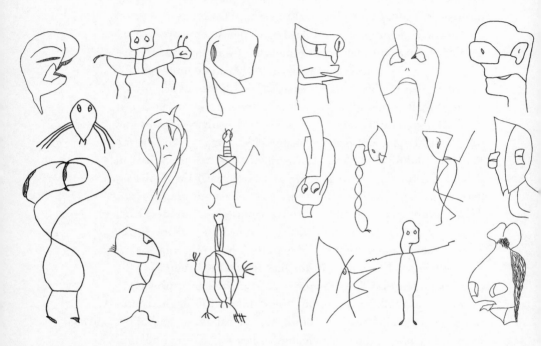

Figure 1.  Graffiti by Abyssinian children (Georges Bataille, ed., *Documents*, vol. 2 [Paris: Jean-Michel Place, 1930]).

tion from the moment that the imagination substitutes a new object for the destroyed ground. Instead of acting in regard to the new object in the same way as to the former one, we can, through repetition, submit it to a progressive appropriation in relation to the originally represented object. By these means, we pass rather rapidly from an approximative figuration to an image that increasingly conforms to that of an animal, for example. It is then a question of a veritable transformation of meaning at the beginning of the development. For the moment, I will simply note that such a transformation occurred for the Aurignacians in the representation of animals and not in the representation of man. It also does not take place in the drawings of most children, in regard to which one must grant a considerable share to the will to distort forms to the point of making them laughable, nor does it take place in the art of a great number of present-day savages. On the other hand, an opposing transformation of meaning took place during our time in the figurative arts: a transformation that rather abruptly displayed a process of decomposition and destruction that was no less painful to a lot of people than the sight of the decomposition and destruction of a corpse. But of course, Luquet's conception is no more able to encompass this modern form of representation than it can encompass sculpture in general, for if this decomposed painting alters objects with an unprecedented violence, it presents examples of intellectual realism only to an insignificant degree.

Be that as it may, we have seen that Luquet's work, summarized in the volume he recently devoted to primitive art, makes a considerable contribution to the few notions we have of the origin and the meaning of figuration. On this point, Luquet's opinions are a positive contribution, difficult to discount, however questionable his conceptions connecting the evolution of the individual and historical evolution. These opinions must only be

43

criticized where they do not sufficiently address psychological motifs. Such motifs are extremely easy to note with children, whereas we have very little data for prehistoric man. But it is by no means useful to claim that this development occurred in the same order with one as with the others. It is enough to note in the two cases the result of the implied psychological factor to know the alteration of forms. Only the differing treatments of animals and humans will be able to provide some insights into the psychology of prehistoric man, and I am confident that the analysis of this difference will lead to satisfying results.

CHAPTER TWO

# The Frobenius Exhibit

# at the Salle Pleyel

The importance of this exhibit has perhaps not been sufficiently emphasized: Dr. Leo Frobenius has undertaken the investigation and interpretation of South African mural paintings, often referred to as Bushmen paintings, on a much more vast level than his predecessors. Contemporary man has undoubtedly never, until now, been offered contact in such an intimate way with primitive human life, hardly distinct from nature. One must say, it's true, that contemporary man hardly concerns himself with such contact. The exhibit hall was almost empty.

These paintings, in which it is easy to establish several oppositions, all belong to the Paleolithic civilization of Africa. This civilization, which disappeared thousands of years ago in our region, was interrupted in South Africa only several centuries ago by the invasion of the Bantu, a people infinitely more advanced in ironwork. Thus a pictorial art of typologically ancient men, which had been progressing until recently, presents itself to us richly developed in a number of remarkable examples. Moreover, the authors of the paintings are still known to us through rare surviving Bushmen. This is why, from the point of view of life, such an art surpasses in interest that of the European caves.

As a group, the compositions from South Africa, like those of

other Paleolithic men, are characterized by a stupefying negation of man. Far from seeking to affirm humanity against nature, man, born of nature, here voluntarily appears as a kind of waste. The paintings conserved by the Frobenius expedition develop this primitive theme through the most varied forms, in such a way that a mechanism that can still only be deduced with difficulty (by means of the published iconographic documents and with our understanding of totemism) appeared alive before our eyes in the exhibition hall. Man's first movement amid animals and trees had been to conceive of the existence of these animals and trees and to negate his own. The human body appears as a Cartesian diver, like a toy of the wind and the grass, like a cluster of dust charged with an activity that decomposes it. The blatant heterogeneity of our being in relation to the world that gave birth to it, which we have become so incapable of proving through tangible experience, seems to have been, for *those among us* who have lived in nature, the basis of all representation.

The elephants and zebras around these human beings seem to have played the same eminent role as houses, churches, and administrative buildings do around us. But the unhappy waste passed his life not to submit to these buildings, these churches, but to kill them, to eat their meat. This is the rupture, the heterogeneity beneath all its forms, the capacity to ever restore that which has been separated by an inconceivable violence, which seems to have engendered not only man but his rapport with nature.

NOTE: The exhibit catalog was published by Leo Frobenius and Abbé Breuil as *L'Afrique* in *Cahiers d'art*, nos. 8–9 (1930). It includes written documentation and abundant illustrations.

# A Visit to Lascaux

*A Lecture at the Société d'Agriculture,*
*Sciences, Belles-Lettres et Arts d'Orléans*

My lecture tonight will be of a philosophical nature. Of course, it considers a historical subject; he who says "prehistory" says "history." Yet, the essential point of what I have to say will go further than what you might find in various books that discuss prehistoric man. All I can say now, to reassure you a little, is that I will avoid falling into the sort of technical language that makes philosophy such an off-putting discipline. Likewise, I must specify what kind of philosopher I would like to be, and this will not be easy for me. In effect, if it is true that I am a philosopher, I am an unusual philosopher, and my philosophy has little to do with academic philosophy. I should also issue a warning against mentioning on a test what I will say and show to you this evening. Fortunately, in our day and age, this is no longer of too much importance. I'm not saying that no one in the academic milieu would take my considerations seriously, but they are still not exactly part of the official curriculum. If you will, so that I don't remain too vague, and so that I can *situate* the philosophy you are about to glimpse, I might venture to say that in a sense my philosophy is not so different from Sartre's, for example. Of course, I am not an existentialist, but if I am not, in the end, it is surely because I have rejected that label. This, however, does not stop people from

occasionally considering me an existentialist, as, for example, in the small volume on existentialism in the Que sais-je? series.[1] In order to bring this overlong opening statement to a close, I will say that I have distanced myself from existentialism especially insofar as it has become what I consider an academic philosophy. I will also say that on a personal level, I don't get along with Sartre, and if I wouldn't say that we have our daggers drawn, it is because philosophers don't have daggers. In any case, in his writing Sartre rarely misses an opportunity to talk about me in a snippy way.[2] This has gone on for about ten years and I'm used to it.[3]

Now it is time to leave the existentialists aside so we can move on to the prehistoric human beings and the animals among which they lived. The question of the relationship between human beings and animals throughout prehistory certainly risks seeming to be outside the scope of philosophy. But it is nothing of the sort.[4] On the contrary, it is a truly fundamental question. In fact, when we say that we are human beings, what sense, in the first place, can this have if not that we are radically distinct from animals? This means, for example, that humans are always, in our eyes, endowed with an eminent dignity. Humans count for something. In principle, an animal does not. We send animals to slaughterhouses, and we hardly blink an eye. True, our own kind did as much with other human beings in Germany not so long ago, but in the end this was an enormous scandal, and then, despite everything — I apologize for such an offensive example — in Germany no one thought about pulling human bodies apart as if they were animals. I will allow myself to use a philosophical term here — you'll see I won't abuse this privilege — it means that humans see themselves as transcendent in relation to animals. For a human being, there is a discontinuity, a fundamental difference between an animal and himself. An animal is nothing, or, if you prefer, it is

only a *thing*, whereas we are minds,[5] and when one has a mind, one necessarily counts for something.

Except — there is an exception — what is true for us was not true for prehistoric man. For the men of prehistory — even if we're talking about the beings that anthropologists call *Homo sapiens*, our truly complete brethren, like Cro-Magnon man, who made not only tools but also art proper — insofar as we are able to judge them, animals were in principle no less like them than other human beings. Of course, nothing proves that this is completely and absolutely true, but it is certain that prehistoric man's similarity with animals served an important function for him. We are certain that he confronted the animal not as though he were confronting an inferior being or a thing, a negligible reality, but as if he were confronting a mind similar to his own.

In a moment, I will clearly and distinctly enumerate the perceptible aspects of the equality between prehistoric humanity and animals. Then you will see the extent to which things are clear. But first I would like to make these aspects *tangible*, to make them tangible for you through images that I feel it is safe to say are moving.[6]

These images, insofar as we can summarize them, have a magical character in relation to the hunt. Here lies the most plausible idea that we can assert of the significance they had for these men who previously populated the Dordogne region of France, as no doubt for all the men of that distant era. They were painted in a deep and mysterious sanctuary, one might say at the deepest point in the bowels of the earth that it was then possible to reach. It is not certain if these images were thought to be lasting representations, analogous to the images later situated on the walls of temples and churches; even less can we believe that our ancestors intended these images as decorations for the cave sanctuaries. It is much less improbable to suppose that drawing them was for the hunters

a ritual preparation for big expeditions, upon which the fate of their entire society depended (figure 2a). Raymond Lantier, who offers us this hypothesis, draws it from practices that are still found among modern Pygmies, whose living conditions are apparently similar to those of the Magdalenian hunters. What I find certain, in any case, is that this hypothesis accounts for the obvious indifference of the men of the Paleolithic to the final outcome; in other words, they were indifferent to the state of the cave wall after a drawing. The condition of the cave wall was so unimportant to them that they would not erase or cover the older images, generally resulting in a muddle, contrary to every principle of composition.

In my opinion, this hypothesis equally accounts for a paradoxical fact that I would now like to consider in greater depth.[7] The fact is well known. Whereas the Upper Paleolithic painters left us admirable representations of the animals they hunted, they used childish techniques to represent men. This negligence does not illustrate an essential intention in relation to which the representation of a man did not have any importance in *itself*; the representation of man only mattered in relation to the animal. It was effectively necessary to give the evocation of the animal not only the central value but a *tangible* characteristic that the naturalistic image alone allowed them to attain. The animal had to be, in a sense, *rendered present* in the ritual, rendered present through a direct and very powerful appeal to the imagination, through the tangible representation. It was, on the contrary, useless to try to make man's presence tangible. In fact, man was already present; he was there in the depths of the cave when the ritual was taking place.

Let's take a closer look at the only clear representation of a man found in the Lascaux cave (figure 2b). You see that it is crudely schematic. It appeals to our intellect, not our senses. It is an intelligible sign. I don't mean that it entails a kind of writing, but mov-

ing from the image to writing, we would only have to multiply the signs; we would also have to simplify them and render them conventionally systematic, yet it is clearly a question, for figurative art, of a completely different direction, of another open path.

Let's turn our attention back to the image of the bison, still in Lascaux (figure 2c). Now let's imagine before the hunt, on which life and death will depend, the ritual: an attentively executed drawing, extraordinarily true to life, though seen in the flickering light of the lamps, completed in a short time, the ritual, the drawing that provokes the apparition of this bison. This sudden creation had to have produced in the impassioned minds of the hunters an intense feeling of the proximity of the inaccessible monster, a feeling of proximity, of profound harmony. Definitely a more powerful and disturbing feeling than if it were a question of a previously completed, known painting. As if men, obscurely and suddenly, had the power to make the animal, though essentially out of range, respond to the extreme intensity of their desire. This time it is a question not of rendering it intelligible — as with the human figuration — but of making it tangible. This time it is a question of manifesting the animal and letting it loose to live out one of the roles in the drama of the hunt.

I will now call upon the feelings of the hunters, of those among you who have or had a passion for the hunt. First I will ask you if the moment the animal is seen is not a capital moment in the game of the hunt, a passionate moment, a moment that even has — it goes without saying, insofar as it is not necessary to immediately respond with an action, with gunfire — something that constrains, that catches the breath. Next I will ask you an even stranger question. I will ask you if you have a slight hostility toward your prey. It seems that you don't. There is hostility in war, but I believe that in the hunt, the hunter never hates the animal he kills. It even seems that there is often a sort of sympathy

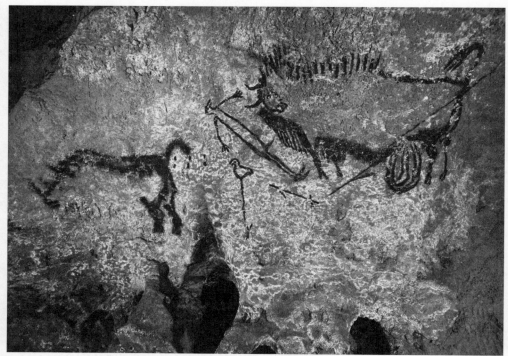

Figure 2a. Images from the pit in Lascaux: the group as a whole (Georges Bataille, *Lascaux, or the Birth of Cave Art* [New York: Skira, 1955], fig 52a) (photo: Hans Hinz).

Figure 2b. Detail: the man.

Figure 2c. Detail: the bison.

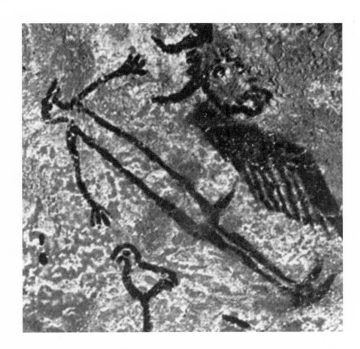

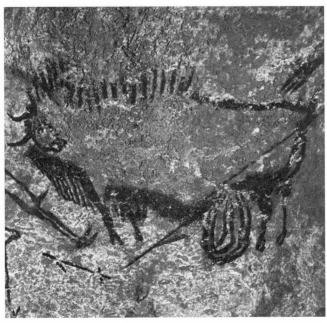

on the hunter's part. And I wonder, if this sympathy did not exist, if hunting would still hold the same interest. There is nobility in the wild animal, in the hunted animal. I have no idea what hunting would be if we had substituted chicken for partridge, or bunny rabbits for hares, or even fat pigs for wild boars. This would not be hunting; instead, it would be a rather comical endeavor, perhaps even a bit repugnant. Additionally, I think that in general, hunting has archaic traits. I don't have the time today to go into more detail on this point, but it wasn't by chance that I called upon the hunter's sensibility. It is a sensibility that doesn't seem in the least bit foreign to primitive humanity, and you understand completely in what sense I mean. In fact, nothing would be more uncalled for than to scorn the humanity to whom we owe the admirable paintings of Lascaux. I will even say that for me the feelings that we call noble — in the medieval sense of nobility, referring to the habits of the so-called noble class — are all archaic feelings, feelings that connect us to the earliest humanity. In any case, everyone knows that hunting is a game, not a job, despite its productive nature, and that this game was formally reserved for nobles, as work was reserved for serfs, for slaves.

I went into detail on this point before talking about the close connections, the connections of sympathy, that united the men of the caves with animals. For primitive man, as for the hunters of today, sympathy by no means excluded the will to kill. Further, more specifically, for the men of primitive times, as for men of the modern day whom we rightly or wrongly call primitives, the act of killing could also be shameful. Many primitive men ask for forgiveness beforehand for the evil that they are about to do to the animal they are pursuing. This seems outrageous to us, but it seems necessary to a consciousness less intricately confined by human pride. We cannot be sure that the men who lived in Lascaux, for example, asked the bovine that they killed for forgive-

ness, but we don't have much reason to doubt a feeling on their part that corresponded to this behavior. In fact, what is certain is that the images they left us amply testify to a humanity that did not clearly and distinctly distinguish itself from animality, a humanity that had not transcended animality. Earlier I emphasized the schematic nature of the representation of the man we find in Lascaux. But this representation is not only schematic, and therefore negligible for the sensibility. There is another aspect that I have not discussed: the man on the wall in Lascaux has the head of a bird; that is, he is *disguised* as an animal, that he is wearing a mask. Thus one might say not only that the Lascaux man affirmed his humanity, the way the most cultivated man does, the man defined himself as the king of animals, but also that he concealed this humanity behind an animal mask. Now, the Lascaux man is by no means an exception. While generally the representation of humans is rare in Upper Paleolithic art, it is unremarkable that man be depicted with a portion of his features borrowed from an animal.

I will show some examples of this.[8]

There is something truly unique here. For primitive human beings, the animal is not a thing. And this characterizes very broadly all of primitive humanity, for whom ordinary animality is rather divine. The thing is obviously not human. But the thing is on the side of humanity; it is a tool, which in the time of Lascaux is all that separated human beings from animals. In addition, if man is not a thing, he will become one when slaves appear, that is, men subjugated to work. Herein lies something that deeply underlines the meaning of the discovery of Lascaux.

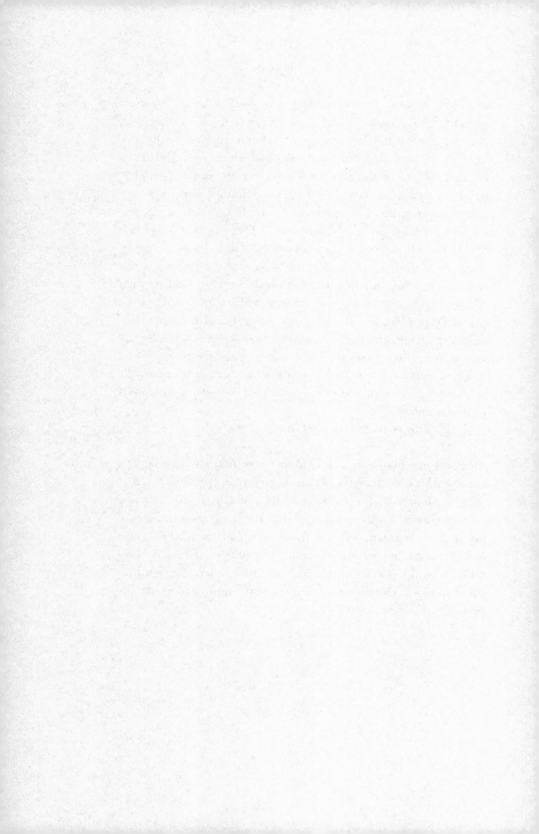

CHAPTER FOUR

# The Passage from Animal to Man

# and the Birth of Art

The wealth of Abbé Breuil's illustrative documentation and the scientific value and profound nature of his explanations make his recent book a true summa of the knowledge that contemporary man has been able to gather on the art of prehistoric man. All the caves known at the time of his writing are the objects of meticulous description and a detailed discussion of dates, clarifying summaries, and photographs. Occasionally he presents simple clarifications; at other times, these new contributions are considerable (as is the case for the prodigious engraved walls of Les Trois-Frères). And, for all the stations of this recently revealed domain, we will for a long time to come be required to refer, before any other source, to what this work teaches us.[1]

The author limited himself to France, to a large part of Spain, and to Italy. He does not discuss the art from the southeastern region of Spain, known as Levantine art (this art is in fact more recent, although, according to Breuil, it is a direct derivation of the older Franco-Cantabrian, Aurignacian, and Perigordian art). He also does not discuss African art. Yet if we envision the *birth* of art (better yet, the birth of man himself), all that is missing is the not inconsiderable, but secondary, contribution of the minor art normally designated, when discussing prehistory, by the name

portable art. With the help of this monumental book, the enigma posed by the passage from animal to man is assuredly something we must force ourselves to resolve: we can, we must go to these places, but these places, without this guide, would rarely reveal their secrets.[2]

The earliest prehistoric art surely marks the passage from animal to man. In all probability, however, when figurative art was born, man had been around for a long time. But not in a form characterized by the kind of tumult that we experience as human beings, feeling similar to one another and yet distinct. With the name *Homo faber*, anthropologists designate the man of the Middle Paleolithic age; not yet holding himself erect, he was also quite far from our myriad possibilities, of which he only shared the art of tool making. *Homo sapiens* alone are like us, at once in appearance, cranial capacity, and, beyond their concern for immediate usefulness, the ability to create not just tools but objects in which sensibility flourishes.

The appearance of the first man is known to us only through his bones. Cranial capacity is a representation of his mind. Prehistoric art is therefore the only path by which the passage from animal to man became, at this distance, *tangible* for us. At this distance and also, we must say, only recently. In fact, this once-disregarded art has only for a short time been the focus of a two-stage discovery. Initially, the primary revelation of Paleolithic parietal art met only indifference. As in a fairy tale, in 1879 Marcelino de Sautuola's five-year-old daughter discovered marvelous polychrome frescoes in the cave of Altamira, near Santander. Her tiny frame allowed her to effortlessly wander into a room with such low ceilings that nobody had previously been able to enter it. Thereafter, visitors flocked to the scene, but the idea of attributing an admirable art to very primitive men was unaccept-

able. There was something shocking about it; experts shrugged their shoulders and, in the end, failed to concern themselves with the unbelievable paintings. Misunderstood, derided, the paintings only recently, after 1900, were exonerated by science.

Yet in order to be admired, the paintings of Altamira required work from their admirers. In 1940, these works were still the most beautiful art that our earliest ancestors left for us, but they did not provoke the same extreme awe as the discovery of Lascaux. "Until then," according to Breuil,

> the greater mass of the public, except for a very few individuals, were not interested in cave art, which is not easily appreciated or even deciphered, being in caverns where access is difficult and sometimes dangerous. The extraordinarily fine state of preservation at Lascaux, a true jewel of Quaternary Art, by kindling the admiration of non experts as well as that of specialists, has definitely introduced Prehistoric Art to the horizon of every educated man.[3]

This is the least that one might say. In fact, what is striking about Lascaux is that when reflecting deeply on the first tangible sign left by man of his emergence in the world, we can finally gauge what was marvelous about it. We can finally gauge what we still are.[4]

The discovery of prehistoric art allows us to discern, though with great difficulty, a reflection of the lives of the first men. But now we no longer have to search: these paintings have the force to dazzle, even to the point of disturbing us.

Recently, luck led a few young boys underground, into a room of a thousand and one nights: in the woods near a town in the Dordogne, they struck matches in the depths of a cave where they were looking for a dog.[5] They saw that the walls were covered with frescoes of a dazzling freshness.

These frescoes not only seemed to have been painted yesterday; they were incomparably captivating: a kind of savage and graceful life emanated from their disordered composition.

Nothing could have rendered the presence of this nascent humanity of long ago more tangible. Yet this tangible aspect also amplifies the paradox proper to all prehistoric art. The traces of their distant humanity that these men left, which reach us after tens of thousands of years, are almost completely limited to representations of animals. These men made tangible for us the fact that they were becoming men, that the limitations of animality no longer confined them, but they made this tangible by leaving us images of the very animality from which they had escaped. What these admirable frescoes proclaim with a youthful vigor is not only that the man who painted them ceased being an animal by painting them but that he stopped being an animal by giving the animal, and not himself, a poetic image that seduces us and seems sovereign.

This is what the animal figures of Lascaux, after many others, say, but in saying it, they complete a lengthy revelation with a kind of apotheosis.

What must continue to astonish us is that the effacement of man before the animal, at the very moment when the animal within him became human, is the greatest effacement that can be conceived. In effect, prehistoric man depicted animals in fascinating and naturalistic images, but when he wanted to represent himself, he awkwardly concealed his unique, distinguishing features beneath those of the animal that he was not. He only partially divulged his human body, and he gave himself an animal head.

This aspect does not seem to me to have been as clearly delineated as he would have liked. At the same time, its strange character emphasizes the interest in the passage from animal to man. The decisive step took place when man saw himself for what he

had become, accepted, far from feeling ashamed of, as we do, the share of the animal that remained within him, and disguised the humanity that distinguished him from the animals. He masked the face of which we are proud, and he flaunted that which our clothes conceal.

We will see that such tendencies are consistent; it will be difficult not to find, if not immutable truths, at least the elements of a problem. But we should not be surprised if prehistorians avoid this problem. We are of course in no position to lament it: these elements could only have inflected research in a pre-given direction and in vain.

Breuil says simply: "In this wall art of the dark caverns in which hunting magic holds the greatest place, the human figure is always rare though not absent, but generally very conventional. Most of these figures are masked, or if one prefers, provided with non-human attributes."[6]

I will attempt to offer a general outline of these figures.

The most beautiful figures are carved and barely decipherable. An exception, to some extent, the "dead man" in Lascaux is painted or rather drawn with exaggerated features; but if it is easy to interpret, the grotesque and childish craftsmanship (much more shocking than the realistically executed neighboring bison) leads us to think that there is some taboo affecting the accuracy of the man's image. Breuil sees a dead man "l[ying] slantwise on his back" in front of a wounded bison with his guts coming out: he is, in any event, ithyphallic, and "his head is small and appears to be that of a bird with a short straight beak."[7]

For being initially less readable, the semi-human figures in Les Trois-Frères are of a more tangible veracity (figure 3). One of them, surprisingly alive, is on the cover of the book. He seems lost within a proliferation of animals, all having been composed one on

Figure 3. Line drawing of man-bison from Les Trois-Frères (Georges Bataille, *Tears of Eros* [San Francisco: City Lights Books, 1961], p. 41).

Figure 4. The "God" of Les Trois-Frères. Drawing by Henri Breuil (Abbé Henri Breuil, *Four Hundred Centuries of Cave Art* [Montignac: Centre d'Études et de Documentation Préhistoriques, 1952], fig. 130).

top of the other, forming a massive confusion of animals: horses, bison, and ibex all mixed together (even a rhinoceros adds his baroque shape to this torrent of savagery) offer a grandiose accompaniment to the veiled apparition of the human form. According to Breuil, this dancing and ithyphallic man with the head of a bison would play the "musical bow."[8] The documentation of this painted cave's ceiling is the result of Breuil's painstaking and tireless work: neither photography nor plain eyesight is enough to grasp the full extent of the confused features that only the drawing renders decipherable. As indirect as it may seem, the documentation that Breuil has published has an undeniable grandeur; few figurative works are more beautiful to my eyes than this animal symphony, submerging furtive humanity in every sense: undoubtedly a promise of triumphal domination, but on the condition that humanity be masked.[9]

There is nothing more to say about the other figure from Les Trois-Frères who again presents us with the ambiguous configuration of an ithyphallic man from the waist down and a bison from the waist up.

It is the figure already made known and familiar under the name the "sorcerer" by Breuil (he now, however, prefers calling it the "God" of Les Trois-Frères) that most notably deserves our attention (figure 4). It is, says the author (who collaborated with Henri Bégouën on the study of this cave), "the only painted figure" (it is, however, both carved and painted). It is nevertheless barely intelligible in photographs; only through sketches is it made clear. This isolated "God," situated very high,

> presides over all the animals, collected there in incredible numbers and often in a terribly tangled mass. He is 75 cms high and 50 cms wide, he is entirely engraved, but the painting is unequally distributed: on the head there are only a few traces, on the eyes, the nose,

forehead and the right ear. This head is full face with round eyes with pupils; between the eyes runs a line for the nose, ending in a little arch. The pricked ears are those of a Stag. From a black painted band across the forehead rise two big thick antlers with no frontal tines but with a single short tine, fairly high above the base of each branch, bending outwards and dividing again to the right or left. This figure has no mouth, but a very long beard cut in lines and falling on the chest. The fore-arms, which are raised and joined horizontally, end in two hands close together, the short fingers outstretched; they are colourless and almost invisible. A wide black band outlines the whole body, growing narrower at the lumbar region, and spreading out round the legs which are bent. A spot marks the left knee-joint. The feet and big toes are rather carefully made and show a movement similar to steps in a "Cakewalk" dance. The male sex, emphasized but not erect, pointing backwards but well developed,[10] is inserted under the bushy tail of a Wolf or Horse, with a little tuft at the end.

"Such is," Breuil concludes, "the Magdalenian[11] figure considered to be the most important in the cavern and which, after much thought, we consider to be the Spirit controlling the multiplication of game and hunting expeditions."[12]

I doubt it will be possible for us to *know* anything so precise about this topic, but these carved images, taken together, refer to the hunt, and the man with the stag ears, who rises above the tangle, cannot be separated from the hunt. Breuil's hypothesis appears completely reasonable to me: I will only oppose his feeling of an ungraspable reality, a reality too rich to be so quickly pinned down, like a clearly labeled insect or specimen in a glass box. In my opinion, this definition leaves out something essential. Regardless of whether this figure was intended to govern the activities that were of the greatest importance for the men who

conceived of it, I can, on the other side of this utility, which is comparable to that of a mechanical system, discern its implications on the level of *human* life, which this dream creature *negates*.

It is easy to say of a drawn animal: it is a reindeer, a stag, or a mammoth. Such pronouncements permit life to pass: these *apparitions* designate less this or that being envisioned as a thing than the feelings of those who have fixed them in time. Similarly, *a fortiori*, these bison-headed men designate a world in which the complex game of feelings developed humanity. Of these humans, the man with the ears of a stag is distinguished from the other figures only by the privileged position he occupies. Each time, it is a question of denying man the benefit of animality. Of course, these beings have man's prestige and mastery; they are only what they are because they are men and not merely animals. But these men flee their humanity; these men refuse the destiny that determines them: they overflow into savagery, the night of animality, which is nevertheless born of their clarity and calculation. We often feel the weight of civilization, but this is the result of pride; we thirst for something else, and we often attribute our lethargy to our sophistication: it is easy to see a sign of old age in feelings contrary to efficacy; feelings never contribute to the human task of exploiting every possible resource.

But these feelings so forcefully swayed developing humanity that they slowed down a tendency, which came to dominate only much later, to see reason as the supreme value on which to found our contempt for animals.

Taken together, the human figures in the caves, which are numerous, though exceptional in comparison to the crowds of animals in which they are lost, fit what I have just said about them.

On the other hand, instead of calling them human figures, Breuil more often refers to them as semi-human. Whether we

think of them as wearing some sort of animal costume, or as evoking creatures halfway between man and animal, or perhaps even as an artist's error or a slip toward the grotesque, they retain a human aspect that seems to have been accorded to them only half-heartedly. Some of these images are very old and must date back to the Aurignacian or Perigordian eras: like the "dead man" of Lascaux, which I mentioned earlier, or those human silhouettes in Altamira, which seem to be wearing a mask but can only be deciphered with great difficulty and to which Breuil compares the man of Hornos de la Peña, "resembling a monkey, all the more so as there is a false tail."[13] The equivocal creature of Hornos is ithyphallic and is even like "the horrible anthropoid" of La Peña de Candamo, "with knock-kneed legs and arched feet."[14] In Pech-Merle, "a masked Man with a pointed muzzle" reminds us of the figures from Les Trois-Frères.[15] The numerous "human or rather semi-human figures" at Casares date to "the end of the Perigordian evolution towards the Magdalenian style."[16] Breuil distinguishes Casares for its "most suggestive ... group scenes ... like some vulgar drawings; the men all have grotesque faces as on the ceiling of Altamira and at Hornos; they are associated with fish or Frogs."[17]

The carvings in the Combarelles cave, near Les Eyzies, are much more recent (they belong to the Magdalenian era), but the manner of representation has hardly changed. Breuil describes

a whole series of anthropoid figures which may perhaps be masked and seem to have some magical meaning. Amongst the most striking is a strange human silhouette; the head takes the shape of a Mammoth's head, the two arms sticking out in front might well be tusks. Elsewhere there is an obese Man seeming to follow a Woman; and here and there, human people with animals' heads are engraved on the walls; all are distinguished for the extreme negligence of the way they are made.[18]

The figures in the Magdalenian cave Marsoulas have these same limitations but emphasize a comical note and consist of an abundance of rough compositions, "mostly faces and sometimes grotesque or masked profiles."[19]

In every possible way, at least concerning the male figures, the portable art found in the caves complements the images depicted on the walls. According to Johannes Maringer, these representations "consist merely in caricature drawings in which human and animal traits are mingled, and might just as well represent hunters in disguise as individuals with bizarre magic masks and strange ceremonial costumes. Many of them are very likely pure products of fancy."[20]

The female figures, which I will discuss below, pose problems independent of those related to the scenes I have just described. Nonetheless, these scenes appear to have a hidden meaning. I don't even know how to begin to speculate about this. There are a purpose and a systematic design in the representations of these men, so similar to each other, yet so different from the naturalistic and generally beautiful representations of animals. These figurations would require a broad explanation. According to Breuil, "These figures ... cannot evidently represent a real human type, and they probably have no uniform meaning."[21] Confronted with certain hypotheses, I am tempted to go further. "We have spoken of the influence born of the talent which Paleolithic artists had for painting animals."[22] Yet it is precisely a matter of acknowledging this exclusive character, and of not naively seeing in it the reason for the nearly complete loss of the faculty of imitation when depicting human beings. Breuil struggled to explain this peculiarity in conjunction with the specific nature of the object represented, this despite all of the naturalistic representations. I have already cited his particular explanation of the "sorcerer" in Les Trois-Frères. He also provides a general

formula enumerating the various possible hypotheses concerning each case. He writes,

> These are hunting or ceremonial masks of either ghostly or mythical beings. The Man with a Mammoth's head, the one with a bird's head, and all the other masked beings, here or elsewhere, are perhaps hunters in disguise, ready to start on their expeditions. More probably they are members of the tribe performing some magic rite, or mythical beings from whom favors must be requested and who must be conciliated.[23]

I have only a few objections to this and will add nothing to his statement as a whole, except that sometimes traces of specific realities from the past should have disappeared, which is different from what this reflection is likely to suggest.

In all the representations of prehistoric art, female figures form a third world, as much opposed to the world of men as to that of animals. Most of the female figures belong to portable art: they are statuettes whose characteristics are well known. They most often emphasize fertility — hips or breasts. One might sometimes say they were idealized representations, if these idealizations did not tend toward deformity. They are always placed in opposition to the male figures, whose rough rendering they have normally been spared: they are represented either through minute naturalism or through a deformed idealism.[24]

They do, however, have two points in common with the masculine images I have discussed.

The faces of these female figurines are never given the slightest animal aspect, but, we must add, their human aspect is also suppressed.

Most of the time, the face has the same slick, smooth surface as the posterior: no eyes, no nose, no mouth, and no ears. The head

of the Venus of Willendorf is a uniformly granular sphere, resembling a fat blackberry (figure 5). The woman's head executed in bas-relief in the Laussel cave and attributed to the Perigordian era, is a kind of irregular disk (figure 6). This absence of a face is no less remarkable in the three women in bas-relief in the Angles-sur-Anglin cave. They are indeed "reduced, or almost reduced, to those parts of their bodies below the waist."[25]

The other point has to do with the emphasis on their sexual organs. This characteristic is even more marked than in the representations of the masculine figures, especially since those of the latter are often limited to the upper portions of their bodies.

The absence of a face on the female figures does, however, admit an extremely archaic and remarkable exception. A very small head of a young woman, carved in a mammoth's ivory tusk, was discovered at the end of the nineteenth century in a cave in Landes, at Brassempouy (figure 7). The nose and the mouth had been so well formed that this tiny face, known as the "figurine with the hood," gives an impression of youth and great beauty. If it were necessary, here we would have proof of the capacity that Aurignacian art would have needed had it wanted to depict human beauty. Yet this unique face cannot cancel out what the absence of a face or these animal faces signifies for us: that the Paleolithic man concealed with a mask what is a source of pride for us today, and he openly paraded what we use clothes to conceal.[26]

The women with smooth faces offer perhaps little credence to the hypothesis of those who see the images of men with animal heads as depicting disguised hunters. Something more general than a hunting trick seems to me to have dictated this impetus not to represent humans in the same way as animals.

Surely, if we look for what this could be and if we adhere to a basic interpretation, not intimating what we do not know, we will feel helpless. Nevertheless, it seems worthwhile to remind

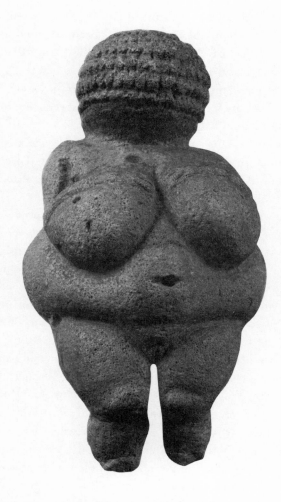

Figure 5. The Venus of Willendorf. Naturhistorisches Museum, Vienna (Erich Lessing/Art Resource, NY).

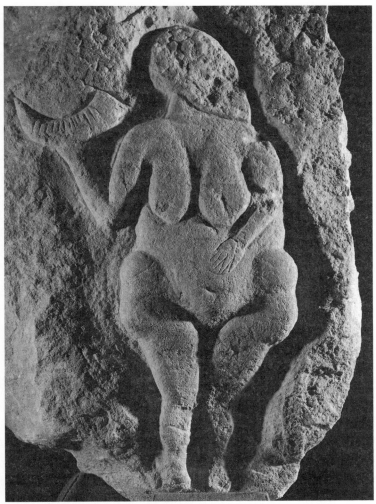

Figure 6. The Laussel Venus. Musée d'Aquitaine, Bordeaux (Erich Lessing/
Art Resource, NY).

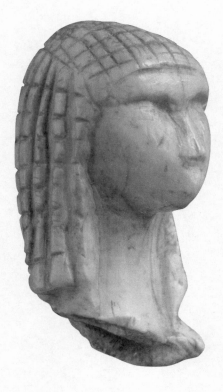

Figure 7. The small ivory human head from Brassempouy, Landes (Réunion des Musées Nationaux/Art Resource, NY).

ourselves of the extent to which a monkey's ugliness disturbs us: it never ceases haunting us. The attitudes I'm talking about surfaced at a time when the sight of a monkey was definitely familiar and were even more important since Middle Paleolithic man certainly looked like a monkey. We might ask this question: did Middle Paleolithic man's appearance, Neanderthal man's appearance, which the first men who walked fully upright had to have known well, cause the same horror in these men that the sight of a monkey induces in us? We must first acknowledge that we know nothing for sure about any of this, that as a matter of course we will never be able to know anything definitely about this. Undoubtedly. But the anthropoids about whom Breuil speaks ("the horrible anthropoid with knock-kneed legs and arched feet") form a continuum with grotesque men and men with animal heads. The question might now be asked a bit differently: when did the man who walked upright learn to regard himself with compassionate admiration, and when did he first regard the previous, stooped man and monkeys, then the entire animal kingdom, with aversion? There will never be a precise answer to this question. Humanity never rendered itself completely homogeneous in its own eyes. For us, beauty and humanity go together in a sense, but this assertion is denied by human ugliness, which repulses us no less than human beauty attracts us. If we stop clinging to superficial judgments, every objection seems coupled with another that contradicts it. If we invoke monkeys on one side and beautiful wild animals on the other, human beauty is on the same side as the beautiful animals; human ugliness, on the side of the monkey. But in regard to the apparently late opposition of animals and man, if human ugliness remains animal-like, it is in a discreet and insignificant way, and monkeys are returned to the animal kingdom.

In other words, the component judgments are ambiguous.

It seems that within the oppositions in prehistoric art, animality is designated positive, humanity negative. But the animals represented in the caves or on decorated objects are not *all the animals*. They are those that arouse man's desire, those that he eats (always on the condition that they also be large and worthy of respect), and wild beasts. These are both the animals that the men of the caves hunted and those the early civilized man treated as equals; either these men count on receiving life from this food, or they are hoping to assume the animal's ferocity as their own. Regarding the animals that arouse man's desire — which are precisely (if we overlook the differences inherent in the diversity of wildlife) those that cavemen depicted — the general disposition of the "primitives," in particular that of the hunters, is at the same time strange and well known; it is friendly. "Primitive" hunters feel no contempt for what they kill. They grant their prey a soul like their own as well as an intellect and feelings that do not differ from their own. They ask their prey to forgive them for killing it, and sometimes they cry for it, in a touching mixture of distracted sincerity and simple playacting.

This friendly attitude of our present-day "primitives" is linked to the practices of sympathetic magic. The "primitives" think that the representation of a scene is effective: in their eyes, it can influence reality. Everything indicates that this active value was in the minds of the authors of the cave paintings. No one can doubt the validity of Breuil's interpretation, which asserts that "in this art found on the walls of obscure caves..., the magic of the hunt is given the greatest precedence." These animals, pierced with arrows (they are not all depicted in this way, but they often are), show the object of prehistoric man's desire in a state conforming to that desire. There are also pregnant females and scenes of animals copulating: a desire for the multiplication of prey is con-

nected to that of its capture. Ferocious animals and felines, which are often represented in the caves, correspond to the desire to eradicate danger and, no doubt, without mention of their skins, to the desire to psychologically appropriate their courage. This is a basic and solid interpretation. Yet it is no less valid to attribute the ambiguous *friendship* that hunting communities now have for animals that they covet and that they kill to Paleolithic man. These fascinating figures on the cave walls are beautiful simply because their authors loved what they depicted. They loved them and they wanted them. They loved them and they killed them.

We ourselves might love animals, but as a rule we love them inasmuch as we desire neither to kill nor to eat them. We look down on them in any event. Modern man's gaze in regard to animals, his gaze in general, distinct from individual reactions, the gaze with which we see them, is an empty stare; it is the same gaze that sees useful things and any other random object. In our eyes, generally, the animal does not exist; this is why it does not die. Similarly, if you will, we get along with one another in order to eliminate death, to rid it from our horizon, to create in the end a world in which it would be as if the animal's agony and death were nonexistent. There are still, one might say, the agony and death of man, but in the case of animals this is linked to the sentiment that they are fundamentally inconsequential, and in the case of man to the contrary sentiment: for us, animals are things, which we precisely are not. Humanity radically separated itself from the animal world, yet this occurred only recently, when the theriomorphic gods progressively eliminated their animal appearance and when we became incapable of attributing a language and feelings similar to our own to animals. La Fontaine's fables help remind us of former days, when animals spoke.

An animal world does exist, wherein men were formerly integrated. It was populated with animals that man loved. This world

did not extend to all animals: it did not include roaches or lice. It also excluded monkeys. It is the poetic animality found in the caves. It undoubtedly endures for us, yet we have separated ourselves from it. Humanity was born from it. It was born from it by founding its superiority on the forgetting of this poetic animality and on a contempt for animals — deprived of the poetry of the wild, reduced to the level of things, enslaved, slaughtered, butchered.

It is true that man's evaluation of his superiority does not escape ambiguity. It refers us back to a conventional image and does not counter the fact that a part of man is revolting to the eyes of the other part.

To conclude, I will endeavor to offer a picture of the whole, infinitely complex situation of humanity in a world among beings that we are close to (and from which, furthermore, we were born). But first I would like to return to the precise meaning of the documents that permit us to measure the significance of the oldest effects.

What cave art signifies is covetousness and a faith in the effectiveness of covetousness that renders naturalistic figuration more intense. But man, as a rule, was not the focus of this covetousness. Women were its object at times, and this is perhaps the reason for the naturalistic aspect of the images representing them.

Regarding verisimilitude, the highest precedence always returned to the appearance of animals on the walls of a dark cave. Everything points to the fact that the carvings or the paintings did not have meaning as *permanent* figures of a sanctuary in which rituals were celebrated. It seems that the execution of the painting — or the carving — was itself part of these rituals. We can say very little about these rituals. Breuil is perhaps correct in evoking "dances and ceremonies, endless examples of which are known

amongst all hunting peoples, in which the 'Great Spirit' ruling all the forces of Nature is invoked, and the souls of the Animals slaughtered are invited to be reincarnated."[27] We know nothing about the belief system linked to these rituals. And we can even imagine that, the rituals usually existing prior to the beliefs that they naively interpret, the earliest prehistoric men did without them or were less encumbered by them. In addition, it is not certain that these places could accommodate important ceremonies or dances. The caves were sometimes just narrow corridors (nevertheless, Lascaux's exceptional richness and the enormous beauty of its paintings could, to some extent, be compared to a great hall wherein dozens of men could easily have fit). In any case, Breuil has the best of reasons for writing, "In the course of these ceremonies, the Ministers of the cult intervene, engraved or painted panels were executed according to methods and techniques in which the professional artists were trained, as trained as those of Egypt, Greece, or our cathedrals."[28] Carved panels — or frescoes. If the image itself, and not the moment of its execution, had counted, the confusion of the figures would be inexplicable. It is certain that Paleolithic man never wanted to decorate the cave wall: in the darkness of the cave, with the glow of the lamps, he celebrated a rite of evocation. He cared little about the images that were already there; all that mattered to him were the animals, which would appear suddenly, making their presence tangible, in response to the intensity of his desire. The nascent image ensured the approach of the beast and the communication of the hunter with the hunted. Previously, the one who evoked a bull or a stag was its intimate, its possessor.[29]

Even this unique aspect of parietal art is very meaningful. These works were not, by any measure, at any time, objects of art: when one considers the products of every era, nothing is further from what normally constitutes a thing. Their meaning was

in their *apparition*, not in the durable object that remained after the apparition. In my opinion, this is what gives the extreme confusion of the cave walls such charm: the continual, lively negation of the durable object, which, in the end, each and every figure became, without ever merging with the confusion wherein it is lost — which is not reducible to a unity in the sense of a thing.

The limited scope of this occasional essay makes it impossible for me to completely exhaust the problem posed by the opposition presented by the apparition of the prey on the cave walls and of the human figures, however disappointing, that accompany them. But the key, it seems to me, is in this aspect, this value contrary to that of the thing, proper to the figurations of the animals. Apparently, the constant ambiguity of humanity is originally linked to this duplicity with regard to animals. It is customary to reduce the meaning of sympathetic magic — the recourse to the image of the animal to ensure the capture of the real animal — to the desire for efficacy. There is a certain poverty to this view. Not that prehistoric man's intention had not really been what modern sociologists define it to be, but there is another aspect to it. The image evoked is always the negation of the thing. Significantly, the point of the evocation is overtly the reduction of the real being to the condition of the possessed thing. In fact, the evocation is also, in an essential way, an excuse: in addressing the animal, the human predator asks forgiveness for treating the animal as a thing so that he will be able to accomplish without any remorse what he has already apologized for doing.

The apology is obviously duplicitous, just as there is falseness in the fact that man, asking for forgiveness, recognizes his disgracefulness. He confesses that he reduces the animal to the level of the thing, since, in the end, the object of his desire is the thing that the animal is when it is reduced to a foodstuff. In Paleolithic art, this confession occurred in a marked way, if we judge from

the effacement of man's face in favor of the affirmation of the animal. But this kind of humility before the beast is obviously feigned. The die is cast from the outset. There is no reason to think that man did not from the beginning have the sense of superiority and pride that distinguishes him in our day. To some extent, at least. Of course, playacting in relation to animals has been going on for a long time. Hindus, who treat, or mistreat, cattle rather poorly while feigning to see gods in them, must have behaved like this for a long time. Prehistoric man, who killed and ate the animals whose appearance he had intentionally evoked, was not alone in feeling the aversion for the human form that, judging from his art, we are safe in saying he felt.

Be that as it may, appearances lead us to believe that he had not yet given himself over to the admiration — rather than horror — of the self that present-day man has of the archaic aspect of his species (specifically as seen in his anthropoid figurations). A kind of hesitation, of which we can know neither the degree nor the form, does not permit him, or so it seems, to deepen the gulf that separates him from what we must call the unfinished man, whose allure was, more than his own, similar to that of a monkey. Ancient humanity was no more obligated than present-day humanity to be entirely beautiful, and the predominant sentiment of Paleolithic man seems to have been that of his own ugliness. In any case, Paleolithic man situates himself very far from our own general reaction, according to which the animal world — monkeys and other beasts — is, in relation to man, who is noble and beautiful, on the other side of the abyss. A sense of magnificence and beauty seizes him when he faces bulls, horses, bison, not when he faces himself. Facing himself, he most likely had to laugh.[30]

The allusion that I just made to laughter illustrates that I can only touch upon the problems I have posed. In effect, laughter, which

not only is unique to man but of which man is the unique object, is evidently implicated in the strange appearance of the first human reactions that the art of the caves permit us to understand. It even seems to me that the meaning of laughter cannot be understood independently from the information I have emphasized in this essay. But I cannot dwell on this any longer. I would just like to say that I would not be surprised if someone had trouble seeing what is solid and basic about the considerations I have introduced. Significantly, I have spoken, sometimes in a difficult way, only about the most evident facts.

So as not to be informal, within the limits of the representations of the scholarly world, the opposition between what is a thing and what is not a thing cannot be dismissed. This is truly the level on which the specific characteristics of humanity are constituted.

For at least two million years, man, rather bizarrely, has yielded to an elevation of the mind linked to the feeling that durable things offered him. But I wanted to show that he was heading in a very different direction when he was "born." In fact, when he was "born," he did not prefer what he would eventually become, *that which he is*: the creator of a world of durable things. On the contrary, he effaced the aspects of this world of which his face is the sign.

He had not yet prevailed, but he apologized.

He is succeeding today, but he deeply senses the reasons that the first man had for apologizing for already being *what he would be*.

Today's man suspects the inanity of the edifice he has founded, he knows that he knows nothing, and, as his ancestors concealed their features with animal masks, he summons the night of truth wherein the world that has ordained his pretension will cease being *clear* and *distinct*.

CHAPTER FIVE

# A Meeting in Lascaux

## *Civilized Man Rediscovers the Man of Desire*

After more than ten years, we are still far from having fully recognized the magnitude of the discovery of Lascaux. It goes without saying that these paintings are beautiful, they enchant everyone who sees them, and they allow us to feel closer to the earliest men. But, understandably, we find these expressions daunting. They are cold, and it may seem pretentious to discuss these cave paintings more passionately.

They are within the provinces of both science and desire. Would it be possible to discuss them the way Proust discussed Vermeer or Breton discussed Marcel Duchamp? Not only is it inappropriate to fall under their spell when near them, in the disorder of a visit, lacking the time to collect ourselves, but prehistorians also bid us to keep in mind what these apparitions meant to the men who animated them and who, unintentionally, bestowed them on us.

The anticipation and desire of these hunters, these carnivores who arranged these images on these rocks, and their unsophisticated magic ordained these beautiful animals to carry the promise of carnage and quarry. An appetite for meat? Undoubtedly. We cannot think that the prehistorians have misled us. It is their duty to define the abyss that separates us from these men living at the

dawn of time. It was up to them to determine the meaning of these figures and to tell us how they differ from the paintings we love. The images before us are the mirrors of a long-standing dream that passion pursues within us.

In vain we sought our dreams in these figures, which were a response, as the dreams of children often are, to the cravings of hunger. In Lascaux, we are unable to feel that which makes us dissolve when we look at a painting by Leonardo da Vinci, that which dictates that we have only one, rather vapid and ungraspable, notion — similar to the dispersed diversity of the universe — of the painter and the landscape, of the painted face, and of this gaze that drinks it in.[1] These hunters of the Dordogne would better understand a housewife from Sarlat buying meat for lunch from a butcher shop than they would Leonardo da Vinci, or those drowned eyes intoxicated by his painting. They skillfully simplified their representations of animals, and the world is no less rich for the large appetizing beasts that populate these walls. The cave paintings of Lascaux are beautiful, and we marvel at their state of preservation, but they only announce their author's desire to eat. Prehistoric man painted them before hunting, believing that the possession of the painted figure would ensure the possession of the actual animal represented.

What can oppose the cry of joy which alone has the power to correspond to the sight that has been waiting for us for a million years in Lascaux?

What shatters this is the illusion that across such a long period of time — the mind cannot imagine anything more distant — I recognize someone who resembles me. It is myself in fact that I think I recognize, myself and the marvelous world linked to the power to dream, a power common to myself and the earliest man. I may be wary of a feeling that runs counter to the conclusions of scholars. Yet could I abandon it before science, which has the burden of

proving its assertions, which has clearly demonstrated its inanity?

The opinion according to which the first men, close to the animals and burdened by the difficulties of material life, would have been on the level of the most primitive men of today often passes as a response to the objectivity of history. For a long time, science has seemed linked to the idea of continuous progress, passing from wild animals to primitive man, who was himself still savage, and then finally to the fully civilized man, which we are.

In any case, we can know nothing essential about Leonardo da Vinci if we are not familiar with his paintings. This said, it is not necessarily easier to know his paintings than the paintings of Lascaux; at minimum, we can distinguish but a question of degree from one case to the other. I am not saying the communication coming to us from so profoundly distant a place as Lascaux has the same force as if it came from a time nearer to our own. But this is not clear. The cave paintings would have great power if we were not intimidated by the summons to reduce them to a work of magic, to a practical, utilitarian meaning, to the flat meaning of this poetic term. The most cautious prehistorians agree on this: the meaning that prehistoric man gave his figures does not mean that the Lascaux paintings are not, unintentionally, works of art. But *for us*, what does a work of art mean when it, not being destined for our eyes, was not intended as a work of art by those who made it?

Even the most inept figurations would have been effective as a work of magic — at least if the intention to go further were not implied. An extremely powerful communicative quality, beyond the end point of pure magic, was nonetheless able to fulfill the shared passion of the painter and of all those anticipating the work. There was nothing more mysterious in such qualities than in the unrest that emanates from the violence of a tom-tom, which even affects whites. Nothing more unintelligible. On this level (but only within these limitations), science ultimately has nothing

83

to say. It can still talk about the figures that represent our feelings and impressions, about the conditions or circumstances related to the creation of the image. The impression itself, on the other hand, is beyond its grasp. We are reduced to explaining that impression by directly reproducing its cause (the painting) or, however awkwardly, searching within the order of words, or sounds, for the sources that suggest it.

The uneasiness that paralyzes us as we stand before and consider the figures of Lascaux ultimately leaves us with a weak and disappointed feeling and seems to be in opposition to the force of the impression actually felt. What pushes us, past the initial moment, to see in these paintings a world of only an unfortunate sense of need — impenetrable to us — is linked to our inability to find a complete response to our desire in an animal world. In our eyes, it is just an incomplete world. The conditions and circumstances linked to our strongest impressions and feelings never imprison us within this animal depth. At a very young age, we learned to see *what is lacking* in the animal and to designate with the word "beast" those among us whose lack of reason made us ashamed.[2] This meeting in a Dordogne cave, given to us unintentionally from the depths of time by these hunters, could be disappointing if very quickly we did not see, in the tests it imposes on us, a way to set ourselves free. We have to free ourselves from all the human foolishness that prevents us from rediscovering ourselves and from establishing the most seductive contact between the simplest and the most complex beings — from the earliest humans to the most contemporary. Ultimately, since a deep similarity brings us closer to our forefathers, it would be enough to detach ourselves through the most complete and focused thought from this careful construction that distances us from these men who seemed to be related to animals, and who — science teaches us — felt remorse when they killed the animals that would give

them nourishment. Lascaux asks us to no longer deny *what we are.* We denigrate the animality that, through the men of these obscure caves, who hid their humanity beneath animal masks, we have not ceased to prolong. We cannot stop being human, and we cannot forgo a rationality that only knows the limits of reason. Yet just as our forefathers felt remorse for killing the animals they loved — and had to kill — we could, in Lascaux, feel shame for being, through reason, slaves to the work that we must pursue at any price. Thus the cry of joy I mentioned becomes more strange and straggled, more gay.

# CHAPTER SIX

# Lecture, January 18, 1955

It has become commonplace today to talk about the eventual extinction of human life. The latest atomic experiments made tangible the notion of radiation invading the atmosphere and creating conditions in which life in general could no longer thrive. Even without war, the experiments alone, if pursued with a little persistence, might themselves begin to create these conditions.

I do not intend to talk to you about our eventual demise today. I would like, on the contrary, to talk to you about our birth. I am simply struck by the fact that light is being shed on our birth at the very moment when the notion of our death appears to us.

In fact, only recently have we begun to discern with a kind of clarity the earthly event that was the birth of man. Similarly, you would find only scattered elements of what I would like to discuss with you tonight in books. These elements have been available to us for so short a time that we have not even had time to elaborate a true synthesis of them. I myself only just compiled the results of the research I had devoted to the question in the past few months; they will not appear in book form before the coming spring.[1] This lack of maturity will not astonish us if we keep in mind that the capital discovery in this domain, the one I will discuss with you in a moment, dates back to September 1940. This is the date of the

extraordinary discovery of the Lascaux cave. Other elements were already relatively familiar, like the difference between the Neanderthal man and the beings we call *Homo sapiens*, who appeared in western Europe in a period that barely precedes the first paintings of the Lascaux cave.

I will begin by discussing this difference because, in terms of prehistoric anthropology, the birth of the human race is given in this precise form. It is the passage from Neanderthal man to *Homo sapiens*. I am making myself understood. The Neanderthal man who populated the Perigord region in the middle of the Stone Age perhaps resembled a monkey as much as he resembles us. We know he held himself erect on two feet, but he had weak bowlegs, and he walked as some monkeys do, with their weight pressing down on the outside of their feet; his head still jutted forward like an animal's. If we discovered in some unknown land — which of course is absolutely out of the question — Neanderthal men living today, we could not make soldiers out of them, as we could of just about any man from a backward civilization. In fact, we could not even make them march in a straight line. We could not make them march in step. The most striking difference between the Neanderthal and the complete man can be expressed in a language appealing more directly to our sensibility. To use the expression of an American anthropologist: the Neanderthal man had the neck of a bull, whereas the *Homo sapiens*, who succeeded him and who from the very beginning was similar to us, had the neck of a swan.[2] Keep in mind that despite everything the Neanderthal was a man in many respects: he made fire; he knew how to make tools and, even more important, how to make the tools necessary for the fabrication of new tools. He carved stone admirably, and, even more, he made what monkeys do not: the distinction between life and death. A monkey standing in front of a dead monkey does not understand what has happened; he behaves the same,

88

positive way toward the dead monkey as he would toward a living monkey. He doesn't even perceive that it is dead, whereas the Neanderthal man certainly had an idea of death, which translates into a particular, already human, way of being. He might in fact have offered a burial for his dead fellow creature. Yet he not only differed from *Homo sapiens* in his anatomical structure, on the level of comportment; he also lacked an essential element needed to be a man in the fullest sense of the word. As far as we can tell, he made no works of art. He would have had the means to do so. He could have gathered colored minerals, but he did not use them to draw forms. It is the *Homo sapiens*, who looked like us to such an extent that if the earliest among them dressed like us, he could easily pass unnoticed in our midst, the *Homo sapiens* who first made works of art, who first began to sculpt, to draw, to engrave, and to paint. If the Neanderthal man pursued some activity along these lines, no traces of it have reached us. We will see that traces of the artistic activity of the *Homo sapiens* have reached us in great numbers.

This is very important. From the birth of our *species* (Neanderthal man was of the same *genus* as us but not of the same *species*), the human species in the strict sense of the word made works of art. Art is its distinguishing characteristic, along the same lines as its aspect, which is both upright and slender. We knew all this before the discovery of Lascaux. About a century ago, we discovered the first fragments of a portable, often very refined art made by prehistoric man: engraved or sculpted fragments of bone or ivory from mammoths. But only since 1880 has there been a question of paintings discovered in caves. Yet at that time, the intellectual world refused to accept their authenticity. These first paintings, those from the Altamira cave near Santander, were chiefly responsible for the tremendous hostility of the Spanish Jesuits toward prehistory. We assumed that they had

these wonderful bison executed on the Altamira ceiling to discredit prehistory. Since then, the Church's opposition to prehistory has so completely been resolved that the most eminent French prehistorian is now a priest, Abbé Breuil. But only at the beginning of the century, with the discoveries of prehistoric painted caves continuously multiplying, did it appear proven that the first men had created works of considerable caliber. In a certain sense, when Lascaux was discovered in 1940, it had nothing more to teach us (figure 8). But this is only in a certain sense. We knew before Lascaux that prehistoric man was a consummate artist: we knew this from small engraved objects, from sculptures, and from paintings executed on the rock of the caves. But these objects were small, and these paintings were most often hardly legible. If one day you visit painted caves, in general you will find yourself with a guide who will ask you to patiently follow his or her finger or pointer. With any luck, you will finally discover the tip of a horn here and, farther down, the line of the back, then perhaps the animal's feet, and, finally, you will have a vague understanding of the entire animal. Even in Altamira, the first and, before Lascaux, the most beautiful of the prehistoric caves, you needed time to decipher, in the muddle of colored forms, the exact silhouette of a bison. Still, it is possible, on the condition that beforehand we have an explicit understanding of the very beautiful sketches Breuil made of the paintings. Everything changes in Lascaux. The monumental frescoes that we admire so much in Lascaux are nearly intact. They abruptly bring us into the world of prehistoric man without any transition, and they give us a representation of this world that is as clear, as striking, as delicately sensitive as any painting left us by the generations closest to ours.

I will return shortly to the essence of my talk today, the Lascaux paintings, yet I must first discuss their initial significance for

Figure 8. Photo of discovery of Lascaux with Abbé Henri Breuil (Mario Ruspoli, *The Cave of Lascaux* [New York: Abrams, 1987], p. 189).

us. These paintings are the first that announce, by striking our sensibility and shocking it so completely, the presence of man on earth. Man, in the sense of the species of which we are a part, of the surviving human species, which today knows itself to be threatened by death, appeared on earth with art. And Lascaux is the first truly majestic sign of this appearance.

What I have just said also restates the meaning of the film that will now be projected before you.[3]

Perhaps this film does not show exactly what would be most important to show you, mostly because one of its former users seems to have taken such an interest in it that he absconded with the most significant part. The end is missing, which would have shown you the essential elements of the cave. But the film is no less useful, since it emphasizes the discovery of the cave, perhaps not in the way it should have, but you're going to see it anyway. After the film, I will do my best to sort out fact from fiction. In any case, my slide presentation afterward will, I hope, remedy the mutilation of the film in a satisfying way. I would only like to point out before beginning the film that the first few images you will see of figurations are not from the Lascaux cave but from one of the caves of Cabrerets. First, they are outlines of hands preserved against a background of paint. It was relatively common during the period of the caves to place a hand on the rock and color all around it so that the hand appears in white. There are also extremely muddled engravings in which you will certainly not have the time to decipher, even when forewarned, the silhouettes of a man and a woman. Despite the title of the film, Lascaux is only seen later in a rather limited number of figures. First an ibex, of little significance. Then a very beautiful horse surrounded by arrows, and another right next to it, which has been named the Chinese Horse, given its resemblance to Chinese painting. Last, a beautiful frieze formed by successive heads of stags. Except for

the ibex, you will see these images more clearly and tranquilly during my slide presentation afterward, when I will be able to elucidate them for you. The other figures were taken from other French caves, from the central region of France or from the Pyrenees. These last images are important because they give us some examples of the art of this period outside Lascaux; they were chosen from among the most legible images.[4]

I will come back to the rather succinct reenactment of the discovery of Lascaux you just saw in the film. Now we are going to look at a number of images, all from Lascaux. They will give you an idea, as insufficient as it may be, of what this marvelous cave is like. It will be easy for me to explain them as we move from one image to the next.

The image you see now is important because it transports us back to the time of the discovery of the cave. It dates back to the days immediately following that discovery. As you can see, there is at least one nearly exact element in the film's reconstruction. The boy you see in the middle of the photograph is young Jacques Marsal. He participated in the discovery, and the young boy in the film undoubtedly portrays him. We can see Breuil on the right. He came once he was told of the discovery. On the left, the instructor Léon Laval, whom the boys told in the first few days after the discovery, and Marcel Ravidat, whom I'll talk about in just a moment when I go through a detailed account of the discovery, as exact an account as is possible.

The film you saw is acceptable in some ways, even undeniably important. (For example, at the beginning, the almost Siberian, desolate aspect of the Causses — limestone plateaus — offers us a valuable sense of what the regions in the southwest part of France that were inhabited by these first men were like at the end of the Ice Age. The tundra aspect of the filmed hills sounds, as much as

is possible, the exact note.) But nevertheless, the film only gives us a well-ordered re-creation of the discovery of Lascaux. This discovery has preoccupied me for a long time now, and I should offer a reason for this, because my interest exceeds the anecdotal. It is because today we can see Lascaux only under very well defined conditions. In the summertime, if you want to visit the cave, you take a little path from a lot, where ten to twenty cars are parked. Then you enter the cave by going down stairs similar to those in a Paris subway station. First you enter a small room where, as in a subway station, admission tickets are sold and where, as in a subway, there is a little bookstore where books and postcards are displayed. In this little room, a number of people patiently await the departure of the preceding group. When this group leaves, one joins the succeeding group, which descends in turn into the cave, directed by a guide. In sum, I have to admit, these are not the best conditions to be introduced into the world of the first men. It remains possible, obviously, but what if the present-day world follows us in our exploration? What if it follows us in the guise of thirty or forty respectable tourists? Do we not risk remaining in our present-day world? And only rather indirectly glimpsing from afar the reflection of a world that has vanished, a world which I said had become accessible. For my part, this is why I always think back to the time when the first of our contemporaries entered the cave, when they suddenly found themselves in the presence of these marvels that no one had laid eyes on for fifteen thousand years. In this moment, if I had found myself there, it seems to me that I could truly have entered this long-lost world, whereas now, as I just said, the present world follows me; it descends into the cave with me. From this, a certain amount of disappointment takes hold. One should have been there with those who were first, without waiting, after the reopening of a space that had remained confined for about fifteen thousand

years, while the slugs themselves, Breuil points out, could no longer get in. This is what explains its nearly perfect state of conservation. It is only thirty years ago that a storm uprooted a pine tree and left a fissure that the local populace was the first to see revealed a rather deep cavity. They filled the opening with sticks because the sheep grazing nearby could easily have fallen into it. One day a woman removed the sticks so that she could put her dead donkey in the hole. She saw the body fall rather far. She thought that an underground passage was exposed by this fissure, undoubtedly an underground passage from the Middle Ages leading to a small château nearby. Once she discussed it with an eighteen-year-old boy, Marcel Ravidat, whom you saw in the last few slides I showed you.

Then, one day in September 1940, three fifteen-year-old boys, living in Montignac, set out on an excursion toward this small château. They intended to give the little Alsatians, the refugees then living on the farm neighboring the château, a good thrashing. The story rose from the simplest world of fairy tales. It did not even contain a hint of hostility between the local children and the refugees. Two of the young boys, a young Jewish boy and another boy, were themselves refugees from Paris. A common path led them to meet the first of the boys I mentioned, Ravidat, and persuade him to join them. But when they reached their destination, the young Alsatians hid. Our boys were left no choice but to retrace their steps. At that moment, Ravidat suggested that they accompany him: he set off with a flashlight, a Tecalemit, intending to explore the underground passage the lady had told him about. These four boys again set out. The story about the dog being the first to fall into the fissure was invented by a journalist or was local gossip. As you just saw, the director of the film adhered to this version of the story. The single explorer was obviously for the sake of directorial convenience. It is easier to film a single actor. But, as I said, I have

been at pains to get an intimate grasp of the truth of the discovery, from the moment when, for the first time, human beings from our time entered the most distant world. First Ravidat threw large rocks into the hole: the length of the fall and the echo shocked them all. Ravidat then stuck his head into the narrow orifice. All of a sudden he passed through and slipped and fell 7 meters. He kept calm and held on to his Tecalemit flashlight. He switched it on and called up to his companions, who wasted no time joining him. The four boys thus found themselves, next to the remains of the donkey, in a part of the cave anterior to the large room I told you about where the greatest paintings are located. With their first steps, they saw nothing remarkable except, in the insufficient light from their strained flashlight, the crevices of a cave. They crossed the large room without seeing anything, the flashlight not illuminating the paintings that were too far from the center. Then they went farther down the narrow hallway I told you about, into the Axial Gallery. At this moment, they saw a number of lines of various colors: to their utter amazement, they were in the presence of large animal figures. These children lived in a countryside where prehistoric caves abound, so they had heard talk of them. They immediately understood that they had just discovered a new one. But the abundance and the beauty of the paintings were stupefying. In little time, they ran through the various parts of the cave, going from one discovery to the next. Ravidat wasted no time in writing Łaval, whom you saw in the photograph, a simple note detailing the exploration. It is hard to say the extent to which the boys marveled at their discovery. "Our joy," Ravidat writes, "was indescribable; a group of wild savages doing a war dance would not have done better." The truth is that, as one of the boys recently told me, the cave being absolutely amazing, they immediately felt like someone discovering a treasure, a casket of diamonds or a cascade of precious gems. They immediately thought

that their fortune was made. This calculation was quickly revealed to be false, though not for the owner of the cave, who did in fact get something out of it, an entrance fee and book and postcard sales, an annual revenue amounting to about six million francs, but this was not so for the boys. But this calculation has for us a specific meaning. If we suddenly enter this world, the oldest one that man created, we are seized by a feeling of fabulous wealth. This was what the children felt. This was how they understood what appeared to them in a literally stupefying way: this is commonly the strongest feeling a human being can have, the feeling of personal wealth. Thus the world the boys entered was comparable for them to a cascade of precious gems. I spoke about the stupefying experience these children had because, for us, when we lose ourselves in a crowd of visitors, this feeling is reduced. The crowd of people of our time is lifeless, it is poor, and in front of the paintings of Lascaux it forms an opaque screen.

Now let me explain what I mean. This crowd is not completely unavoidable. If one goes to Lascaux during the winter, it is easy to visit alone, or nearly alone. Lascaux, which is certainly one of the great wonders of the world and one of the most striking, is likewise far from inaccessible. It is 360 kilometers from Orléans. The route is easy, and if you get up early enough, one morning by car suffices. Further, the rapid-transit trains can take you to Brive in a few hours, and from Brive only a 30-kilometer car ride remains. But I really wanted to emphasize this point, that Lascaux is essentially rich, rich to the point of dazzling us, and that we have to at least in our minds place ourselves in similar conditions so that we can completely experience the effect of the dazzling power of these paintings. Without question, this power fully affected the men of the caves in other eras. Nothing will ever be able to give us the feeling of unlimited richness that these men who had nothing behind them experienced in the cave at Lascaux.

97

I emphasize this feeling of richness at the risk of appearing cut off from the strongest concern of man in our day: commiseration with poverty. Commiseration with poverty is one thing, but something more important, I think, imposes itself on us: communication. Further, communication between men, on the contrary, requires wealth. Men communicate among themselves within dazzling experience; they communicate in the dazzling experience of the festival, which always demands, if I may say so, the richness to flow in waves, as though in a cascade of precious gems. Christianity, it is true, disputes this fundamental truth and has sought to derive communication among men from pity for the unfortunate. To a certain extent, it has been successful: we can in some way commune through pity, yet Christianity, in turn, became a cascade of riches. Even for us, the admirable churches from the Middle Ages did not stop the cascade of wealth. Think of the enormous amount of work all these piles of painted rock represented to an infinitely less prosperous period than our own, a period whose technical capabilities were rudimentary. To the wretched population of the Middle Ages, these prodigious monuments were but a luxury. At base, they served nothing. They were monuments of uselessness, monuments of luxury, in a way monuments of extravagant wealth. We should not forget that they were built in the face of a misery infinitely greater than our own. Yet through them, the past communicates with us. Not only have these cathedrals from these times ensured the communication of men among themselves, even beyond any pity for their misery, but they also maintain among the masses of humanity from long ago and us a feeling of deep communion. In one sense, we, in the middle of the twentieth century, are poor, we are very poor, we are incapable of undertaking an important job if it has no return. Everything we undertake is submitted to the control of profitability. One sole exception: the engineering and materials of destruction, works

that today threaten to exterminate the species and even to end terrestrial life. Be this as it may, if we consider the cradle of this species, if we see ourselves in these beings who decorated Lascaux, it is because they offer us the feeling of wealth, this measureless feeling that would take us by the throat in Lascaux if the poverty of today's world did not enter the cave along with us.

It is banal to represent, in the contrary sense, the extreme poverty of nascent man. The imagination of industrial man leads him to give Stone Age man a haggard, unkempt — in a word, miserable — appearance. Furthermore, some positive findings reinforce this representation. We are able to effectively understand the severity of the climate that supported the men who left us the painted caves. To tell the truth, the men of Lascaux whose paintings can be situated very approximately between twenty and thirty thousand years before our era had to have benefited from a relative climatic warming. In principle, the animals represented on the walls of the cave were part of the fauna of a temperate climate. Nevertheless, we are sure that the climate was still relatively very cold. On the other hand, they had no other resource than the hunt, to which gathering and fishing added only a meager variety. We must wait some ten thousand years, for the Neolithic, to add herding, then agriculture. In these conditions, man always seemed to be on the verge of serious food shortages. Add to this the danger of wild animals, probably already war, and frequent hunting accidents. It has also been possible to study what could be, if not the average age, then the normal age of the adults. The age of fossilized remains can easily be determined. Thus we know the age at death of the individual whose remains are preserved. From this we are led to conclude that men rarely lived beyond their fiftieth birthday, and only just barely if they did. Women were more fragile and died a little earlier than men. I already indicated the misery

99

of the men who built the cathedrals: how much greater was that of those who came first.

Moreover, we might claim that the feeling of richness that the cave gives us is very questionable. A general interpretation of these rock paintings exists. The primitive men who painted them had a sordid, self-interested goal in mind. These paintings functioned in the same way magic does. One had to believe what many primitive men still believe: that through the depiction of real things it is possible to act on them. By painting their prey, they impelled them to appear suddenly in the forest in the same way they appeared suddenly on the walls of the cave. In this sense, depicting arrows flying toward the animal really put the animal in danger. Prehistorians agree on this point: primitive men's desire for success in the hunt — without which human life would have soon faded away — is the purpose of these paintings. Even though it leaves many points unexplained, the justification of these primitive paintings by magic cannot be fundamentally disputed. But I am struck by the importance it has been given by most of those who have written about prehistoric life. It seems that they might first have perceived another aspect of these works of art they have struggled to explain. These are works of art like all others; they are no less beautiful than others. In Lascaux, one of our most famous contemporary painters, dazzled by the power of these paintings, said that no one had done anything better since.[5] Besides, all works of art — Egyptian, Babylonian, Greek, or barbarian, medieval or modern — always have an external justification. This justification differs with each civilization. It would therefore appear that every civilization makes works of art, each one for a different reason. This is tenable for only a single instant. Every civilization made works of art under a different *pretext*. But works of art all end up with the same result, with the result that endures after the pretext upon which they were made no longer has any

meaning. We no more concern ourselves with the success of prehistoric man's hunt than we worry about the afterlife of the pharaohs, but the result never changes. The works constructed on these pretexts enchant us, and if every civilization created works that have this power to enchant in common, it is because they all had the same profound purpose in making them: man's fundamental desire, regardless of era or region, to be filled with wonder.

If we discern this aspect, it will be easy for us to tell ourselves that despite his miserable conditions, Lascaux man was filled with the highest aspirations.

I wanted to connect this taste for the marvelous with what generally is considered contemptible, material wealth. But it seems necessary, at this point, for me to emphasize the connection between art and economics. How could we deny, for example, the economic significance of a cathedral? A cathedral in the Middle Ages is a manifestation of the considerable amount of man power needed for its construction and immobilized for an equally considerable period of times — it is reasonable to say about a century. This corresponds to this principle: a work of art is a work. Quality undoubtedly enters into this work, but quality is after all only a certain quantity of labor that is harder to procure than ordinary man power. What, in other words, is wealth? It is always reducible to work. In fact, the work of art is wealth expended without utility. However, wealth expended to satisfy any need whatsoever does not give the feeling of richness. What gives this feeling of richness in its plenitude is a jewel, a diamond. A hammer or a machine does not evoke this feeling: it exists to be used, not to dazzle. The feeling of richness is connected to the fact of being dazzled. Similarly, the fact of being dazzled gives a feeling of profound richness.

If there is such a dazzling cave — which can only be compared to and even surpasses the most beautiful wonders of the world —

no other is as unique within the realm of wonders. This unique-
ness can be linked to prehistoric man's concern for assuring
miraculous hunts. It can also be linked to the conditions in which
these paintings were preserved. The cavern was sealed from the
circulation of air for more than fifteen thousand years, allowing
no destructive agent to interfere, so that most of these paintings
have come to us nearly intact. But this surely is in keeping with
nascent humanity's desire for the dazzling feeling of richness.
Undoubtedly, too, this feeling is in accordance with the desire for
miraculous hunting expeditions. Undoubtedly, but what counts
essentially for us is to recognize here what dominates the life of
our species, what has from the very beginning dominated the life
of our species, and what is the foundation for communication
among individuals. From the moment it came into existence, this
species longed for this world of wonder that a work of art creates,
that only a work of art creates. What would a humanity reduced
to its material works be? Something unimaginable to us. We see
the first men committed to a path that up to now humanity has
maintained, at least up to now. We recognize our likenesses in the
most distant past in the enchanted aspect of these subterranean
rooms. These rooms were inhabited. These men inhabited the
entrance of the caves, but these uninhabited rooms where they
accumulated admirable paintings had unquestionably a sacred sig-
nificance for them; they no doubt entered them in the same way
we enter churches. Even the feeling of sacred horror that is always
connected to darkness had to have emanated from these caves.
Humanity has always grappled with the horror of darkness, espe-
cially earliest humanity. Using stone lamps, upon which a meager
flame was fueled by animal fat, they saw in the flickering light
similar to the flickering light of candles in our churches these ani-
mals, who appeared to be carried by a supernatural force, flocking
in the half-light. This must have seemed miraculous to them,

since the richness continues to appear before our eyes. The first men had found the haven that we constantly seek, in which the world exists as an answer to our most secret aspirations.

My intention today was to help you understand what the most ancient art, that of Lascaux, meant for those who created it while simultaneously revealing what it means to us. From this, I would like to ask you to reflect on one aspect of all these things. In general, it seems to me that our present world disparages man's longing for the marvelous. The present-day world tends to neglect the marvelous, and in principle it is hard to object to its indifference. Nothing is more difficult to understand today than the pursuit of the feeling of richness I discussed earlier. Yet it seems nonetheless that men have always lived in anticipation of the moment when they would experience this feeling. Despite the incomprehension of the modern world, I think that all of history speaks with me, and what I showed today is simply that the earliest period of the human species speaks in this same way. But there is another constant in this history: every time men's expectations are not fulfilled, they refuse to accept this disappointment. You might say that they are unanimous in this regard. They do not express it, they would not know how to do so, yet they are no less unanimous. From two things one: either they want to have the dazzled feeling of richness, or they aspire to destruction, as if destruction were still a way to feel rich. Smashing, killing, massacring have always been the consolation of those who achieved nothing. We often forget what men really are. Significantly, numerous recent examples truly show that it is never hard to change people who only the previous day peacefully, inoffensively roamed the streets into veritable wild beasts. Yet wild beasts do not destroy in the same way as men; they destroy, they kill in order to eat. Today I wanted you to see that even from the birth of humanity, when man's need for miracles is not satisfied, it transforms itself into a

passion for destruction, being at certain moments the only possible miracle, preferable to boredom, be that as it may. Such is the intensive employment of modern means of destruction: it is incontestable, prodigious, sensational. It is useless to say that I never fantasize about giving in to the desire for a miracle of this kind. Yet we are at an exceptional turning point in history, when the primary aspirations, the essential aspirations of man reveal their most seductive side. This is what I discussed this evening: the chaos toward which these aspirations may lead finally opens before us the prospect of absolute death. I do not at all believe the end to which I just alluded will be fatal. But it seems necessary to carry a clear understanding of our condition to the end. Only this clear understanding can guide us into the dangers toward which, inevitably, we are heading. This clear understanding, to say the least, must give us an unfailing serenity, since it makes us feel a fundamental connection that has existed from the birth of our species between this species and everything that is worthy of admiration.

# The Lespugue Venus

Since the earliest times, human beings have represented themselves through images intended to affect the sensibilities. Often these images incited laughter. Often they incited the chaos of eroticism.

In principle, images of men can have this significance just as easily as images of women. Yet on the whole, it is certain that in a privileged way, women awaken the desires of men. In principle, it is the women who offer themselves to the desires of men, although (still in principle) they initially evade the desire they have awakened.

Generally speaking, with regard to images that awaken desire, this small insight is limited to the female image. I will speak first of figures from prehistory, a period for which we cannot be sure if women already had assumed the comportment they had during historic times. However, if I set out from prehistory, it is so as to grasp, in the end, an aspect valuable for us.

Of course, the aspects that have erotic signification vary according to time and place. They vary first depending on whether women live naked or clothed. Furthermore, if female images from the earliest times are shown nude, this does not mean that women did not have to protect themselves from cold weather more

intense than that of the present day. Nevertheless, nudity did not necessarily receive, so early, the erotic sense it has today.

If I consider the erotic value of an image from prehistoric times, I must base that value on elements quite different from those that disturb us today. When discussing the celebrated Lespugue Venus, I suppose that essentially it had a value founded on neither its nudity nor its beauty, but what, perhaps wrongly, I imagine to be its *deformity*. I cannot deny that the hypothesis is debatable, but I think that reflecting on the possible erotic meaning of the Lespugue Venus can enlighten us on the meaning of the female form in general.

The figure I am now discussing is a statuette made from the ivory of a mammoth, about 15 centimeters long, found in 1922 in a cave neighboring Lespugue (Haute-Garonne) (figures 9a–9c). It belongs to the Aurignacian period, at the beginning of the Upper Paleolithic. It dates, therefore, exactly to those primitive times when humanity came into being. The human beings of the Upper Paleolithic can be clearly distinguished from earlier human beings in that they were the first to have an aspect similar to ours, as opposed to that of apes, and the first to have the passion to make works of art. The Mousterians, during the preceding period, had a prominent jaw and an animal-like neck and left us no works of art. The birth of art — which we cannot date precisely — coincides with a decisive physical change; it might precede us by about thirty thousand years.[1] Our statuette must have come into existence shortly thereafter, at least if we recall that during this period thousands of years count less than decades do today.

Evidently, the Lespugue Venus has nothing to do with our modern concept of female beauty. But in a sense, few works of art are as beautiful. True, our sensibility has nothing to do with that of prehistoric man, who knew how to conceive this statuette as

well as execute it, but if we discuss the aesthetic power of this man and of his work, we cannot mistake it entirely: the magic of art animates this figure. Once we stop trying to locate within it the expression of a female beauty corresponding to our preconceptions, we can admire it. Most of the photographs published of it are not engaging, but, if I may say so, the day I saw it in the glass case at the Musée de l'Homme, I was no less dazzled than I had occasionally been when contemplating consecrated masterpieces. A ray emanates from this figure, which would have left us unmoved if art were still a slave to the reproduction of a conventional physical beauty. Only the mind that modern painting has permitted to grasp beauty beyond traditionally defined elements can be opened to this authentically primitive art, to this art whose conventions are completely foreign to ours.

Yet this feminine image does not overthrow our customs in the same way that some archaic images do, owing to an inability to represent real forms. The paradox of the Upper Paleolithic world is that it gave animals the expressive value of the real, whereas its representations of humans, much more rare, are occasionally formless, even caricatural, occasionally deformed, sometimes disfigured by an animal mask, which eliminates their humanity. Apparently, man from the earliest times *could have* depicted his brethren with the same precision he used with animal images; he did not want to do this. Perhaps he was only interested in animals because, unlike men, animals were beyond his reach. Be that as it may, when contemplating the Lespugue Venus, we have to realize that it is not a question of a realistic representation analogous to that of the bulls in Lascaux or the bison in Altamira. These bison, these bulls faithfully respond to what prehistoric painters had observed. But in relation to real women whom the sculptor was able to observe, the Lespugue woman is at least transmuted. The

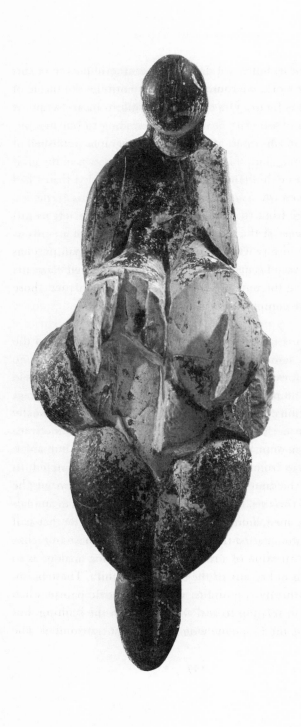

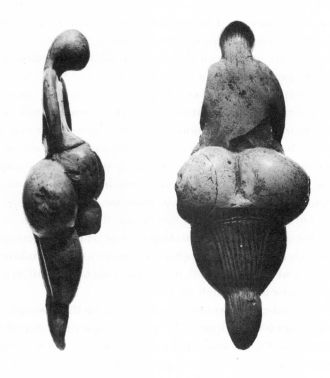

Figure 9a. Front view of the Lespugue Venus, Musée de l'Homme, Paris (Scala/ Art Resource, NY).

Figure 9b. Side view of the Lespugue Venus (Henri Delporte, *L'Image de la femme dans l'art préhistorique* [Paris: Picard, 1979], p. 32).

Figure 9c. Back view of the Lespugue Venus (Delporte, *L'Image de la femme*, p. 33).

comparison between her appearance and the steatopygic forms presented today by Bushman women of South Africa was appealing. But nothing firmly supported it. It is not a question, as in the cave paintings of animals, of carefully observing a formal detail and reproducing it exactly. She whom prehistorians named the Lespugue Venus is not just any "woman" the way a bull in Altamira is any bull, specifically "the bull," envisioned indistinctly from a group of bulls of the same species. The Lespugue Venus is precisely not "this woman among others"; she is "woman" conceived in a uniquely particular way. Her difference from the animal representations demonstrates this. It is more difficult to truly know the meaning of this aspect through which she has been envisioned. Yet if we perceive analogous images that emphasize the same aspect, not only is our initial hypothesis reinforced, but her significance is less likely to elude us.

I propose the following hypothesis.

We are too far from this humanity of which the Lespugue figurine is a sign not to recognize the chances of error inherent in a judgment about a past that may have been very different from everything that we understand.

Nevertheless, I would now like to discuss the possibility of our envisioning the Lespugue Venus as a response to sexual desire. Undoubtedly, the women of this time were not reduced to their sexual function, but I can suppose that a group of female images from this period, which have come down to us, would represent essentially this function.

Of course, if they represent this function, they are in a sense glorified. Thus the Lespugue Venus would be an exaltation of sensual riches evoked through feminine forms. This exaltation, it seems to me, inextricably linked the beauty of the body with its sexual activity. Up to a certain point, today we evaluate the beauty of a woman like that of a horse, without concern for the

sexual significance of those elements we judge beautiful. We assess the beauty of a face, picking it apart. But the men of the Paleolithic might more appreciate the characteristics that for us run counter to elegance, the characteristics that emphasize *genetic* functions. They might love these characteristics to the point of heaviness, resulting in what we perceive as *deformity*. Be that as it may, the Lespugue Venus exalts these characteristics by expressing their charm through a secret joy. We might suffer seeing a woman with these painful shapes, but before us this figurine is beautiful. We must assume that the one who wanted her this way was dazzled and could not have made her like this without a marked devotion.

In its paradoxical *beauty*, analogous to the beauty of architecture, this figurine is exceptional, yet its characteristics can be seen in other images from the same period. We might think that its author's stroke of genius could not have been shared among ancient humanity, but his taste had to have been conventional. It was then common to glorify, to the detriment of what for us took on the sense of beauty, that which signified the genetic function.

Toward the end of the nineteenth century, four statuettes, today housed in the Musée de Saint-Germain, were discovered in the Grimaldi cave in Italy, on the Mediterranean shore, not far from the French border. Each of them has its own unique look, but their characteristics connect them as a group to the woman from Lespugue.

One among them is even truly steatopygic.[2] Her buttocks form a horizontal protuberance beneath her hips. But steatopygia is not an essential aspect of these figurines. Another one, the most beautiful and the closest to the one from Lespugue, has barely protruding buttocks.[3] Undoubtedly, we can see in the steatopygia of the first an observed trait, but the essentially symbolic value of

111

these female images cannot be due to the abandonment of *all* observation: it only implies the passage to the first level of that which signifies the genetic function. There is a blossoming of the genitalia manifested by the enlargement of the pelvis and the breasts, a blossoming of sexuality in the abounding folds of soft flesh. On the other hand, the expression of individuality is suppressed. As with the figurine from Lespugue, the figurines from Grimaldi have smooth faces, deprived of traits, featureless.

Essentially the same is true of the five other statuettes from the same period, one found in Savignano, Italy,[4] four others in Eastern Europe in Willendorf, Lower Austria (see figure 5),[5] in Vestonice, Moravia,[6] in Kostenki, near Voronezh,[7] and at Gagarino, on the upper Don River.[8]

The same is true of the female figures in the bas-reliefs found in Laussel (which are perhaps a little less old). These bas-reliefs do not include the back part of the figure. Nevertheless, though it is possible to imagine the features of the smoothed-over face, given the wear and tear on the stone, the enlargement of the pelvis and the breasts concurs with what I just highlighted.[9]

The strangest of these bas-reliefs is undoubtedly the one that shows the coupling of a man and a woman, depicted in the same way as on a playing card: the two opposing characters lie on their backs (figure 10). We had doubts about the erotic significance of the image; at most, it would be possible to see a birth scene in it, the child opposite the mother. But it is difficult to imagine a figuration, hardly realistic as it is, in which the child would be the same size as the mother. The coupling of two characters opposed in this way would unite seated partners; the practice is still common today in some regions. This seated coupling would be seen from above and emphasized to create a clear representation.

If you accept the erotic significance of this last image, it is logical to accept that of the whole group of images. The interpreta-

tion is all the more acceptable since, during the same period, most of the male figures (painted or engraved on rock or bone) are ithyphallic.[10]

A curious figure from Italy — from the Lake Trasimeno region — confirms the hypothesis of erotic preoccupation at the origin of the female images. This minuscule figure (it is 3.7 centimeters tall) has the breasts, belly, and buttocks of a corpulent woman. In addition, while her head reminds us of the faceless heads of the Aurignacian statuettes — though relatively more voluminous — it is unequivocally a phallus.[11]

These Aurignacian images of women are well known. Their relative deformity astounds us, and numerous explanations have been offered. Many prehistorians sought in them a representation of reality. We assumed, on the other hand, that they were linked to fertility rituals. Some prehistorians see them as priestesses, or even ancestors. In effect, efforts attempting to deduce a physical type and racial features from these images hardly merit our attention, and the various opinions on their religious meaning only lead us to inconsistent explanations. Despite the obscure origins of these images, there is a certain concurrence on the subject of the accentuation of sexual characteristics.[12] My hypothesis along these lines is only a hypothesis, but I would like to specify its inevitable consequences.

If these images have an erotic significance, it is evidently relatively *direct*.

This significance, however, is not *most direct*. (The presumed coupling from Laussel and the woman with the phallic head from the Trasimeno Lake region would be the only exceptions.) Essentially, the direct erotic significance comes from coupling or from the sex organ itself. Above all, male desire is directly aroused when the female genitalia are open to aggression. Likewise, insofar as

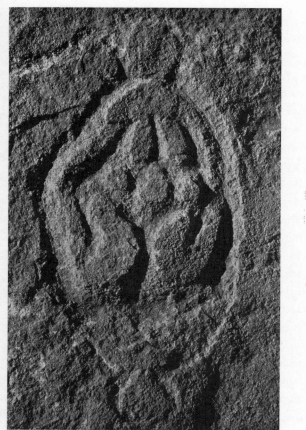
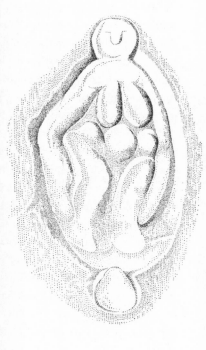

Figure 10. Coupling image from Laussel (S. Giedion, *The Eternal Presence: The Beginnings of Art* [Washington, DC: The Trustees of the National Gallery of Art, 1962], pp. 238, 239.

female desire might be directly aroused by a male image, the ithy-phallic man would be the object of this. Yet in general, a man does not seek to attain a woman by becoming the object of her desire, by propositioning her with this object. In general, the woman offers herself to the man's desire. Thereafter, through decision, force, or trickery, often by demonstrating his prestige, a man has to conquer a resistance that, on the behalf of the wom-an he desires, always goes hand in hand with an initial surge of provocation.

These reactions are customary between the sexes. A direct female proposition barely has any meaning except in venality. Considered generally, the object that male desire views is there-fore not completely direct. Men and women agree in advance to a sort of conventional ballet. In this ballet, the final goal does not appear at the very beginning. A woman does not have the shame-lessness to display it; openly displayed, it might even put off the propositioned man. A middle term is necessary, declaring the goal yet holding back the aspect of brutality.

Apparently, the Aurignacian female images have the sense of this middle term. Their sexual characteristics — the enlargement of the throat and the pelvis — are *secondary* sexual characteristics. It so happens that the genitalia are clearly delineated, but the corolla blossoms around the specialized organs without accentu-ating them to the detriment of the flower itself. Thus in these images, the attention is drawn to the whole. Only at the moment when desire is realized, beyond the rich significance of the image as a whole, is attention drawn to the genitalia proper.

This interval between a response to desire — rich with signifi-cance — in which the direct object is, if not dissimulated, put in a secondary position, and the moment when this object counts as primary is rediscovered on every level in the relations between the sexes. The Lespugue Venus, and the images that resemble it, only

represent the most direct form. As I have said, the erotic meaning of these figures is debatable — the time is too remote; documents are too rare — but this interval is nonetheless the basis for the significance of images of women in general. For men, these images have simultaneously an attractive quality and a more or less direct meaning, but any way you look at it, the Lespugue Venus represents by and large *the most direct signification*.

This is obviously worthy of attention (which, however justified our fundamental reservations, continues toward the erotic sense of the Aurignacian figures): as a response to masculine desire, the Lespugue Venus represents a pole, in opposition to which women of a contrary type are situated, a type that I think could be signified by the name Mrs. Graham, after one of Thomas Gainsborough's paintings of a woman of that name (figure 11).[13]

The portrait of Mrs. Graham is one of the most direct responses to male desire that it is possible for us to conceive. In this response, what must necessarily be maintained in the name of the final goal is most exquisitely veiled. This image effectively erases the accentuated secondary characteristics of the Lespugue Venus (the breasts are hardly developed, the hips narrow); on the contrary, it places the most value on the face — in other words, on the part of the figure farthest from the final goal. This, however, is one of the most seductive images of a woman that has ever been painted. Despite everything, she is perfectly desirable, yet respect is imposed in part by the refinement, the luxury, and the solemn regulation of the clothing, and in part by the purity of her gaze and the lines of her face, the pride of her posture; in the end, what we know about the manner of personages of her rank removes any thought of this being a representation of realized desire. As a totality, these aspects respond to the possibility of awakening this desire, but if they want to awaken it, it is through a network of

obstacles that may eventually intensify it but that first change it into reserved admiration. Sometimes even this dazzled aspect inhibits all desire, and yet desire remains its meaning. Desire unequivocally utilizes the obstacles in order to render this satisfaction, if not more pleasant, more contrasting, and, through this, more in keeping with its constitutive violence. But in these conditions, the interval of time between the object desired, offered in platonic contemplation, and its realization is extreme. Robert Musil, on the subject of the sexual relations of a distinguished civil servant and a woman corresponding in part to aspects of Mrs. Graham (but this is 1913; Diotima is more opulent), writes of a "change in the nature of two people, which always began promptly on time," but was "violent, assaultive, and brusque," and unleashed with an "even greater power" than that of the very beautiful and very civilized woman subjected to it.[14]

Be that as it may, one must consider the two opposed poles of the figures that arouse male desire, on this side of the absolutely unveiled apparition of the final goal.

On one side, the genetic, functional characteristics are indicated. The final goal is perhaps on the second level, but these characteristics represent it directly. It is remarkable that the reminder of fecundity is in no way opposed to sexual attraction.

On the other side, the *genetic* is veiled as much as possible. The forms that recall procreation are depreciated in favor of those in which this aspect is less tangible. This opposition of these two poles finds itself in a constant balancing act, which cannot escape attentive observation. Around 1900, the attractive image of a woman somewhat resembled the Lespugue Venus. Between the two wars, the opposite image was, by and large, more effective, as it is today. However, nostalgia for the significant forms of female genetic functions is often expressed. The primacy of beauty deprived of a throat or hips is put into question. After the First

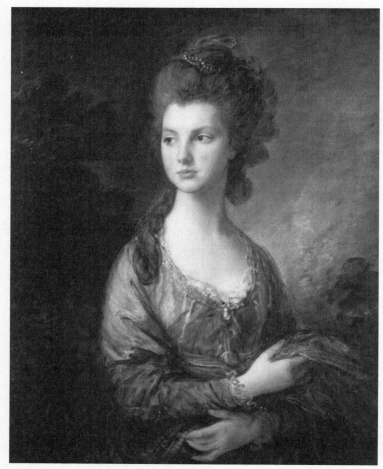

Figure 11. Thomas Gainsborough, *The Honorable Mrs. Thomas Graham*, Widener Collection (© 2004 Board of Trustees, National Gallery of Art, c. 1775/1777).

World War, a wave of sexual liberation embodied this aspect: the image of an ethereal woman, given a contrasting value because she commanded respect due to her fragility, contradictorily assumed erotic significance. Simultaneously, this kind of respect, which often leads to inhibition, was more connected to the developed forms of fecund women. (However, it must be said that our civilization has become less disposed to agree on this point: in the end, what matters most often is individual whimsy, fashions bear less and less on significant aspects, and the confusion of styles and humors is in accordance with the predominance of commodities.)

CHAPTER EIGHT

# Prehistoric Religion

Understanding is a defining characteristic of humanity, but even though we usually do not pay attention to it, humanity's understanding of itself and of the world presents a significant lacuna.[1] In principle, no one perceives this lacuna; yet if understanding has a decisive value for man, it is the same as this lacuna. No one perceives it, yet the world is disappointing on this matter: the world is a trap for man, man is himself a trap for man.

The difficulty of conceiving this lacuna demonstrates the extent to which it is disturbing. At the very heart of existence, we find a kind of chaos, a gaping void perhaps, which conceals a chaotic delirium. At the heart of existence, we find art, and we find poetry, and we find a multitude of religions. Yet no one knows what art is. Or poetry, for that matter. No one, in the end, knows what religion is.

I would like to emphasize, in the first place, that men do not know what religion is.

We all think we know what it is, but now is the time to say it simply, that is to say, at once, tragically and comically: we know nothing, ABSOLUTELY NOTHING. We know trees, laws, and work. And not only can we recognize trees, laws, and work, but, what matters most, we can define them: *we can say exactly what they are.*

It is equally true to say that we know how to *recognize* religion: we can distinguish it from science, politics, and art, but when saying *what it is*, we resort to some questionable definition.

A moment ago, I said: it is time to stop, time to mark the astonishment of he who wants to define religion. Unless he simply admits that insofar as religion is indefinable, it can only be defined rigorously through the impossibility of defining it.

In other words — and this is the least that we must assert — the world of understanding is to religion as the clarity of day is to the horror of the night.

In principle, this assertion changes nothing: despite this inability to define religion, if, abandoning the clarity that founds science and setting out from an indefinite feeling, even from darkness, from the horror inspired by the night, we envision as religious these *facts* that we understand crudely, if wisely, we can discuss them generally and even define them in isolation. If, however, we are able to define "burial" or "sacrifice" in this way, it does not follow that we are able to say how burial is religious or how sacrifice is one of the major aspects of religion. On the contrary, from the moment burial seems essentially religious to us, we abandon the idea of knowing what burial essentially is. We stop explaining *what it is* insofar as we say that it is religious: in fact, this means that it is not what it appears to be but *something else*, which we can only talk about by opposing "what it appears to be" to a meaning given "from beyond," the apparent meaning that allows us to discuss it. Further, this meaning "from beyond" excludes these explanations, which in their entirety, differing from each other, are given by those who observe the ritual. It is a question of a meaning referring to "the horror of the night," to what understanding does not grasp, to what we only know through violent feelings (violent feelings, like horror, which respond to nothing rational, which we simply endure).

Yet if it may eventually be possible to discuss religious matters, it is only insofar as we admit this ignorance, insofar as we straightforwardly confess it.

I spoke of "the horror of the night." Some authors think they are advancing on the path of knowledge when they use terms of this type. In particular, I'm referring to Rudolf Otto's terminology in his book *The Idea of the Holy*.[2] As far as *understanding* is concerned, these terms are of a negative value: they have no other kind of value. If they connote night, it is in the most negative way. There is a facility in the act of imagining Otto's book as a positive description of the *sacred*. Essentially, the *sacred*, like religion, can only be described through circumlocution: from the moment we admit that it is indescribable. Despite all this, the characteristics it is possible to offer touch on aspects through which we are occasionally able to perceive its presence. It would be pointless to think of these aspects and what Otto says about them as corresponding to what the sacred is. We can experience the sacred. We cannot, however, offer a positive description of the *sacred* without aberrations. If I speak of religion — and if I speak of the sacred — it is not from the outside, as it would be when I speak of what I can *understand* accurately. I insist on the insulated nature of my language. It is through a brutal, *aggressive* negation that I designate *an experience that in itself is a negation of understanding.*

This is evidently debatable when reviewing a work on the history of religions and when questioning principles that are usually taken for granted. Questioning these principles does indeed, so it seems, lead us outside the domain in which, hidden from the turmoil of thought, the "history of religions" has to be limited. This is particularly true when discussing prehistoric times and the origin of religion.

Indeed no one studying the religion — or religions — of prehistory questions the necessity of beginning by defining and

describing religious matters from the outside, independent of any reflective, inner consideration. Nothing, by definition, is known about prehistory, except through the material traces that the human beings of these distant times left behind. At most, the possible comparison with the religions of ancient peoples would introduce a less distant element in relation to *inner* experience.[3] However, as Johannes Maringer says at the beginning of his book, prehistory is no less defined by the absence of writing at the time it studies. The materials it uses exclude the sort of inner experience that religious texts precisely, if rarely, make us understand.[4]

When studying the religion of prehistoric man, we must set out from evidence that contains only rudimentary, external information. Proceeding in this manner, from the site, the state, or the nature of human remains, scholars have been able to draw conclusions that permit us to discuss the funerary customs of the humanity from which they originated. In this sense, Maringer's book gathers an ensemble of data from the countless inquiries of prehistorians. It goes without saying: no one would know how to discuss the importance of this gathering of information, which is not only correct but the foundation, if not of the beginning of the history of religion, then at least of what we can know about religious matters from the outside. Following those prehistorians who discussed the earliest religious occurrences, Maringer, undoubtedly more perfectly — that is, while taking into account the most recent discussions and interpretations — demonstrated the importance of the discoveries of the skulls and remains of the earliest humans: the discoveries at Zhoukoudianzhen, the closest finding we have to an anthropoid in China, and those at Swanscombe and Fontéchevade in Europe (the latter being very primitive; the former, closer to us than more recent humanity, called Neanderthal, which we will discuss later). The material from these diverse discoveries refers to a temperate period a long time ago. Maringer

rightly emphasizes, in all these human remains, a predominance of skulls and mandibles, which necessarily makes one think of a systematic preservation of the most significant parts of the defunct body: the face, the head, which has not ceased representing the being itself.[5] The period in question, long ago but warm, is separated from that of the Neanderthal man by an ice age (the third of these glacial periods). Only in the warm period that followed, especially at the beginning of the fourth (and last) ice age, did the Neanderthal man practice the ritual of burial. Maringer's book presents the current state of our knowledge on this subject. It refers to the numerous findings of isolated skulls and mandibles that date back to the same period.

The interpretation of these occurrences as religious is hardly contestable. Even outside of all belief, it is true that, in regard to death, contemporary humanity maintains an attitude comparable to that of these very early prehistoric times, but only a *religious* response was able to determine, originally, the fear or respect for the dead that the discoveries of the prehistorians translate. On a point where agreement is general, it is not necessary to introduce complex considerations.

In addition to refining our understanding of Middle Paleolithic man's attitude toward the death of his counterparts, Maringer's book offers valuable information on prehistoric man's attitude toward the animals he killed, bears in particular. This is a relatively new observation: in fact, the question, already raised, was never considered in a way that made it familiar. In Maringer's book, it is treated extensively on several occasions. And the rituals revealed by the discovered remains, of which some are recent, are very usefully compared with the behavior of modern Siberians.

In caves in diverse places in the Alps, or in neighboring regions, the remains of bears have been found, sometimes gathered together in great numbers and often arranged by human hands in

such a way as to suggest a ritual intention. These are skulls in particular, which were positioned in various ways, sometimes protected by stone coverings, sometimes placed in niche-shaped crevices. They may be associated with long bones (marrow bones). Some prehistorians believe that these were reserves, either of meat or of brains and marrow. Others see them as trophies of the hunt. But only the ritual meaning of these remains is reasonable. Maringer presents both of these possible interpretations. We could see them as offerings made to a divinity, probably a supreme god. But it is equally possible to envision a cult worshipping the bear analogous to that of the Koryak in Siberia. In other words, bear worship as it still exists today — or existed previously — not only among the Koryak but also among other Siberians, or among the Ainu, on a northern island in Japan next to Siberia, would have its origins at the dawn of humanity.

This is not as clear for the Middle Paleolithic, to which the deposits of remains we have been discussing principally belong, remains that are found in and near the Alps but could still be found in other regions. (If the caves in the Alps have preserved their deposits, it is perhaps because the ice age that followed rendered them inaccessible when caves were being used as dwellings almost everywhere else; on the other hand, new discoveries may be made in parts of the world where excavations have not yet been conducted systematically.) Maringer is inclined to see the bones as the remains of offerings to a supreme god rather than as traces of an ancient bear cult. Yet he admits this last origin at least in the case of bear bones from the Upper Paleolithic found in 1936 in Silesia.[6] The teeth of the fossilized skulls had been cut (filed down) on the young *living* bear by men of the ice age, in nearly the same way that the Ainu and the Giliak tribes now cut them (file them down) in their bear festivals (so that the animal, before being ritually beaten, is unable to wound the participants).

These bear festivals, of which we have detailed descriptions, are not only among the most fascinating rituals that we know; they took on a solemnity and an exceptional importance in the hunting societies that performed them.

For the peoples we have discussed (who file bear teeth down), as for all of those who in our day celebrate the cult of the bear, this animal, which they sacrifice, is the object of a veritable devotion. Maringer writes:

The bear enjoys particular veneration among the adherents of this cult. It must not be called by its animal name, but rather "grandfather," "old father," "fur father," or simply "he." Often the bear is regarded as a kind of intermediary between man and the spirit of the mountain or forest. The Paleo-Siberian tribes regard the bear as a mythical first man, and venerate it together with their ancestors.

An elaborate ritual has been developed to honour the *captured* bear. As soon as it is trapped, but especially after it has been killed, the hunters offer it their profound apologies. The Koryaks, for instance, welcome the dead bear to their camp with dancing and by swinging torches. One of the women puts the bear's head on her own head, wraps herself in its skin and dances in this attire, at the same time exhorting the bear not to be angry or sad. Afterwards the skin, with head attached, is displayed in a place of honour. The bear is a guest at the feast where its own flesh is eaten. The banqueters shower it with fine phrases and offer it their choicest dishes. Among other tribes, the women weep lament over the dead bear as for a departed loved one; the bear, meanwhile, is festively adorned, placed upon a mat, and plied with food and drink. The hunters make offerings to it, address speeches to it and become increasingly boisterous. Finally they carve the bear up, drink its blood and share out its flesh. But the high point is always the eating of the flesh of the head, which as a rule includes the brain.

The last act of the ceremony is the deposition of the skull in a hallowed place, or its solemn internment usually along with the rest of the bones. Among the Tungu and Yakut tribes, the banqueters may not break a single bone. All bones are wrapped in birch bark or similar stuff, and then placed on a tree.

In the Bear Songs of the Finnish epic the *Kalevala*, the bear is respectfully requested to give of itself piece by piece. After the bear has divested itself of all its beautiful and useful properties, its skill is invited to take up a secure abode, with a splendid view, in the topmost branches of a fir tree.

The Lapps prepare a grave for the bear, lining it with birch twigs. There they deposit all the bones in anatomic order: the spinal vertebrae are threaded on a rod, the nasal bones, the generative organs and the tail are put into place, and the whole is then covered with twigs and earth.[7]

I have quoted Maringer at length because the comparison of the most recent example of a bear cult with the data that the field of prehistory extracted from documents aims at contesting reservations that I thought necessary before anything else (I wanted to demonstrate the difficulty of broaching the study of religion). In fact, if we compare the prehistoric facts I have reported with these subsisting forms, we see religion in a new light. What we seize upon does not allow us to define religion, to say what it is exactly, but perhaps we are beginning to discern one of its original elements. At the very least, we might ask ourselves if the bear festivals described in recent books did not have their origins in the most ancient times. The bear festival being essentially the putting to death — in sum, the sacrifice — of the animal, we would have a principle from which we assuredly would not be able to grasp what religion is, but upon which we would be able to ground the research from which a definition would appear.

I will return to this below, since it concerns the subject introduced in the first lines of this essay — and since these last considerations could invalidate it. But for the moment, I would like to finish with the prehistoric relationship between man and bear, as Maringer's work has exposed it for us.

For Maringer, the Silesian skull with the filed teeth would be enough to prove the existence of a ritual sacrifice of a captured animal. But the ritualized sacrifice of the bear corresponds so well to Upper Paleolithic man's religious sentiment that it appears elsewhere in another confirmed form, this time in the south of France, with the clay model of a bear without a head found in the cave at Montespan. The recognizable animal has withers bulging from its paws; the right front paw ends with five well-conserved fingers. It was discovered in 1923 by Norbert Casteret, who found "the fossilized skull of a young bear" on the ground. This skull "had certainly fallen from a statue," and its location suggested that it must have been "stuck there long ago by a wooden dowel" in order to complete the model "with a real head." The dowel had decomposed, but "traces" of it "remained." Prehistoric men not only had to affix this acephalous statue with "the actual head of a bear"; they also had "to wrap it again in the skin of a plantigrade. Then they beat the head angrily with assegai and lances countless times." Its body is "pierced with many round holes at the exact places of the vital organs."[8]

The question raised by the Montespan model follows the ensemble of questions posed by the discoveries of the bear remains we have discussed, because of the skull found between the paws of the depicted animal. On the other hand, it can be linked with those posed in general by the animal figurations — so numerous — left by the men of the Upper Paleolithic during the same period.

Thus the Montespan bear occupies a central position in relation

to an ensemble of questions that are usually posed in isolation, which we will now enumerate one after another:

1. that of the attitude toward the dead, revealed by skeletons or parts of preserved skeletons;

2. that of the attitude toward bears, revealed essentially by discoveries of their bones;

3. that of animal figurations during the Upper Paleolithic.

We have envisioned the first two in isolation. Before broaching the third, it would be helpful to show that the first two, even though they initially appear perfectly distinct from each other, share a profound solidarity. Thus the general solidarity of the three questions will have become obvious when considering the third, and the unity of the different religious facts of the Paleolithic world will be apparent.

Once I have considered this question in this way, in solidarity with the others, the question of the figuration of animals in the Upper Paleolithic, in fact that of the connections of prehistoric art to religion, I will have elaborated in its entirety, from Maringer's work, essentially what we know today about prehistoric religion. Maringer's work being, among works on prehistoric religion, the most recent — and the most complete — I will be able, to conclude, to try to say just how this understanding of the facts brings us closer to the considerations of the first pages of my study.

The solidarity of the bear and human remains found throughout the entire Paleolithic clashes with our current and firmly established sentiment about the difference between humans and animals. This sentiment is in fact founded on definable oppositions. But it is a restricted domain within which the sentiment is not at risk. At least in the interior of this domain, a clear and fundamentally graspable distinction cannot be created. In regard to prehistoric man, we are reduced to conjecture. But these conjec-

tures are derived from inevitable comparisons. Earlier we saw that Siberians perceived the hunted bear as a "primitive man."

Maintaining the Siberian example, I will borrow this significant passage from a relatively recent book by Eveline Lot-Falck:

> Among hunting peoples, as among Siberians, man feels the most intimately linked to animals. Between the human species and the animal species, domination would have been unfathomable: they were essentially indistinguishable from each other. The hunter sees the animal, at the very minimum, as his equal.... The bear could speak if he wanted, but he prefers not to, and the Yukaghir see this silence as proof of the bear's superiority over man.... "Wild game is like man, only more godlike."[9]

Within this assimilation between animal and man, the bear occupies a privileged position, perhaps because his upright posture is similar to man's. Yet this is a very general way of seeing things. The accumulation of proof is useless; it is enough to allege totemism and, especially, the place that animal deities occupy in mythologies. As far as the Paleolithic world is concerned, it is a matter of conjecture, yet so well grounded a conjecture is not much different from certainty. From the earliest times of the Paleolithic era, the ritual practices that centered on the remains of a bear took this assimilation for granted.

The hypothesis according to which these bones are the remains of offerings made to a supreme divinity is not opposed to the notion that animality, among prehistoric human beings, is not opposed to divinity. The bear could even be envisioned as an intercessor between man and this primary divinity, who had to be distinguished from animals and from human beings by its superiority, its supremacy. What matters most is the impossibility of introducing into this primitive world the opposition that characterizes our

modern religions: that between animality and humanity-divinity. (It is precisely after this poorly articulated opposition was formulated that it became so difficult to perceive the essential opposition between understanding and religion; the conclusion of my study will concern this point.)

Now I turn my attention back to the significance of the Montespan bear, which I said occupied a central position among the religious facts of the Paleolithic era.

Not only must we not forget, in this regard, the prevailing equivalence between man and animal. Considered as possible prey, which the animal represents from the hunter's perspective, the animal is the object of an equivocal attitude: the hunter desires to strike the animal and nourish himself with its flesh, all while venerating the animal. Before killing the animal, the hunter asks for the animal's consent, then he cries, mourning its death; he venerates the animal and can, before its dead body, see himself bound by atonement rituals.

Nevertheless, in the relationship between man and animal, a profound difference remains. On the one hand, a man's death is in principle a passively endured destruction (primitive cannibalism is possible, but it certainly does not negate the fact that, by and large, man hunted animals); on the other hand, the animal's death is an actively provoked destruction. Thus the passive element of religion is introduced by human death, and its principles link it to man; essentially, the *interdictions* (the *taboos*) are human, the primary one among them being the interdiction regarding the corpse (the corpse is not to be touched, or it may only be touched when observing ritual precautions; consequently, murder is forbidden, the corpse introduces a dangerous element). A long time ago, the murder of an animal was the focus of a relative interdiction: if striking the animal could give birth to a feeling of guilt, the animal's death, the death of the being to which the

hunter was linked through these close ties, had the sense of a transgression.

Thus man was at once limited and protected by these interdictions, whereas the animal, which no interdiction limited, provoked transgression, called forth the death that the hunter was ready to offer it.

Keeping in mind the traditional perspectives that prehistorians introduced and continually maintained, we can see that the Montespan model elicits less complex considerations. The hunters responded to the use of magic: the bear was represented, because through striking its effigy, it seemed possible to attain the real animal. Contagious magic ensured the effect of the fictive act on the real action. These ideas have, for the most part, been accepted; they have scarcely even been contested. The animal figurations of the Upper Paleolithic would have no other meaning: the animal's image assured the hunter possession of the represented animal. Along these lines, a prehistorian, Herbert Kühn, could write: "The prehistoric discoveries clearly show that throughout the Upper Paleolithic period . . . magical concepts were prevalent."[10] It would be more accurate to say that since the development of prehistoric studies, and up to now, ideas on magic have been predominant with regard to the Upper Paleolithic.

Maringer casts doubt on Kühn's assertion. But if, intending to show the fragility of all this, I assert perspectives contrary to the usual approach, I have to distance myself a bit from Maringer's account. True, he readily accepts the magical interpretation, and he would love a religious interpretation to counter it, but what he thereby expresses is the pious hope of a Christian, not the argument of someone no longer satisfied by the traditional argument.

His work relies on a definition of religion taken from Wilhelm Schmidt. Religion would be "the knowledge and sentiment of one's dependence upon one or several supernatural powers."[11]

Maringer, before revealing the prehistoric religious facts support-
ing this definition, had to have been at a loss more than once. He
only emphasized those findings that might be interpreted as offer-
ings to a superhuman power. In fact, this is occasionally possible,
even in the Paleolithic era, but we cannot rule out a different in-
terpretation, like that which links some discoveries of bones to
the bear cult. Regarding the ritual treatment of human bones,
Maringer is reduced to saying that "man venerated the memory of
the dead, just as he implored them for their support and protec-
tion."[12] This inadequately distinguishes the survivors' dependence
on the powers invoked; it even contradicts in principle the super-
human character of these powers. In any case, the religious side of
the fear of the dead is obscured here. A slim solution remains: to
find the religious nature of prehistoric man every time it is possible
to link some trace to offerings that manifest a confession of depen-
dence. In this way, taken together, the innumerable examples of
prehistoric art, despite a weak protest, are given over to magic.

And yet, with a self-effacing gesture that suppresses any hint of
audacious ambition, Maringer occasionally displays a lucid
subtlety. Furthering the hypothesis of Abbé Breuil and Hugo
Obermaier on the origin of figurative art, he offers a satisfying for-
mulation to the thought of his illustrious precursors. He writes,

> In all likelihood the mural art of the last ice age began as a kind of
> hand technique. When the hand was dipped in clay or some mineral
> dye and then pressed against the wall of a cave, it would leave a
> coloured impression. Or the three middle fingers might be drawn
> through the clay of the cave wall, forming "macaroni-like" designs.
> Here ice age man was simply paralleling another cave dweller, the
> bear, which had scratched the same clay in order to sharpen its claws
> on the hard underlying rock. But men's fingers, guided by complex
> patterns — wavy lines, spirals, circles and meanders, intersecting one

another, overlapping and intertwining, *till suddenly, as out of a maze, there would emerge the lifelike head of an animal.* The next step followed shortly after: the hunter turned artist would deliberately make pictures of the animals around him.[13]

Man always had in his hands the power to one day willfully make these animals appear, these animals that were initially the objects of a simultaneously disturbing and passionate attitude. Man had the power to make them appear at will and to make them appear *for fun.*[14]

Prehistorians were unable to fathom the difficulty of the passage from this incontestable power to the one that, undoubtedly a long time ago, prepared men to act on the real animal by means of its image. Unquestionably, at some point, men believed in this possibility, but it is strange not to see the long road separating the apparition of the image and its magical purpose. Besides, independent of this difficulty, how do we not first show what the animal image means to those who made it appear? In fact, we have to remember that the image had to have, beyond the relatively meager meaning of game food, with which theorists of magic are content, this rich meaning, which I have by no means discovered, about which Maringer knew how to speak, but which seems necessary to me to accord decisive importance.

Specifically, the apparition of the animal was not, to the man who astonished himself by making it appear, the apparition of a definable object, like the apparition in our day of beef at the butcher that we cut up and weigh. That which appeared had at first a significance that was scarcely accessible, *beyond* what could have been defined. Precisely this equivocal, indefinable meaning was religious.

The equivocality was dominant. On the one hand, the animal was a fellow creature, a friend, and the subject of apprehensive

attention. It is difficult to say if the animal was in some way "divine." In regard to these distant times, the word loses the bit of justifiable meaning it has since assumed. But the animal was, less than man, limited to what it was — to what it was in the domain of definite knowledge. It was possible to define the bison or the stag. But what they were in the depths of a world open to sacred horror, in the depths of the caves where they appeared, could not be reduced to the conceivable definition of a stag or a bison.

The equivocality of this apparition in the darkness, in the flickering light of torches or grease lamps, further doubled the violent reaction that it necessarily sparked: the apparition called out to the hunter's murderous passion, the appearance of the living animal on the cave walls placed it in the perspective of death, the bison or stag appeared only to die.

Death voluntarily offered, deplored as well as desired, placed these animal images in the realm of sacrifice. We have to keep in mind the sacrificial feast to which the beaten bear was invited, where he would see himself being offered pieces of his own flesh.

The path from this point to the magical function of the image may be relatively short, but it passes through the equivocality of the appearance. In the first place, the appearance of the animal, which the figuration called forth, in the instant during which it was created, could not have had any magical significance. Finally, perhaps even rather quickly, the possibility of magical efficacy could appear, but without religious emotion, equivocal, rich with the dramatic intensity of sacrifices, might the image have conveyed a feeling of power superior to that of weapons?

If this way of seeing these images was not imposed from the very beginning, it is because the institution of sacrifice emerged rather late: even today, it is far from certain that sacrifice preceded the birth of art. But it is of no importance if it is true that early on the death of the animal gave rise to the equivocal interest

that conferred on it this dominant position, which it then assumed in the religious sphere. After all, the animal figurations may indeed be at the origin of this institution: their use would have been determined through emotions aroused by the apparition of the beast, followed by a simulacrum of its slaughter. In any case, it is certain that the arrows shown on the animals, or the depiction of the horse falling from a cliff (in the base of a small offshoot of the main passage in Lascaux), initially had, beyond any utilitarian meaning that magical belief would have designated, an emotionally moving sense. From the moment it attracts our attention, not seeing it or ignoring it would be inconceivable.

The caves themselves, we must not forget, had no images of animals while they were inhabited. Their depth and the difficulty of accessing them contributed to the feeling of sacred horror that emanated from these equivocal aspects, these tragic aspects.

In particular, the most moving image is found in Lascaux, in a part of the cave that is so difficult to access that today the public is not admitted, in the bottom of a kind of pit. A dying bison, gutted, losing its intestines, is depicted there in front of a dead man (apparently dead). Other details hardly render this strange composition intelligible. I cannot insist on it: I can only recall the childlike aspect of the image of the man; this aspect is even more striking since the dead man has the head of a bird. I do not claim to explain this celebrated mystery. None of the proposed interpretations appears satisfying to me. However, looking at it from the perspective I have just introduced, situating it in a world of religious equivocality, rich in violent reactions, I can say that this painting buried in the depths of the holiest of holies in the Lascaux cave is a measure of this world; it is even *the* measure of this world. From this moving and unintelligible world from which religion emerged to the inextricable proliferation of religions.

I wanted to demonstrate, using a recent treatise on the subject, what the study of prehistoric religion brings to rigorous thought. Maringer's book gathers together the essentials of our understanding. At times, I have had to contest the narrowness of its scope, but the author is, in truth, in solidarity with prehistoric science.

There is, at the same time, one point on which it seems necessary to introduce an emphatic criticism.

In his book, Maringer wrote a sentence that undoubtedly had only a banal significance for him: "The bones and the stone tools that were gathered in the habitations only offer us information about material culture and alimentation."

This is generally true of remains; it is even more true of each successively examined discovery of tools. However, how does one avoid seeing the stone tools, envisioned in their setting, as being of a determinant significance with regard to religion? In fact, the tools carry the proof of *understanding*. The fabrication of tools required the development of understanding. Man had to *understand* what was around him in order to make tools. And in making them, he *understood* what he was making, then generally what he had made with the help of the first tools. There are no tools without understanding, and similarly, without tools no understanding is conceivable.

Moreover, without understanding, no religion is conceivable. Above all, the religious being must possess understanding. In fact, man alone is susceptible to religion. And just as he is man insofar as he has understanding, he is religious to the extent that he understands that he is.

It would be imprudent to say that man's religious attitude is derived from his intelligence. Perhaps it is derived from it, *but negatively*.

In the beginning, I said religion, in the realm of the under-

standing, was the origin of a fundamental lacuna. And in the beginning, I was able to say only one thing about this lacuna: that no one knew what religion was. But — now finishing the proposed examination of prehistoric origins — we can, we must go further. If we envision the origins, even from the few materials we have, we are led to emphasize the opposition between the world of work — and of understanding — which is born, and the world of religion, which is developed through the negation, sometimes through a destructive effort, of this world of understanding and of work. Now I am ready to propose a general definition, essentially, exclusively negative and paradoxical: not only do we not know what religion is, but we must also renounce this attempt to define it; but in accepting this ignorance, in refusing to define religion, paradoxically and profoundly, we are religious. It is in fact the paradoxical significance of this account not to have been made from a point of view that is outside religion *as a whole*. By no measure would I want to characterize in this way adherence to a given religion. Such an adherence has the virtue of changing in a deceptively effective way the sovereign attitude that in the utilitarian world is the religious attitude. But we cannot talk about religion from the outside; we cannot talk about it without turning it into an experience that limits it, that even contradicts it: the allegiance to a particular religion.

I cannot, in concluding this study, go much further. Now I shall simply say that sacrifice is the negation, and the destruction, of the world of understanding. I do not want to introduce any confusion between sacrifice and what — naively, inadequately — someone might call pure religion. But I can offer a glimpse of the point I have reached. I can at the same time link such a description to what is beyond it, orienting it toward *other things*.

I do not believe that until now humanity has fully understood

that it was first a world of work. It could have been summarized by work, and if one excepts life, there is nothing in it that has not resulted from work. Language, thought, and understanding all belong to the being whose essence is to work. However, work introduces a difficulty: its meaning is circumscribed by its product, but the product itself only has meaning if it is not a tool, the first material, or, more generally, the means to other work. It is possible to say that *life* is *in the end* the meaning of work. But the life in question cannot be the life of an animal, in its limited sense for the butcher in the slaughterhouse. According to modern man, animal life is negligible. The life in question is therefore human life — not the wisely definable human life, but that which only the religious life of man has determined by emphasizing its *sacred* character.

We have seen that in the eyes of archaic man, animal life was not intrinsically different from his own. Forgetting the feeling of the animal would also be difficult for all those modern hunters who probe ethnography before the prehistoric animal figures in the uncertain light of the caves. These moving figurations oppose in a way the figuration of man, what we must consider the inferiority felt by primitive humanity, which worked and spoke, in front of the apparition of the silent animal, which did not work. In principle, the *human* figurations in the caves are of lesser quality, they tend toward caricature, and they are often concealed *beneath an animal mask*. Thus it seems to me that *animality* for the man in the painted caves — as for archaic hunters of our day — was closer to a religious aspect, which later came to correspond to the name "divinity." It is not *humanity* that constitutes the world of work, language, and understanding. Apparently, man initially disdained the values originating from understanding and work in favor of other, less accessible values; but the other values had the singular merit of offering

an immediate response to what man calls the "sovereign," through these *means* of satisfaction, which have the secondary quality of work, which cannot respond to desire *immediately*.

If I have been understood, it is easy to perceive how the marvelous apparition of the animal — which until now concealed this desire, which sometimes obeyed the subterranean power of the cave paintings — provoked the sacrificial attitude, which tends, at least at first, to suppress the subsequent interest of an apparition.

This demand for a sovereign value, refusing every subordination to interest, throws itself against so-called insurmountable difficulties, in particular the difficulty of defining, if only negatively, that which is not definable, which I have discussed from the first lines of this essay.

On the subject of the origin of religion in the most ancient times, it seems appropriate to propose this discussion, which introduces a less delicate interpretation than the tradition of the prehistorians.

Should the prehistorians be allowed, without completing the task, to denigrate, without meaning to do so, images that clearly respond not to a need for food but to the possibility of seeing appear *that which seduces*, that which escapes, at least in the instant of its apparition, concerns about utility?

It is not a question of stupidly wanting to escape utility, still less of denying fatality, which always, in the end, has the last word. But it is possible to introduce a discussion, resting on specific facts and on a central point.

What in the development of religious history concealed this movement, which, in the instant I wanted to make tangible, is the passage from the initial opposition between *animality-divinity* and *humanity* to the opposition that still prevails today, that reigns over even minds foreign to all religion, between *animality* devoid of any religious signification and *humanity-divinity*? God making

man in his own image, being consequently the divinity of understanding and of work. (This does not signify the disappearance of religious possibility, but from the moment the older forms lost their initial power, this possibility only survived *in spite of it*: from one end to the other, real religions have carried within themselves the negation and the destruction of what they were.)

# The Cradle of Humanity

## *The Vézère Valley*

Pierre Teilhard de Chardin observes that the human species, although it introduced reflection into the world, "upset nothing in Nature when it came to be." Recent scientific discoveries have emphasized this discreet, which is to say insignificant, characteristic of our birth. Our species came into the world "just like *any* other species."[1] This observation opposes, without contradicting, the characteristic that we cannot fail to attribute to this coming into the world. The essential element of our birth is truly a characteristic *unique* to humanity. From the outset, humanity has been distinguished from animality by a quality that has placed it at its antipodes. From the very beginning, the difference was in a sense no less clear-cut than it is today. But it did not "upset nothing in Nature," and humans themselves, when they gained the advantage of thought, did not initially comprehend the significance of their venture. What separated them from animals did not appear to them as a conquest that was to be the foundation of their nobility and dignity. What was essential in their eyes was not reflection. They shared what was essential with the animals. What was essential was *being*; and animals, the strongest ones at least, seemed to be, like them, *beings*.

I will carefully state the facts that allow me to advance these

principles about humanity, from the moment when, in a precise way, we can understand human actions. However, we can say very little about the first beings who appeared to be human, or nearly human, and left traces of their existence on our planet. We can grasp only a glimmer of the intelligence that distinguished them as being midway between evolved monkeys and complete humans: they worked stone. More often than finding their fossil remains, which are perishable, we have found across the largest area of the earth stone tools made by our most distant ancestors. The study of the deposits where we find these tools permits us to evaluate the age of these different indications of human life at its origins. In an approximate way, science speaks of some 500,000 years since the appearance of the first traces. The discovery of tools near the remains of the *Australopithecus*, which we have recently considered a monkey, led us to push back this date. However, from much more recent traces (only some tens of thousands of years separate us from those who left them), we are capable of representing the beginnings of human life with a certain degree of clarity.

Within a rather restricted area — limited to the southern Loire valley in France and the Cantabrian coast of Spain — departed humanity left us signs of its presence, or more precisely signs of its labor, which form a coherent image of its earliest activities. In the Vézère valley of the Dordogne, we must situate the center of a nascent civilization, which left behind preliminary sketches. This civilization is no doubt far from the first steps and the initial utterances of the species. However, since we do not have access to other testimonies as rich as the very beautiful works from the Franco-Cantabrian region, we are limited to a very fragmented glimpse of earlier humanity. Essentially, we can just say of the humanity that preceded this civilization that it did not possess,

that it only announced, and very late, that which is proper to the Franco-Cantabrian civilization: the power to create a work of art.

What lends the greatest importance to this first sign of unleashed humanity — which the birth of the work of art is — is the extreme slowness of these beginnings. The rhythm of the development of civilization in no way resembles that which we perceive in our own day. These last fifty years have seen infinitely rapid techno-logical changes. But if the first 500,000 years of human life saw human beings in opposition to animals, it was a slow change, a change of infinite discretion. The birth of art, unquestionably more than forty thousand years ago, follows an interminable period of stagnation. If we situate ourselves at the very moment art surged into existence, the prospects that open themselves behind us are still the most primitive.

The tableau of life in the Vézère valley in France some tens of thousands of years ago, as I will attempt to show, places the un-folding of human evolution in question, from the most impover-ished forms to the point when humanity decidedly distanced itself from the animal, unleashed itself in a way, risking the full gamut of its richness.

What we now conceive clearly is that the coming of humanity into the world was a drama in two acts. Better still: that the second act, in which the essential matters were decided, was preceded by a much vaguer and much longer act, which is comparable in its slowness and indecisive appearance to a period of incubation.

Before the beginning of the work of art, an almost unchanging way of life was pursued. At most, the use of fire might have come after the invention of stone tools (it has been suggested). The cre-ation of stone tools very slowly became more skillful and more varied. But it was never more than an intangible evolution. The

same could be said of the moment during this period of incuba-
tion that transported this budding humanity toward the con-
sciousness of death.

Up to the birth of the work of art, several diverse beings that
announced the emergence of humanity but were not yet human
in every respect populated our planet. All these beings, like the
numerous animals that paleontology has made known to us, dis-
appeared. But the creator of art, our likeness, is at the origin of
present-day humanity, and his marvelous creation dictated des-
tiny: an event transpired after which humanity existed, after
which it existed *as it is*.

This event was undoubtedly, as with the emergence of our pre-
cursors, rather discreet, of little initial significance. The first act
had been completely indistinct, and it is just barely, if at all, that
the second act — which occurred on the banks of this river that
today traverses a peaceful countryside (though sometimes the fac-
tory sirens disturb the region) — was more spectacular.

Some tens of thousands of years ago, this small valley was the
theater of changes whose consequences are the origin of every-
thing that followed. Take a symbolic example: just as when we
find ourselves in a room that hundreds of musicians fill with
perfect and stunning harmonies, we see in them the triumph of
humanity, we must tell ourselves that everything began in this
valley in this singular period of humanity when this second act
played itself out in the birth of art.

It played itself out without any uproar.

Yet our destiny was at stake.

What was almost meaningless for the human beings of this
time has for us an incommensurable importance.

*Before the Beginning of the Second Act:*
*The Life of the Mousterians in the Vézère Valley*
To see the meaning of this second act clearly, we have to begin
with the tableau of human life in the Vézère valley at the moment
a new sort of man was introduced, a man who carried within him-
self the future of humanity.

But first we must insist on this fundamental point.

Today we praise ourselves for our consciousness of ourselves
and the universe, and for elevating ourselves above the beasts
through our intellect. But at the first moment of the awakening of
the human mind, neither its intelligence nor its consciousness
seemed worthy of interest. What man glorified was not a particu-
lar aspect of the spectacle; it was not this intelligence — of which
today we are perhaps exaggeratedly proud — it was the spectacle
itselfas a whole, in its most tangible appearances, the ensemble of
that which is not human intelligence, the human mind considered
singularly important.

This is the meaning of this nascent humanity; it confers this pro-
found lesson, if we follow the beginning of its evolution through its
remaining traces, more clearly in the Vézère valley than in any
other place.

From a period that began around 120,000 years before us, this val-
ley was the most notable on earth in regard to the number of its
inhabitants. It was certainly first populated even long before then.
Not far from the celebrated center of Les Eyzies, La Micoque,
Tayac, are some prehistoric sites that date further back than the
period we are discussing. Nowhere, in any case, during the entire
Paleolithic, which stretches from the origin of man to a date that
we figure to be fifteen thousand years before us, is the gathered
evidence so abundant. We can only conclude from this that in
other places the activity was not as intense. The findings even

permit us to perceive the highly disseminated nature of the human population of these distant times. The abundance of this evidence was partly dependent on the intensity of the excavations. Yet, be this as it may, at least for the last phase of the Paleolithic, the Vézère region represents a privileged domain of prehistoric life; at this point, it is improbable that any of the new excavations will supplant its primacy in favor of some other region.

But we do not know with any degree of certainty what this privilege earns this valley. The migration of herds of reindeer has been mentioned: in the spring, this seasonal migration would have regularly followed this valley on the way to the Perigord plains at the first grassy slopes of the mountains of the Auvergne. Nevertheless, it is possible that during this period reindeer could have been found in the region in all seasons, as a thorough examination of the remains left there leads us to think. In any case, this abundance of reindeer could be a deciding factor. It is still possible that this valley, between the plains and the mountains, enjoyed a temperate climate, intermediary to periods of great glaciation. This fact could, however, be applied in another way: the reindeer tended to leave the region when the temperatures became milder. During the period of the Lascaux cave paintings, this animal was thus so rare that among the hundreds of animal figurations, there is but one scantly decipherable engraving of it.

It was during the Mousterian period (around 120,000 to 60,000 years before our time) that the valley was decidedly populated, which is clear from the caverns of Moustier (a village from which prehistorians borrowed the name of this period) or of La Ferrassie, where not only numerous tools of so-called Mousterian fabrication but also human skeletons from this period were found. The men to whom we must attribute the tools from this period differ profoundly from us. They are not as close to the monkey as those from earlier periods, but we must locate them midway on

the path that goes from the *Pithecanthropus* or the *Sinanthropus* to *Homo sapiens*, who resemble us precisely and populated the valley only at the dawn of art, at the end of the Mousterian period.

We easily identified these men as from the Mousterian period from their skeletons, aspects of which are well defined. They belong to the race of the Neanderthal, which appeared just about everywhere at the same time, with the exception of America, which must have been populated only much later. The Neanderthal man already had a large skull, but the top of his skull was very low. In other words, he did not have much of a forehead. The arches of his eyebrows and his face, which came out a bit from his shoulders, jutting forward on a thick neck, gave him an animal-like appearance. Like us, he had an erect torso, but his legs were not completely straight, and, like anthropoid apes, he put his weight on the outside of his foot while walking instead of on the sole of the foot.

Anthropologists have given this creature the slightly debatable name *Homo faber*: toolmaker. They reserved the name *Homo sapiens* — possessing consciousness — for our species. If the Neanderthal fabricated various tools, this required a minimum amount of thought and understanding. In reality, *faber* and *sapiens* go hand in hand: man became *sapiens*; his intelligence developed to the extent that work pushed his capacity for thought. What later distinguished *Homo sapiens* is not consciousness (between the Mousterian man and the man of the cave paintings, there were only differences of degree on this level) but the mastery of the work of art. The Mousterian man knew nothing about art. At the very most, the shape of his tools is evidence of his attention to the completed form, an aesthetic concern, which in a minor way exceeded utility.

On the level of consciousness, the Neanderthal man demands our attention. We must never lose sight of the fact that work

expanded consciousness. Above all, work is the intellectual oper-
ation that changed the brain of the animal that man initially was
into a human brain. This brain took formless flint and separated
out by experimentation the actions that changed this rock into a
useful object, into a *tool*. The Neahderthal man must have envi-
sioned the usefulness of the object and the form that the utility
required: he must have, in a word, implemented his intelligence.
But not only did this early man from Vézère excel in this order of
activity: his stay in the valley did not end without his having com-
pleted the decisive process that gave him, beyond the understand-
ing of objects, consciousness of death.

We often forget that our consciousness of death is one of the
rare, fundamental traits that distinguish us. Yet we kill animals
without a second thought, telling ourselves that they do not have
this consciousness of death. And if we cannot take the killing of a
human being lightly, it is because the human knows what is hap-
pening; he knows what death is. The observation of the behavior
of monkeys has further shown that they do not seem to react to
death; they are unsympathetic. The Neanderthal man, on the con-
trary, was deeply affected. He reacted *humanly* before death. He
was not human uniquely through the application of his mind to
working stone: he understood the use of burial; that is, the
remains of those whom he had known living inspired in him feel-
ings similar to those that generally characterize humanity. Un-
doubtedly, we have no right to believe that these first inhabitants
of the Vézère valley felt the same way we do about the loss of
those close to them. However, we do know the reactions of the
most primitive small tribes when faced with death: it *terrifies*
them. It is the fundamental feeling of which the extremely old
graves in the Vézère valley are testimony. Several skeletons of
Neanderthals buried with the care of their own kind were found
in Moustier: "a veritable cemetery of Neanderthals" was found on

several occasions in the cave at La Ferrassie, near Les Eyzies. The most famous human grave from this period — discovered in 1908 — is that of La Chapelle-aux-Saints, in the Corrèze valley, about 30 kilometers from the Vézère. The skeleton of the Neanderthal found there is now preserved at the Musée de l'Homme.[2] The skeleton was oriented from east to west (the head to the west); this orientation is found again in La Ferrassie and Moustier. Offerings of food, portions of venison, of which the bones remain, most often accompanied the burials.

If we try to imagine the behaviors and feelings of primitive populations, we have to think that death frightened those who remained behind. Undoubtedly, those who buried the body were interested more in protecting themselves from the threat they perceived in it than in protecting the body from the teeth of wild animals. This is how we can interpret an ensemble of coherent responses at the basis of evolving human life.

In the minds of the first human beings, two orders of possibilities conflicted with each other.

On the one hand, a series of effective activities, reasoned in some manner, were available to those who hunted with the help of fabricated weapons, in this way providing subsistence. The hunter used stone axes and pointed stone daggers. He also fashioned stones into balls for throwing. His tools allowed him to methodically carve up animals, to remove their fur. The immense Neanderthal period was initially warm. But soon the last of the great glaciations (the Würmian glaciation) exposed human life to Siberian cold. The fauna was therefore commensurate with this cold: the woolly mammoth, rhinoceros, and reindeer were common in our regions. Man reacted to the harshness of this climate through industriousness: because he was unable to protect himself from it naturally, he must have combated the cold with tanned animal hides. He must also have worked wood and used it, beyond

the upkeep of his household, toward ends that remain unknown to us, since decay destroyed (very nearly) every example of woodwork from this period. This is when humans moved into the caves (but only later did they decorate them with animal figures). Furthermore, we must not tell ourselves that life during this period was horrendous. Today Eskimos live in similar conditions, and Eskimos, whatever painful challenges and suffering they might endure, are hardly lacking in gaiety. We must not posit a feeling of distress at the base of the earliest human life: the capacity to overcome difficulties through continual activity and work undoubtedly made the Mousterian man feel that he would carry the day.

But like all those who followed, the Mousterian man came up against the one power that decidedly humiliated him. Like us, he had to bow down before death; death completely sabotaged his industrious efforts.

The domain of effective activity was opened up with his nascent intelligence. The domain of death was the limit; it is as such that it revealed itself to the mind of these first men: all of a sudden death introduced what denies the value of human activity, which upsets the feeling of capability connected to the first glimmers of intelligence. Animals wait for nothing, and death does not surprise them; death in some way eludes the animal. But man works and awaits the results of his work, and death destroys the tranquil waiting that is the foundation of all thought. Thought is first a waiting: death responds to this waiting by annihilating it; death is revealed to us through the annihilation of this waiting that is the basis of our life. In this way, man's intellectual activity put him in the presence of death, in the presence of the radical, *terrifying* negation of what he essentially is.

The understanding of one type of possibility that reflective activity set in motion led to the understanding of the contrary

type of possibility that the violence of death suddenly introduced. These two possibilities, not one between them, but one and the other in their intimate connection, embrace the full extent of consciousness as it distinguishes man from animal. Consciousness is not only consciousness of objects and actions; it is consciousness of death, designating the limit of the power of human action. On the one hand, its domain is reassuring; on the other hand, it is terrorizing. And this opposition of two irreconcilable domains accounts for the mobile and ambiguous state of mind unique to man.

We can now see why it is inappropriate to narrowly limit the consciousness of Neanderthal man, who deserved the name *sapiens* no less than the human being who, after him, painted the caves. In fact, tools and graves offer effective testimony that this man with the barbaric appearance attained the level at which anthropology has refused to locate him.

Besides, in one sense, the consciousness of death dates further back than the graves from the Mousterian period. Consciousness of death is a corollary of work and of the waiting implied by work, which death disappoints. Even before the graves, human behavior in regard to funerary remains was not like the animal's. Indifference is proper to the animal. However, the only focus of the oldest human responses was the head. In fact, the head, in a privileged way, has the power to signify, when life has withdrawn, what the being was that it incarnated. After death, the head gives the feeling of the life it contained, and it frightens because of its power to express an illusory, yet persistent, reality of the dead being. This is undoubtedly why, beginning in the Middle Paleolithic, the skull was carefully preserved. The meaning, however, of this attention is truly clear to us only from the moment when the preoccupation that it implies touches on the burial practice, from which all equivocation disappeared.

Burial alone allows us to say that these men were afraid of the

dead and that, to escape the threat the dead represented, they made them disappear beneath the earth.

The silence of the dead introduces these frightening and elusive possibilities in which the reassuring perspectives of ordinary life come undone. The dead being is itself the expression of these dreadful possibilities: as if it participated in the noxious violence of which it is a victim, as if the death within the dead threatened the living with contagion. By definition, death is inert, but the error of primitive thought is to see the violence that struck the dead, which nothing can stop, persist in all its aspects. In opposition to the power of laborious activity, the power of violence is identified with death, against which human action is impotent. This power belongs to death; it belongs to the dead. This is why it is necessary to appease it, hence the offerings of venison, which allowed it to be fed in the life of the beyond that the survivors attributed to the dead. The custom of placing the dead body with its feet to the rising sun and its head toward the setting sun must correspond to the concern for helping the dead into the other world, but we do not know what idea these men of this vanished species had of this existence after death. The depiction of an afterlife has varied throughout the ages except on one point: it has always been vague; it has always lacked coherence. We have to believe that it proceeded from the moment the fear that the dead inspired led those who trembled to attribute harmful effects to the dead, consequently a sort of survival. The malfeasance — the threat — is the only continuous element. It is a question not of an order but of a disorder that annihilates the feeling of being able to order life. This feeling of human impotence is profound: we always have it when we are threatened by some danger about which we know nothing; it catches our breath, and with no explanation our teeth chatter. If we know how to control ourselves, at least we can represent the terror that, sometimes still, inspires the illu-

sion of a spectral apparition. This is a fundamental human response: it is at the origin of numerous aspects of life throughout the ages. We must attribute it to the Neanderthal: in this way, we gauge the distance that separated him from animals. In the small Vézère valley, when he lived there, the terror of the dead already existed.

### The Beginning of the Second Act:
### The Invasion of the Valley

The decisive events that above all others marked the history of this valley came after the period of this rudimentary man.

One day, at the twist of a road, perhaps in a group, perhaps alone, a new kind of man appeared. He was much larger than the inhabitant, who for tens of thousands of years occupied these places without contestation. Much larger, more slender, more human. The neck of this man has been compared to that of a swan, whereas the Mousterian's neck resembled that of a bull. The Mousterian was only the approximation of a human being, still crude. The newcomer was man himself; his skeleton hardly differed from our own: meaning, from that of the European.

Apparently he came from a central point in Eurasia. Here and there, in the East, we have found the remains of men whose Neanderthal features were less pronounced. We know nothing about the transition period except the final result: the Neanderthal man disappeared. He disappeared so completely that beyond the appearance of the new man, more than fifty thousand years before us, except in southern Africa, we no longer have any trace of his existence. No race today represents him. Undoubtedly, violence is the only explanation. The more intelligent, more agile newcomer must have effortlessly supplanted him. Further, we have no way of imagining it. Nothing like it resembles our wars. Prehistoric man was often able to retreat without fighting, but when it did happen, the combat perhaps did not prove favorable

for him. There might have been a rather long period of coexistence, which the tools of various styles, unearthed in contemporaneous layers of earth in the same region, have led us to think (we easily differentiate the Mousterian's tools from those of the newcomer). But then "a rather long period" might constitute thousands of years.

In the beginning, the life of the newcomer was not very different from that of the supplanted unfortunate. The newcomer continued fabricating more perfect and more varied tools, which can be distinguished from the older tools only through the working of bone, a material permitting the production of very delicately shaped objects. His most noteworthy contribution is the ornament. For his finery, he used shells, teeth, and bone fragments. Further, after his entrance into the valley, he traced at first silhouettes then real images of animals onto the walls of his caves. His extreme facility and his extended sensibility quickly placed him in possession of accomplished art, of which one might say that its beauty has not been surpassed since. He used a number of colors, various ochers — ranging from yellow to red through sepia — blacks, and occasionally violet. Based on the richness of its paintings from the origins of art, the famous Lascaux cave, which opens at the top of a hill dominating the Vézère valley, 2 kilometers from the small town Montignac, imparts a prodigious idea. Discovered in September 1940, the Lascaux cave is truly one of the wonders of the world. Between this new human being and us, the most moving and the closest link is his marvelous genius. And by according genius to one whom genius dazzles, we acknowledge something of friendship, of true intimacy.

To speak about the relations these first representatives of accomplished humanity maintained with animals, I will come back to these grandiose animal figures from Lascaux. First, however, I want to situate them within an art that is known to us

today through numerous examples. Upper Paleolithic man, who supplanted Mousterian man in the Vézère valley and to whom, since it is his most perfect work, I will give the name Lascaux man, manifested his gifts in a variety of ways and throughout a domain that stretches along the entire northwest coast of Spain, from the Pyrenees in France to the Rhône valley, and all the way to the privileged region of the Dordogne and Charente. This is the domain of Franco-Cantabrian art. It is represented in the Vézère valley in a rather large number of caves, of which the most noteworthy after Lascaux are those of Les Combarelles, Font-de-Gaume, and La Mouthe; in all, there are no fewer than twelve caves — and an additional fifteen rock shelters — where we find works of art from the Upper Paleolithic, on a course from Montignac to Bugue, covering about 30 kilometers. On this course, Les Eyzies represents the most important point of concentration: furthermore, at Les Eyzies, in the so-called Cro-Magnon Hotel, one of the most remarkable skeletons of the newcomer was recovered, whose upright stature, cranial capacity, and character as a completed human being correspond well to the art of the valley.

Although we can locate the center of this decisive activity, its representatives were not truly sedentary. They moved in accordance with the seasons in search of more bountiful game. On the other hand, they spread out: the civilization of painted caves extended outside the area that I delimited. We find its engravings and paintings in southern Spain and even in southern Italy. These, however, are only secondary installations. Such installations could still be discovered elsewhere without changing our notion of the central source, that of the Vézère valley (surrounded by important centers in Charente, the French Pyrenees, and Cantabrian Spain).

But not only must the art from the Vézère valley be situated in relation to the ensemble of painted caves: we must not forget the more expansive diffusion of portable art,[3] the products of which

are unquestionably found in the aforementioned regions but also spread throughout all of Europe and as far as Siberia during the same periods. This portable art first revealed the quality of prehistoric art. Numerous statuettes and objects made of bone or engraved ivory are worthy of admiration, which derives not only from their great antiquity but also from their beauty.

The Vézère valley is therefore only the point where this rich civilization knew its most beautiful success.

What is astonishing in this success is its relative rapidity, although we do have to suppose long centuries (rather than thousands of years) between the arrival of these new men and the marvelous blossoming of this center. This rapidity is commensurate with a period in which the slightest change required an indefinite duration. But the steps of these men possessed a marvelous confidence. If we envision these cave works within the ensemble, hesitations or regressions played only a small part. What is striking is the power of attaining the highest degree of facility without having left behind any traces of groping trial and error. Claude Lévi-Strauss noted the privileged value of first steps in history: from the first movement, they can find what will thereafter only be recovered with difficulty. The first step when humanity emerged from the interminable winter of the earliest times was the most confident, the most worthy of admiration. In the hands of these men, who created art, who strayed from an empty past, there was a virtue comparable to the most accomplished hands of today. At nearly the first stroke, art attained the power of evocation, which would thereafter only be found with great difficulty. These first steps are the acts not of the first men but of men who came after periods of sleep, as is the case with the Carolingian artists, who in our country came after the Merovingian eclipse, or with artists from the Renaissance, who only slowly emerged from the clumsi-

ness of the Middle Ages. Most often, in our day, we appreciate clumsiness, but it is important to remark that manual skill is found in creation from nothing. How can I stress this virtue of creation, which so clearly opposes these first human beings to supposed primitives, who are themselves backward in relation to advanced civilizations only after many thousands of years of stagnation? The real primitives were no doubt closer to us, insofar as we do not cease to create, than to those who perpetuate a mode of life rather close to that of prehistory. Of course the Bushmen, the Australian Aborigines, and the Eskimos who endure, the Siberian hunters of the nineteenth century, present us with a tableau approximate to that of the life of the inhabitants of the Vézère valley in the period of the painted caves. However, these modern primitives lack this outpouring, this upsurge of creative awakening that makes Lascaux man our counterpart and not that of the Aborigine. Profoundly, the Lascaux cave evokes those churches in which magical liturgies assemble hundred-piece orchestras, those theaters in which we listen to Mozart's most beautiful pieces with reverence. Poetic genius is found in all peoples, it is common in all human beings, but it manifested itself in Lascaux with the kind of crashing roar that is proper to birth.

Similitudes between Aboriginal life and prehistoric life allow us to represent the dawning of humanity in a concrete way. Like the men of Lascaux, the Aborigines have tools and stone weapons; they live, like them, as hunter-gatherers. They are equally versed in painting caves. As in prehistoric times, they place their hands on the cave walls and surround them with paint. These hands in our day serve as a signature of authorship that can be found in our caves, such as those of Font-de-Gaume and Les Combarelles, in the Vézère valley, at the Pech-Merle cave in Lot, at the Gargas cave in the Pyrenees. In their initiation ceremonies, the Aborigines

practice the religious mutilation of certain fingers, and the images of hands on their cave walls resemble those in the Gargas cave. Therefore, we have to believe that the human beings of the Upper Paleolithic had reactions similar to those of the Aborigines, that these human beings had, like the Aborigines, a religion, and that this religion was not altogether very different from that of the Aborigines. This well-founded relationship allows us to assess the meaning that the paintings in our caves might have had for those who painted them. It is reasonable to believe that the human beings in the Vézère valley, like the Aborigines, painted the animals that they hunted in the hope that in making them appear on the cave wall, they would bring them to appear before their weapons: to dispose of an apparition was to already make the animal fall into their power. Archaic humanity held a general belief in the magical effect of representations, which are not necessarily as accurate as they were during prehistoric times and which even beyond these first periods were often limited to rough outlines, though sometimes their aspects were dynamic.

## The Life of the Men of the Vézère Valley During the Upper Paleolithic

This striking similarity of the life of the men of the Paleolithic Vézère valley and of the Aborigines should not surprise us.

Abbé Breuil estimates that this first period of cave art lasted forty thousand years. During these forty thousand years, with some periods of remission, western Europe by and large experienced Siberian cold. Nonetheless, these estimations in time remain approximations. Within this immense duration, the divisions that we introduce are themselves most vague. We speak of successive periods: Aurignacian, Solutrean, Magdalenian. But these only concern the nature of tools: every tool has its distinct style, and in the excavations the Aurignacian layer is principally below the

Solutrean layer, which is itself below the Magdalenian layer. But the style of the tools does not always correspond to the division of time and varies from place to place. It is along these lines that prehistorians continue to introduce subdivisions: the Perigordian, the division to which Breuil attributes the art of Lascaux, is by and large contemporary with the Aurignacian period. Yet during these forty thousand years, cave art knew no true decadence. It embodied up to the end the surge of an awakening. If it is true that few paintings correspond to the Solutrean phase, it seems that in the same cave, Magdalenian art directly succeeded either the Aurignacian or the Perigordian. In any case, the late Magdalenian art presents vigorous, intact examples. However, the end of the Magdalenian period, which we date back fifteen thousand years with relative precision, is the ultimate limit of this Franco-Cantabrian art.

This Paleolithic civilization did not disappear for all that. This humanity's mode of life continued, and cave paintings themselves, without speaking of those in the Spanish Levant, partly from the same date as those in our caves, can be found throughout the ages from northern to southern Africa, where in our day Bushmen still understand their functions (one of their paintings represents a locomotive!). In fact, the milder weather at the end of the Paleolithic, the establishment of our present-day climate, allowed civilization to develop in the direction of herding and agriculture. From the Mediterranean East, a more developed civilization spread throughout all of Europe. Societies that did not give up the inherited way of living, founded on hunting and gathering, moved toward the north and the east, or toward the south. If we find some remnant of their civilization, it is usually very far from its original source. If we follow much of the movement from western Europe to southern Africa or from Scandinavia toward the arctic regions, we follow less easily the displacement that might

have ended in Australia, which furthermore did not necessarily originate from our source but just as well from another like it.

Once again these remnants offer us only a poor representation, lacking the richness of the creative movement of the lives of the first men. Yet we must consider the entire domain of these remnants of Paleolithic life if we want to form a complete enough image of the existence of the inhabitants of the Vézère.

The Eskimos alone can give us some idea of these men struggling against the cold: these men were dressed, warmly dressed. They had clothes of fur; we have the scrapers with which they treated hides, the bone buttons with which they fastened them, and, at least for the Magdalenian period, the bone needles with which they sewed them. Despite an improvement in the weather, which we can also date to the period of the Lascaux paintings, the Vézère valley had to have overflowed with vegetation similar to that on the Siberian tundra, and its inhabitants, to whom the cave paintings are attributed, no doubt looked like modern Eskimos.

Despite the absence of an ocean, the type of hunting they practiced reminds us of the Eskimos rather than of the Aborigines. But perhaps Siberian hunters, as observed before the Russian Revolution by nineteenth-century ethnographers, evoke with the highest precision the creators of Lascaux. The Siberian hunters: larger and closer to us physically than the Eskimos. The Chancelade race, closest to the Eskimos, had to have in part populated the Vézère valley, but men of various races eventually lived side by side, and the large Cro-Magnon man probably dominated. What opposes Siberians to Paleolithic man is the general character of their civilization: the Siberians knew about agriculture and how to raise cattle. But they did not have any political hierarchy, and the bulk of their activity is hunting (or fishing, depending on the region). In the Siberian hunters, we must *see* the creators of the civilization of Lascaux.

A beautiful recent book, *Les Rites de chasse chez les peuples sibériens* by Eveline Lot-Falck, permits us to insert ourselves, rather concretely, by means of these peoples, into the world of Lascaux. In particular, in this book we find a representation of the relations that the hunters of the Upper Paleolithic maintained with the animals they hunted. We reach a fundamental point here. From the beginning, I have insisted that the men of the caves regarded animals as their own kind:

> Among hunting peoples, as among Siberians, man feels the most intimately linked to animals. Between the human species and the animal species, domination would have been unfathomable: they were essentially indistinguishable from each other. The hunter sees the animal, at the very minimum, as his equal. He sees it hunt, like him, for nourishment... Like man, the beast possesses one or several souls and one language.... The bear could speak if he wanted, but he prefers not to, and the Yukaghir see this silence as proof of the bear's superiority over man.... "Wild game is like man, only more godlike," say the Navajo, and the phrase would not be out of place on a Siberian's lips.... The death of the animal depends, at least in part, on the animal itself. To be killed, he must have given his consent beforehand, which in a way makes him an accomplice to his own murder. The hunter therefore takes great care when dealing with the animal ... anxious to establish the best possible relations with him. "If the reindeer doesn't like the hunter," the Yukaghir says, "the hunter will not be able to kill him." The bear is only a victim of its own free will, it appears in the right place to receive the fatal blow.... Among the Ketos or Iensseians, the bear comes to the hunter when it is his time to die.... The victim must not have known about, or has forgiven, the murder of which he is the object, and is full of good intentions, so as to return to the hunter or to send his parents.[4]

For us, the animal world is opaque, in some way nonexistent, but for prehistoric man, as for the modern Siberian, this world was open and accessible: it seemed penetrated by human thought. Man knew what the animal was thinking, and the animal knew what man was thinking. And just as men trick one another, so men could trick animals. Man, in any case, lived in this animal world on which his life entirely depended, since animals were his main source of sustenance, without mentioning his clothes and a portion of his tool kit. For man during this period, the transparency of animality ordered his entire life. The animal world of Lascaux is a complete and faithful image of this life. Now we must attempt to gain a deeper understanding of its secret.

## The Secret of Lascaux Man

The starting point of this life, as we have seen, is before the birth of art, the limited horizon of the Neanderthal, of the Mousterian man. This horizon was given in the possibility that founded work and the impossibility announced by the ungraspable approach of death. In this world where man saw no distinction between himself and animals, death opened a terrifyingly threatening space, which dominated everything and was populated by memories of the dead. These dead beings could not be guardians, and their suspended presence threatened the survivors, who ceaselessly feared being dragged into this final disappearance, which they could not imagine without terror. From the very beginning, death had introduced the beyond of human life.

Much later, in a moment that we can, according to prehistory, define as a point of arrival, we find this beyond populated with gods, or spirits at least. If we consider archaic religions, in the way that the history of Antiquity and ethnography lead us to understand them, we see that these gods and spirits are mostly from the animal world. We saw that in archaic mentality, the animal is the

164

same thing as man, but more holy — more holy, which is to say more sacred, more divine. The animal is closer to the world of the gods than man is. Man abides by interdictions, taboos, to which the animal is never held, which are never at stake for the animal. The interdiction and the taboo represent a distance between man and the divine world. In any case, nothing is more common than representing a god in the form of an animal. Egyptian art abounds with such representations, and if they happen to be more rare in Greek art, we know at least that the latter linked their gods to animals — Athena to the owl, Dionysus to the bull — and that sometimes, during their sacred ceremonies, they would wear animal masks. The animal side of a man has something strange about it. It places man in a beyond, above the human order. Something wild and violent is liberated when man assumes the form of a beast; something vague and troubling enters into the composition with the sense of the divine. This is no longer tangible for us in the same way it was for the ancients, yet those among us familiar with the history of religions cannot misunderstand the fundamental nature of this violent feeling.

Thus may we grasp, at the outset, the horrible domain of death, at the point of arrival, the domain of divine animality: the religious life of the men of the Vézère valley developed on this course, and this religious life surely dominated all of life at the time of the painted caves. Nothing proves that the religious thought of the Mousterian era exceeded the terror of death, but the religious thought of the Upper Paleolithic acceded to a more expansive form of religion that founded the sentiment of the divinity of the animal, of the divine nature of animality. In other words, if the animal world was divine, it was so projected into the unreal domain of death: religious thought has always engaged in the contemplation of a world *entirely other* from that of human life. It is always a question of this terrified feeling that death

inspires in man. But the animal is, in every sense, on a par with death. The animal is the being that the hunter only saw in order to kill. In the killing of the divine animal, the hunter overcame the terror of death.

This depiction is not clear right away, but we will see that without it, the meaning of the cave paintings of animals, of the paintings of Lascaux, would escape us.

The reality that these paintings describe singularly exceeds the material search for food through the technical medium of magic. Prehistoric hunting has little to do with the rather innocuous modern pastime. It was the activity not of an individual or of a small number of individuals but of an entire population that sometimes confronted monsters. For the hunters using flimsy weapons, the pursuit of a mammoth undoubtedly had something prodigious in it, which had to have unleashed the passion, the frenzy of an entire group of men. Bison, bulls, and bears were animals capable of transporting the imagination. In particular, we know well what it was to hunt a bunch of wild horses: it consisted in traversing a wide expanse of land, pursuing and tracking one of these groups, then driving it onto a high ledge, from which the entire herd, in its terror, was finally hurled. One painting in the Lascaux cave shows a horse falling in this way from the top of one of the rocks that dominated the Vézère valley. Even in our day, primitive hunting populations have retained the power of unleashing an unprecedented movement. One of my friends was on an ethnographic expedition in a remote region in Brazil; all of a sudden he saw a group of hunters appear following a big animal. He told me he could not have imagined anything more unbridled. The animal ran past like a bolt of lightning, then from all sides men sprang, screaming, while arrows whizzed by. Yet in the South American forest, as in Siberia, as in the Vézère valley of yesteryear, this torrent of life was linked to the animal for whom it sig-

nified death with a feeling of profound unity. While their screams called for its death, they awaited the hunted animal's forgiveness, as in a drama ordered by a tragic fatality.

We do not have to separate these exacerbated conditions from the representations of the hunters in whose eyes the animal had the meaning of a god: the animal appeared so as to die, and those who slaughtered him, who considered themselves his murderers, could mourn this death demanded simultaneously by their hunger and by their desire. We should of course be surprised by this play of contradictory feelings, without, however, forgetting that contradiction is still the principle of part of our actions.

What predominates in this dramatic ensemble is the feeling of a destiny endured that cruelly pits beings of the same nature against each other. These beings who necessarily live off those they kill. At base there is a definite connection: animals were but man's fellow creatures, and their loss was felt like the loss of a loved one; in other words, the dead victim was, like the corpses of humans, a threat to the survivor. One must have believed that the dead bison might have wanted to take revenge on his murderer. It was therefore necessary to ask for forgiveness from the victim; it was necessary to mourn the victim, to honor it like a god. Because death transformed the victim, it had the supernatural prestige inherent in the beyond. But the wild animal, who never lived alongside human beings — whose prosaic lives were partially organized by work — had from the first, even while alive, a divine prestige that humans could not understand.

Thus, for these first men, the animal was more than an equal, a being who embodied the supernatural principle of the dead without having their limitations, in particular the evil character. The first gods were certainly animals, and generally animals had to have seemed divine.

In regard to its own species, humanity first had only the

167

strange feelings evidenced by the figures in the caves. We would look in vain in prehistoric art for representations of human beings similar to those of animals. It is not that this art included no human figures. The animal figures are obviously the most numerous, but they are essentially distinguished from the human figurations through the naturalistic perfection that characterizes them. Humans, on the contrary, are often grotesque; they are generally tiresome caricatures, engraved artlessly and without conviction on the cave wall. Women alone were the object of more attentive representations. A certain number of female statuettes were found dating back to the first part of the Aurignacian era. In principle, their bodies seem monstrous to us; their hips and breasts are enormous: this could respond to the ideal of beauty or at least to the fecundity of human beings during this period. But what decidedly shows their repugnance for the naturalistic reproduction of human appearances is the absence of a face on these statuettes. Instead of a face, some of them have a smooth or ribbed surface; others have a head whose face and nape have, without human traits, the bumpy appearance of a big blackberry. If we imagine that the skulls of the dead were objects of particular attention, because the face identified the now-dead living being, of which there remained, emaciated, the expression and the sign, we are tempted to think that an interdiction opposed the representation of features, perhaps as a result of the interdiction which dictated that the dead be buried in the earth. We know of only a very small number of exceptions to this principle, which prove the Paleolithic artists' aptitude at giving life to their figurations. If they generally abstain, it is therefore for another reason, which is in accordance with a tendency to represent men beneath the features of an animal. Even in Lascaux, only one man is represented, but he has the face of a bird (this is not the only example of a human being from the first part of the Upper Paleolithic shown

with the traits of a bird). During the Magdalenian period, a painting in Les Trois-Frères, in Ariège, shows a man with the antlers of a stag facing an indeterminate animal; engravings from the same cave show two beings with bison heads who have additional human aspects. What seems to be fundamental is the rejection of our face. So true is it that the animal had for Paleolithic man an essential, seemingly divine quality that the human form could not have expressed.

In the animal world of Lascaux, as in that of all the painted caves, we are therefore in the presence of a choice: these men chose the animal world as the object of an interest that was not only alimentary but essentially adhered to the divine nature that they attributed to it and that they did not attribute to man in the same way. That they had hoped to force through sympathetic magic — by painting these horses and bulls on the walls — a path toward these elements of their subsistence cannot be doubted, but by painting the animals that they killed, they envisioned something other than their earthly desires: what they wanted to resolve was the haunting question of death. Certainly death did not cease terrifying them, but they overcame it through identification, through a *religious* sympathy with their victims. This sympathy was in a sense absurd, since they did kill them. But it was profound in this particular sense: that by killing them, they made them divine. And in its essence, the divine is that which exceeds death. The men of the Upper Paleolithic did not use the much later universal ritual of sacrifice, which must have been perpetuated in Christian sacrifice, in the death on the cross. They were unable to use it, since sacrifice, at base, supposed the raising of livestock, the disposition of animals (human sacrifice was only developed much later). But this only signifies, it seems to me, the absence of familiar forms. The state of mind that engendered the use of sacrifice was apparently the principle of the religious life of

the men of Lascaux. It concerned brazenly overcoming the terror of death despite the terror facing them. This attitude is founded on the equivalence of the death of man and the death of the animal and on the possibility of looking at the latter in the face, of taking it on oneself.

In the deepest part of the lair of Lascaux, it is possible to see this fundamental reflection before the death of man and of the animal.

### In the "Holiest of Holies" of the Vézère Valley

If we enter the cave at Lascaux, we find ourselves at first in a vast room where a fresco of animals unfolds, dominated by four enormous bulls. It is the most spectacular section of the cave, but we can proceed on the right through a narrow corridor toward a small room whose walls are covered with muddled engravings, which is commonly called the Apse. At the other end of the Apse, a narrow opening overlooks a deep well, into which it is now possible to descend with the help of a vertical iron ladder, securely affixed to the rock. As a general rule, visitors are not admitted into this part of the cave. The ladder leads onto a sloping platform, offering a view of a kind of chasm, where only three or four people can awkwardly stand before the most bizarre of these age-old frescoes. A veritable scene, at first barely intelligible, is figured on the rock. A gutted bison faces a nearly sprawled-out man, whom he threatens. It seems like this man is dead. Contrary to the bison, he is represented not naturalistically but roughly, as if a child had traced its schematic silhouette. Above I alluded to this human figure, who has the head of a bird. Toward the left, a rhinoceros wanders away. This gripping ensemble leaves a feeling of mystery. The explanations of the scene given until now have hardly moved us. Reducing it to an anecdote, to a hunting incident, these explanations left the feeling that only a deeply reli-

gious intention could have motivated this figuration: in particular, the birds could not lack significance. But if someone told us that the man, a sorcerer, was not dead but in an ecstatic sleep, that the bison was a sacrificial animal, we could only turn away from so extravagant an interpretation.[5] In 1954, when I wrote a book on Lascaux, I renounced the comprehension of this mystery. But today I think it is possible to shed some light on it and to affirm that this painting, of all of them, is moving and rich in the most profound sense. In the "Holiest of Holies" of the cave, it placed together within a grandiose image the death of an animal and the death of a man. Yet such a representation had to have been in some way inaccessible. (There is another example, in Les Trois-Frères, of a representation of divine meaning, which dominates the entire cave.)

Of course the bison losing its entrails is not a sacrificial animal, but it is an animal that dies. And animals on the cave walls are as a general rule living animals. At most they are pierced with arrows: the hasty horse falling headfirst that figures at the end of the Lascaux corridor called the Axial Gallery is, however moving, an exception to the rule. In any case, the figuration of the death of the animal raised the question of the sense of crime and transgression, which will remain fundamental in sacrifice. The death of the man (we can in fact only see a dead man in the fallen figure) is linked to the death of the animal, not that the agonizing bison necessarily killed him, but that the two deaths are in some way complementary. The man is guilty of the bison's death because a line coming from an expressly drawn propellant penetrates the animal's stomach. Because the man is guilty, his death could therefore be taken as a compensation offered by chance or perhaps voluntarily to the first victim. It is of course very difficult to assess with any accuracy the Paleolithic artist's intention, but the murder of an animal required expiation from its author. The author

had to have rejected that which weighed down on him from the killing of his victim: he himself fell from this act, prey to the power of death, and had to have at least purified himself of a marked stain. The representation in the pit grants this situation a final consequence: he who gives death enters into death. The bird face reminds us of the bird costumes typical of sorcerers, the shamans of Siberia. This kind of bird signifies the shaman's voyage into the beyond, into the kingdom of death. The bird on the perch emphasizes this deeply religious meaning. It is possible to hesitate over a precise interpretation of details of this extraordinary scene, but the mystery in whose presence we are placed is in every sense the mystery of death. This representation invites he who faces it to draw a fundamental power from the contemplation of death, the power to live on a par with death, which is proper to religions of all times. Expressed in the depths of the pit is the depth of religious unrest, which was born.

In any case, the bird symbolizes an overcoming. In the pit, death assumes its somber power, but the bird announces the victory that in the end carries off the misfortune of man and the force he has in confronting it.

The presence of the rhinoceros undoubtedly responds to the primitive hunter's tendency to shift part of the responsibility for the victim's murder onto others. In the introduction of the rhinoceros, there is a kind of explanation that Breuil has already suggested (yet without seeing the scene as anything other than a scene of the hunt): perhaps the propellant did not reach the bison, and the rhinoceros is truly guilty, the rhinoceros that moves away after having gutted the dying animal. The principle of the primitive hunter is to link the death of the animal to a catastrophe independent of his own intention. But the painting in the pit remains equivocal.

We nonetheless have the right to divine in the "Holiest of Holies" in Lascaux the grandiose religious conception that prefigures the religious conceptions of all times.

What Lascaux man discovered in the convulsive obscurity of the animal world, far from the reactions of modern man, who opposes the indifference of reason to death, is that grandeur is linked to the fact of being suspended, hung over the abyss of death, yet full of virile force.

But this man at the heart of the cave's recesses did not assume the proud and particularly personal heroism that is peculiar to modern times. He did not slip into this individual vanity that humanity perhaps found in war. He could have dismissed the coarse Mousterian beforehand, but this would have been like a much stronger animal that makes weaker animals withdraw. Real war only runs rampant during the time of agriculture, when it became easy to live off the work of others, pillaging instead of working.

From the depths of this fascinating cave, the anonymous, effaced artists of Lascaux invite us to remember a time when human beings only wanted superiority over death.

CHAPTER TEN

# Unlivable Earth?

Our holidays — be they civil, military, or religious — designated by the same name as holidays of the distant past, seem, however, to have only a formal connection with previous holidays.[1] True, we only know these archaic holidays through film, holidays during which frenzy is the rule and, with no ritualized structure, real furor is attained. Yet to the most sensitive among us, it is enough to find ourselves in front of a moving image of such frenzy to know that it corresponds to a nostalgia enduring within us and that this nostalgia, at least in this form, survives in depression. Our civilization links us to these necessities: nostalgia, no doubt, signifies something unattainable to us; we cannot even for a moment dream of recovering a richness whose loss we are only able to measure while deploring it.

But when we seek to understand the possibilities from which we escaped long ago, violent impulses cannot fail to disturb us, impulses that henceforth cannot deliver us but that offered extreme exaltation to those who preceded us. Something is lacking in us, something that we do not understand clearly but that in its absence distinguishes us from the crowds who, in great tumult, danced and leaped for joy, lost consciousness in their half-divine, half-demonic intoxication.

We were driven out of this half-paradisiacal intoxication! We know we have fallen! Can we claim a naïveté without which we henceforth have only the sense, the certainty of having lost this intoxication? Evidently, when faced with a vision of these archaic peoples — brought to us sometimes by a film, by a trip, even through stories — we cannot doubt that as a whole we are separated from them by an impenetrability within which our world disappears completely (this real world of factories, machines, science, and conflicts of interest). Such is the vision, the intervision, of a kind of incredible, marvelous, but inaccessible dream.

We know that we cannot attain this world without denying, without suppressing what we are. But in catching sight of it, we are led to forget its real spirit, its horrible tribal wars, its tortures, its massacres; or, in a less primitive civilization, the reduction of an unfortunate group of conquered men to slavery, men transported by force, under the lash, toward unspeakable markets.

Only by dint of grievous lies can we conceal the accursed truth of history. There is something frightful in human destiny, which undoubtedly was always at the limit of this unlimited nightmare that the most modern weaponry, the nuclear bomb, finally announces.

Only the first period, that of man's initial effort — ascending to consciousness in the Paleolithic era — seems to have escaped the horror that war and murder, both contemplated and generalized, then slavery introduced. Only these — most distant — times escaped, times when man, with a perfect slowness, disengaged himself from animality through work, attained consciousness by degrees, made works of art, and, from that moment at least, came to resemble us in every way, having both our skeleton within and our seminude, furless skin without.

It is at the beginning of the so-called Upper Paleolithic that, in this way, the fundamental revolution took place, the revolution

from which man emerged fully formed. Completed man? On two levels at least: biologically, this man already had the same characteristics that all men from various races have today; as for his mental astuteness, he had the power — and the desire — to make a work of art, and he so perfectly had this power that the most famous of contemporary painters, speaking on this subject, has asserted that since then we have done nothing better. No doubt magical — utilitarian — intentions were associated with the superficial joy of reproducing, and rediscovering, in a way grasping, the objects of continual preoccupation: hunted animals, sometimes animal deities, and then all of a sudden the obsessive aspects of the human race.

In the darkness of the caves, by the flickering light of grease lamps, objects of momentary desire and of long-held obsession were composed. These vast, successive murals have a meaning that may be outdated but anticipates that of the festivals. Insofar as the animals represented are there so that the hunter, for a fleeting instant, can have them in his grasp, the paintings are situated far from a different representation, far from the neighboring reality of the festival. It was at the end of the Upper Paleolithic that these themes appeared, enriched, beyond the immediate reality of the hunt, by the more composite reality of the festival. In Les Trois-Frères — in the Ariège department — these different themes appear all jumbled up: from an immense crowd of animals, figures that are half-human and half-animal emerge. They lead, it seems, a musical tumult, a dance of deliverance into intoxication. The straightforward animal figures were those of the hunt, but these strange — human yet animal — figures were in fact divine: for the undeveloped men, the animal, being essentially man's double, had something of the divine, the very thing he no longer attains except in the prodigious effervescence of the festival.

The strangest thing is that during this harsh era, when human

life was fragile — men usually lived past fifty, women on average lived much shorter lives (we know how old the skeletons were when they died; their burial preserved them) — war, which opposes men in inexpiable combat, was not apparent. If men killed other men, they were of a different species. Thus Upper Paleolithic man had to hunt, and it seems he was as capable of killing the Neanderthal man as he was of killing his prey. Actually, the line separating man from animal was not as clearly delineated as it is today. The first men, as well as some very primitive savages today, think they are really animals: because animals are, in their mind, the most holy, having a sacred quality, which men have lost. Thus, according to the simplest among us, animals, not men, are gods: animals alone have retained these supernatural qualities, which men have lost.

Of course it is hard for us to think that we are becoming completely wretched!

And yet...

We might have a sublime idea of the animal now that we have ceased being certain that one day the nuclear bomb will not make the planet an unlivable place for man.

# Notes for a Film

Italian mortuary chapels
funerary music     Chinese
                    savage
Primitive funerary festivals
Beginning war scene       cannon
        corpses.      taps
                        without life
                        without men
immediate fantastic countryside
        funerary
Chinese music. then the beginning of language

The cult of the dead
View of the earth before animals
animals without men
animals dying from human hands (that we do not see)
the cave at Lascaux
men disguised as animals
Carnac
Stonehenge   Musée Borély
the forgotten dead then the sepulchre

open sepulchres then
pyramids; Egyptian temples
Obelisk of Luxor, the execution of the magic flute.
A dual part: man, the most ancient, the most prestigious.

Desert, no birds
Life has not appeared on earth, the sphere rolls in the immensity
of space, opening itself to the light of the sun, the sound of the
elements

wind  thunder      lightning over the desert

life appears                              music?

                    sudden passages followed by disappearances
                                distant herds
animals                             everything entirely peaceful

then death        animals killing each other

man appears            smoke

animals hunted, a hecatomb

scattered traces of remains, traces of a
      foyer, caverns, furtive shadows, lamps

killers of animals

possible exclusivity      harmony between the cult and murder
in the R. Monbel         initially with lamps

projection of images — Greek nude male, a youth or bearded
      prehistoric man represented by
      himself

            but the image wants danger
                    erotic
         already sacrificial
         representation is already murder
         animals are gods —
            Egyptian gods

*Man is the only animal that kills its kind obstinately and furiously*

War scene, cannons, in the distance the ground is strewn with the dead, men are still falling.

*But man is also the only one troubled to the point of absolute laceration by the death of his kind*

Night falls on the preceding scene, the cannons slowly drift off and grow quiet, then taps resounds most sharply.

Everything quiets. The sun rises on an earth on which life has yet to appear

*Millions of years*

The earth before life, represented by the desert, without trace of plant or animal. Sunset. A violent wind stirs the sand. We hear the long moan of the wind.

Darkness falls and the starry night invades the screen animated by an almost intangible movement, elements of slippage, of recoil

DAYS AND YEARS, CENTURIES AND MILLENNIA SUCCEED ONE ANOTHER, IN A VANISHING POINT OF THE UNIVERSE THE EXTENDED EMPTINESS OF THE PLANET, ALTERNATIVELY, GORGES ITSELF WITH LIGHT AND SINKS INTO NIGHT. SLOWLY, THE STIR-RING OF WATERS . . .

Sunrise over water. We first make out the vast, slow noise of the waves, then later a muted passage from Haydn's *Creation*, his *Water Music*. The sky covers majestically the full daylight, but at the moment the sun attains its full intensity, the clouds grow dark. After rolling thunder, lightning strikes and the human voice recommences, prolonging itself across the rumblings, the lightning and the blinding fulmination of the storm

. . . SLOWLY, TRAGICALLY, THE TUMULT OF WATERS WILL RAISE THE UNHAPPY WONDERS OF LIFE. THUNDEROUS LIFE SPRINGS FROM THE DISORDER OF THE ELEMENTS LIKE ELECTRICITY FROM THE DISORDER OF STORMS.

Beneath the quieted sky, the waters are still tumultuous, but they withdraw. The beach slowly appears at low tide. In a crevice in the rocks, a kind of jelly wavers, shines in the sun.

In the depths, the flowering of some rare microbes, infusions displacing themselves in the water, represented in the same way as a voyage through undersea fauna.

THE EARTH LITTLE BY LITTLE COVERED WITH VEGETATION,
AND ANIMAL LIFE ABOUNDS

Moss and mushrooms . . . insects, tiny landscapes of moss,
insects and mushrooms. Vast stretches, coastlines, shoreline herbs
and flowers, flying fish on the waters, then birds. Birds devour
insects in flight. An immense variety of small animals and insects
tear each other to pieces.

# Notes

Editor's Introduction: The Sediment of the Possible

1. See Georges Bataille, *Prehistoric Painting: Lascaux; or, The Birth of Art*, trans. Austryn Wainhouse (Geneva: Skira, 1955); Georges Bataille, *Erotism: Death and Sensuality* (1957), trans. Mary Dalwood (San Francisco: City Lights Books, 1986); Georges Bataille, *The Tears of Eros* (1961), trans. Peter Connor (San Francisco: City Lights Books, 1989).

2. The notes provide bibliographic and contextual information for each selection included here.

3. Steven Ungar, "Phantom Lascaux: Origin of the Work of Art," in Allan Stoekl (ed.), *On Bataille*, special issue of *Yale French Studies* 78 (1990), pp. 246–62. Maurice Blanchot included his review of *Prehistoric Painting: Lascaux; or, The Birth of Art* in *Friendship* (1971), trans. Elizabeth Rottenberg (Stanford, CA: Stanford University Press, 1997). Vincent Teixeira offers a limited, or what Bataille would call a specialized, gloss of Bataille's writings on the visual arts, including his writings on cave paintings, in his book *Georges Bataille, la part de l'art: La Peinture du non-savoir* (Paris: Harmattan, 1997). Georges Didi-Huberman situates Bataille's writings on prehistoric art within the larger context of Bataille's aesthetic philosophy and practice in *La Ressemblance informe; ou, Le Gai Savoir visuel selon Georges Bataille* (Paris: Macula, 1995). The veritable flood of introductory works on Bataille that have recently appeared in English mention these materials only in passing, if at all.

4. While I will occasionally touch on recent developments in the field of prehistory, my focus will be on the place of prehistory in Bataille's own thought and writing.

5. Bataille, *Tears of Eros*, p. 36.

6. *Ibid.*, p. 37.

7. Georges Bataille, *Guilty* (1944), trans. Bruce Boone (Venice, CA: Lapis Press, 1988), p. 108.

8. On the aesthetic theory and practice of *Documents*, see Yve-Alain Bois and Rosalind E. Krauss, *Formless: A User's Guide* (New York: Zone Books, 1997); Didi-Huberman, *La Ressemblance informe*; and Denis Hollier, "The Use Value of the Impossible," in Hollier, *Absent Without Leave: French Literature Under the Threat of War*, trans. Catherine Porter (Cambridge, MA: Harvard University Press, 1997).

9. Georges Bataille, *The Accursed Share: An Essay on General Economy, vol. 1, Consumption* (1949), trans. Robert Hurley (New York: Zone Books, 1991).

10. Georges Bataille, *The Accursed Share: An Essay on General Economy, vol. 2, The History of Eroticism* (1951), trans. Robert Hurley (New York: Zone Books, 1993).

11. Georges Bataille, "Schéma d'une histoire des religions," in Bataille, *Oeuvres complètes* (Paris: Gallimard, 1970–88), vol. 7, p. 407. Bataille rewrote his lecture as *Theory of Religion* (1948), trans. Robert Hurley (New York: Zone Books, 1992).

12. Bataille, *Oeuvres complètes*, vol. 12, p. 420.

13. See Georges Bataille, "L'Inceste et le passage de l'animal à l'homme," *Critique* 44 (Jan. 1955), pp. 43–61; repr. as pt. 2 of *History of Eroticism*, pp. 27–58. Later, in *Erotism*, Bataille again reprinted this review, with minor changes, as "The Enigma of Incest" (pp. 197–220). Here, too, the title is significant: in *The Tears of Eros*, the enigma is the enigma posed by the scene in the pit at Lascaux (see p. 50).

14. Bataille, *History of Eroticism*, p. 52.

15. *Ibid.*

16. *Ibid.*

17. On complementarity and general economy in Bataille, see the admirable series of works by Arkady Plotnitsky beginning with *Reconfigurations: Critical Theory and General Economy* (Gainesville: University Press of Florida, 1993).

18. Bataille, *Erotism*, p. 75.

19. Bataille, *Prehistoric Painting*, p. 20; trans. modified.

20. Bataille, *Oeuvres complètes*, vol. 12, p. 421.

21. *Ibid.*, p. 417.

22. *Ibid.*, p. 421.

23. That this statement is false does not negate its value as a motivating ambition, as a goal of thought.

24. Charles Olson, in his "Bibliography on America for Ed Dorn" (1955), encourages a similar "shift" in historical thought (see Olson, *Collected Prose*, ed. Donald Allen and Benjamin Friedlander [Berkeley: University of California Press, 1997], pp. 297–310).

25. Bataille, *Prehistoric Painting*, p. 11.

26. Bataille, *Oeuvres complètes*, vol. 12, p. 421.

27. Alexandre Kojève, *Introduction to the Reading of Hegel* (1947), ed. Raymond Queneau, trans. James Nichols (Ithaca, NY: Cornell University Press, 1980), pp. 39–40.

28. *Ibid.*, p. 39.

29. Bataille, *Theory of Religion*, p. 17.

30. *Ibid.*, p 19.

31. *Ibid.*, p. 25; my emphasis.

32. Marquis de Sade, *The Complete Justine, Philosophy in the Bedroom, and Other Writings*, ed. and trans. Richard Seaver and Austryn Wainhouse (New York: Grove Press, 1965), p. 644.

33. *Ibid.*, p. 661.

34. Bataille, *Erotism*, p. 105.

35. Bataille, *Tears of Eros*, p. 31.

36. See *ibid.*, p. 44. Bataille follows Sade here, but borrows this interpretation from Nietzsche, who writes: "A living thing seeks above all to *discharge* its strength — life itself is *will to power*; self-preservation is only one of the indirect

and most frequent *results.*" Friedrich Nietzsche, *Beyond Good and Evil*, trans. Walter Kaufmann (New York: Vintage, 1966), sec. 13.

37. Bataille, *Erotism*, p. 85.

38. Blaise Pascal, *Pensées*, ed. A.J. Krailsheimer (London: Penguin, 1966), sec. 53. The extent to which Pascal guides and colors Bataille's thought has yet to be fully explored.

39. Bataille, *Erotism*, p. 84.

40. Quoted in Michel Surya, *Georges Bataille, la mort à l'oeuvre* (Paris: Gallimard, 1992), p. 363.

41. For a recent interpretation of this scene coincident with the key elements of Bataille's interpretation, though grounded in an advanced understanding and extension of prehistoric anthropology, see David Lewis-Williams, *The Mind in the Cave: Consciousness and the Origins of Art* (London: Thames and Hudson, 2002), p. 265.

42. Salomon Reinach should also be mentioned in connection with the development and application of this theory in the context of prehistoric culture.

43. The paucity of actual hunting scenes and of depicted wounded animals, as well as of animal species that figured as staples of local diets, went unknown, ignored, or unrecognized during the era when this interpretation held sway. For a history of interpretations of cave art, see Lewis-Williams, *Mind in the Cave*, pp. 41–68.

44. Bataille, *Prehistoric Painting*, p. 9.

45. Georges Bataille, *Inner Experience*, trans. Leslie Anne Boldt (Albany: State University of New York Press, 1988), p. 94; trans. modified.

46. Bataille, *Erotism*, p. 75; see also *Tears of Eros*, p. 37.

47. Bataille, *Erotism*, p. 74.

48. On the notion of absolute death in the context of post-Hegelian Continental philosophy, see Edith Wyschogrod, *Spirit in Ashes: Hegel, Heidegger, and Man-Made Mass Death* (New Haven, CT: Yale University Press, 1985).

49. For a historical description of the imaginary of atomic disaster, see Spencer R. Weart, *Nuclear Fear: A History of Images* (Cambridge, MA: Harvard University Press, 1988).

50. *The Nietzchean World of Hiroshima* would have comprised a reedition of *On Nietzsche* (1945) and *Mémorandum* (1945), among other materials. For Bataille's most extended discussion of the implications of nuclear war, see his review of John Hersey's account of the bombings and their aftermath, *Hiroshima* (New York: Knopf, 1946), "Concerning the Accounts Given by the Residents of Hiroshima," trans. Alan Keenan, in Cathy Caruth (ed.), *Trauma: Explorations in Memory* (Baltimore: Johns Hopkins University Press, 1995).

51. Nazi racial theory deploys medical science on behalf of a pathological imagination. The Jews, obviously, are not a separate species. At stake here is the function of a potentially prehistoric imaginary in a contemporary episode of man-made mass death. On the role of medical science on behalf of the Nazi agenda, see Robert Jay Lifton, *The Nazi Doctors: Medical Killing and the Psychology of Genocide* (New York: Basic Books, 1986).

52. On this point, too, the similarity of Bataille's perspective and Sigmund Freud's is noteworthy. Freud ends his prescient *Civilization and Its Discontents* (1930) with a concise statement of the problem: "Men have gained control over the forces of nature to such an extent that with their help they would have no difficulty in exterminating one another to the last man."

53. Bataille, *Oeuvres complètes*, vol. 11, p. 226.

54. See, for example, Bataille, *Tears of Eros*, p. 149.

55. Bataille is not alone in these ruminations. Charles Olson, for example, envisions Buchenwald as an Altamira for our time in his poem "La Préface" (see *The Collected Poems of Charles Olson*, ed. George F. Butterick [Berkeley: University of California Press, 1987], p. 46). Clayton Eshleman, too — and more so than anyone else — has continued and deepened the thought of these connections in a series of poetic descents into the Paleolithic imagination beginning with *Hades in Manganese* (Santa Barbara, CA: Black Sparrow Press, 1981). It is significant, finally, that the most prominent icons of our visual culture rarely include reference to contemporary totems of death.

56. Within the vast literature on genocide and man-made mass death, a few pointed references may be helpful: on the "banality of evil," see Hannah Arendt, *Eichmann in Jerusalem: A Report on the Banality of Evil* (New York: Penguin,

1994); on philosophical rationalism, professionalization, and objectivity in relation to genocide, see Richard L. Rubenstein, *The Age of Triage: Fear and Hope in an Overcrowded World* (Boston: Beacon Press, 1983).

57. Georges Bataille, "Slaughterhouse" (1929), in Bataille et al., *Encyclopaedia Acephalica*, trans. Annette Michelson (London: Atlas Press, 1995), p. 73.

58. Eveline Lot-Falck, *Les Rites de chasse chez les peuples sibériens* (Paris: Gallimard, 1953).

59. Bataille, *Guilty*, p. 8.

60. *Ibid.*, p. 40–41.

61. Kojève, *Introduction to the Reading of Hegel*, p. 3.

62. The conjecture that the "shaman" — pictured falling backward — is "dead" originates in the interpretation of Abbé Breuil. The shaman need not be dead to share the fate of his victim, for both are surely on their way toward death.

63. Bataille, *Inner Experience*, p. 153.

64. Bataille, *Guilty*, p. 117.

65. Georges Bataille, "The Solar Anus" (1927), in Bataille, *Visions of Excess: Selected Writings, 1927–1939*, trans. Allan Stoekl (Minneapolis: University of Minnesota Press, 1985), p. 5.

66. Bataille, *Inner Experience*, p. 109.

67. Bataille, *Theory of Religion*, p. 11.

68. Georges Bataille, *The Unfinished System of Nonknowledge*, ed. Stuart Kendall, trans. Michelle Kendall and Stuart Kendall (Minneapolis: University of Minnesota Press, 2001), p. 206.

69. Bataille, *Inner Experience*, p. 156.

70. Lewis-Williams, *Mind in the Cave*, p. 8.

71. *Ibid.*, p. 9.

72. Paul G. Bahn, *Journey Through the Ice Age* (Berkeley: University of California Press, 1997), p. 6.

73. Weston La Barre, *The Human Animal* (Chicago: University of Chicago Press, 1954), p. ix. La Barre's work, as is clear from the aforementioned title, shares many similarities of concern with Bataille's. On prehistoric culture, in

addition to *The Human Animal*, see La Barre's *Ghost Dance: Origins of Religion* (New York: Doubleday, 1970) and *Muelos: A Stone Age Superstition About Sexuality* (New York: Columbia University Press, 1984).

74. Bataille, *Oeuvres complètes*, vol. 12, p. 433.

75. On recent changes in the publishing industry related to this point, see, for example, André Schiffrin, *The Business of Books: How the International Conglomerates Took Over Publishing and Changed the Way We Read* (New York: Verso, 2001).

76. Bataille, *Oeuvres complètes*, vol. 7, p. 462.

77. Bataille, *Erotism*, p. 8; trans. modified.

78. Bataille, *Tears of Eros*, p. 52.

CHAPTER ONE: PRIMITIVE ART

"L'Art primitif," *Documents* 7 (1930), pp. 389–97; repr. in Bataille, *Oeuvres complètes* (Paris: Gallimard, 1970–88), vol. 1, pp. 247–54.

1. This essay is a review of Georges-Henri Luquet, *L'Art primitif*, Encyclopédie scientifique, Bibliothèque d'Anthropologie (Paris: G. Doin, 1930), vol. 13.

2. "Ontogeny repeats phylogeny" is, of course, a tenet of psychoanalysis. See, for example, Sigmund Freud, "The Infantile Recurrence of Totemism," in *Totem and Taboo* (1912). — TRANS.

3. The term "alteration" expresses both a partial decomposition analogous to that of corpses and the passage to a perfectly heterogeneous state corresponding to what the Protestant professor Rudolf Otto calls the "wholly other," which is to say the sacred, realized, for example, in a ghost. See Rudolf Otto, *The Idea of the Holy* (1917), trans. John W. Harvey (Oxford: Oxford University Press, 1923), pp. 25ff.

4. See figure 1. Abyssinian children's graffiti, taken from the churches of Godjam, Abyssinia, by Marcel Griaule.

5. These admirable graffiti were taken from the churches of Godjam, Abyssinia, by Marcel Griaule during his recent expedition. Griaule copied no fewer than five hundred, which he hopes to publish shortly. The children draw

during the services and appear to prefer forms susceptible to several interpretations, having the value of a pun.

CHAPTER TWO: THE FROBENIUS EXHIBIT AT THE SALLE PLEYEL
"L'Exposition Frobenius à la salle Pleyel," in Bataille, *Oeuvres complètes* (Paris: Gallimard, 1970–88), vol. 2, pp. 116–17. Intended for publication in *Documents*, it was found among Bataille's papers at the time of his death.

CHAPTER THREE: A VISIT TO LASCAUX
"Conférence à la Société d'Agriculture," in Bataille, *Oeuvres complètes* (Paris: Gallimard, 1970–88), vol. 9, pp. 325–30.

Bataille gave this lecture at the Société d'Agriculture, Sciences, Belles-Lettres et Arts d'Orléans in December 1952. He placed the text of his lecture, titled "A Visit to Lascaux," in a folder with his article "A Meeting in Lascaux: Civilized Man Rediscovers the Man of Desire" (*Arts*, no. 423 [Aug. 7–13, 1953], pp. 1 and 6; translated herein).

The *Société* bulletin published the following summary of the lecture:
Mr. Bataille visited the recently discovered Lascaux cave, near Sarlat. The walls of the cave are covered with paintings that have retained an extraordinary freshness of color. There are bison, hunted and pierced with arrows, one of them losing his entrails. These scenes do not always present a coherent composition; they overlap one another sometimes. The decorative intention, if present, does not predominate.

Additionally, the caves in which one finds the paintings are almost always very dark and difficult to access. Specialists in this field have long agreed in viewing these as secret sanctuaries, wherein the scenes represent ritual figures of a magical nature. These rituals have a relationship with the hunt, on which the lives of these distant ages depended. Before leaving for an expedition against bison, bulls, or deer, they held these rituals to take possession of their prey by fixing its image, to perhaps disarm it in advance by calming it with sorcery. We find, in our own day, analo-

gous conceptions among the Pygmies, whose living conditions are not very different.

These primitive beings did not believe themselves superior to the animals: themselves being hardly separated from animality, having only an obscure consciousness of their humanity. In these animals that they hunted dangerously, they suspected, dreaded, the redoubtable forces, probably divine, of "spirits." Whereas we see, at best, inferior brothers, they discerned mysterious forces.

While, to better fix their prey, they formed admirable figurations with precision, with "presence," when they wanted to represent a human being, they contented themselves with a crude and ridiculous outline. This is because they did not have the same interest in making him present, fixing him. And often, as in the cave of Les Trois-Frères (Ariège), they gave him an animal head; they disguised him, dissimulating his humanity.

1. Paul Foulquié, *L'Existentialisme*, Que sais-je? (Paris: PUF, 1946). A paragraph devoted to Bataille with a misquotation: "I teach the art of turning anguish into delirium," though Bataille wrote "into delight" (Georges Bataille, *Inner Experience*, trans. Leslie Anne Boldt [Albany: State University of New York Press, 1988], p. 35). — GALLIMARD NOTE

2. Other than the article "Un Nouveau Mystique," reprinted in *Situations*, Sartre writes about Bataille on several occasions in *What Is Literature?* (*Situations II*) in generally unkind terms. — GALLIMARD NOTE

3. The entirety of the preceding, the first four pages of the lecture, is crossed out in the manuscript. — GALLIMARD NOTE

4. The previous two sentences were crossed out in the manuscript. — GALLIMARD NOTE

5. *Esprits* (minds or spirits). The Hegelian register of these terms should be recalled throughout. — TRANS.

6. Here a blank space in the text undoubtedly indicates an interruption in the lecture for projections. In this blank space, some words are noted:

the whole world knows

Lascaux

    its value

immediate emotion

not

spiders

wood-lice — GALLIMARD NOTE

7. Crossed out: "because it makes me cut to the quick of my subject." — GALLIMARD NOTE

8. Another blank space in the text apparently corresponds to new projections. — GALLIMARD NOTE

CHAPTER FOUR: THE PASSAGE FROM ANIMAL TO MAN AND THE BIRTH OF ART
"Le Passage de l'animal à l'homme et la naissance de l'art," *Critique* no. 71 (April 1953), pp. 312–30; repr. in Bataille, *Oeuvres complètes* (Paris: Gallimard, 1970–88), vol. 12, pp. 259–77.

1. "It is not a complete Corpus," the author himself says, "but it gives the essentials of the paintings and wall engravings in the painted caves, published or not, copied by me, or published by other specialists" (Henri Breuil, *Quatre cents siècles d'art pariétal: Les Cavernes ornées de l'âge du renne*, ed. Fernand Windels [Montignac and Paris: Centre d'Etudes et de Documentation Préhistoriques, 1952]; trans. Mary E. Boyle as *Four Hundred Centuries of Cave Art* [New York: Hacker Art Books, 1979], p. 17).

2. In this essay, I will briefly mention Hans-Georg Bandi and Johannes Maringer's work, *L'Art préhistorique*, which continues the project of Hugo Obermaier. This work is a useful contribution to the domain envisioned here, most notably with regard to portable art, which it discusses abundantly. Maringer wrote the section on prehistoric art. Bandi wrote the sections on the Levantine (the discovery of which is due in part to Obermaier) and on the Arctic, which we will not be discussing here. See Hans-Georg Bandi and Johannes Maringer, *L'Art préhistorique: Les Cavernes, le Levant espagnol, les régions arctiques*, trans.

Jean Descoullayes and François Lachenal (Basel: Holbein; Paris: Charles Massin, 1952); trans. Robert Allen as *Art in the Ice Age: Spanish Levant Art, Arctic Art* (New York: Praeger, 1953).

3. Breuil, *Four Hundred Centuries of Cave Art*, p. 17.

4. Obviously Lascaux is not exactly the first instance. There were rumblings, traces of which occasionally remain. But it is the first *tangible* instance in which sensibility fully reaches its highest power. A painter, whom many consider the most qualified, recently said of these paintings: we have done nothing better since. [Picasso. — Trans.]

5. By 1955, Bataille was no longer taken in by this journalist's version of the story. In *Prehistoric Painting: Lascaux; or, The Birth of Art*, trans. Austryn Wainhouse (Geneva: Skira, 1955), p. 137, he attributes the discovery to a more intentional exploration of the cave. See also *Oeuvres complètes*, vol. 9, p. 90. — Trans.

6. Breuil, *Four Hundred Centuries of Cave Art*, p. 24.

7. *Ibid.*, p. 135.

8. *Ibid.*, p. 170.

9. At the risk of introducing an equivocation: how, before this figure, can we not think of Descartes's enigmatic motto *larvatus prodeo*? [See the first paragraph of René Descartes's *Cogitationes privatae* (1619–22): "Actors taught not to let any embarrassment show on their faces, put on a mask. I will do the same. So far, I have been a spectator in this theatre which is the world, but I am now about to mount the stage, and I come forward masked [*larvatus prodeo*]" (Descartes, *The Philosophical Writings of Descartes*, trans. John Cottingham et al. [Cambridge, UK: Cambridge University Press, 1985], vol. 1, p. 2; for the Latin original, see Charles Adam and Paul Tannery, *Oeuvres de Descartes*, vol. 10, p. 213). — Trans.]

10. More precisely, the sex is erect, but this erection is pointed down.

11. We are aware that prehistorians must, if the date is not available, assign names to the periods whose order of succession is known: for the four hundred centuries Breuil envisioned, we have first the Aurignacian and the Perigordian, then the Solutrean and the Magdalenian. The dead man depicted in Lascaux must date back to the Perigordian (or the Upper Aurignacian) period.

12. Breuil, *Four Hundred Centuries of Cave Art*, p. 176.

13. *Ibid.*, p. 355.

14. *Ibid.*, p. 386.

15. *Ibid.*, p. 272.

16. *Ibid.*, pp. 391 and 389.

17. *Ibid.*, p. 391.

18. *Ibid.*, p. 95. Sketches of a face or a profile are reproduced in Marcellin Boule, *Les Hommes fossiles: Eléments de paléontologie humaine*, 3rd. ed. (Paris: Massin, 1946), fig. 226, no. 8.

19. Breuil, *Four Hundred Centuries of Cave Art*, p. 245. There are thirty-nine vaguely human figures in the Combarelles cave, but the animal figurations are at least ten times more numerous. Breuil's sketch of the "Man with the Mammoth Head" (?) is reproduced by Bandi and Maringer, *Art in the Ice Age*, fig. 70.

20. Bandi and Maringer, *Art in the Ice Age*, pp. 34–36.

21. Breuil, *Four Hundred Centuries of Cave Art*, p. 95.

22. *Ibid.*

23. *Ibid.*

24. This is of course in my opinion. The name steatopygous Venus has been given to these figurines, comparing their accentuated forms to those of Hottentot females.

25. *Ibid.*, p. 335. "There was insufficient place at Angles-sur-Anglin to carve a bust and normal head, as the roof was very low," says Breuil (p. 335). He adds, however: "It looks as if one head, in any case, was sculpted, but there is no apparent sign of shoulders or arms" (p. 335). No trace either, it seems, of the nose, mouth, eyes, or ears. Furthermore, the author equates the women in the Angles cave with a Magdalenian statuette known as the Shameless Venus, which, constructed without a head, was therefore not broken, as had previously been thought. In fact, her cranium would have "a carved bevel. It is perfectly plausible that the figure was created with several pieces fitting on to each other" (p. 335).

26. I must nevertheless cite the November–December 1952 issue (published in February 1953) of the *Bulletin de la Société Préhistorique Française*, which documents (pp. 622–24) the discovery, in August 1952, by Vergnes, of a number of animal figures carved in the cave at La Magdeleine (Tarn). Two

engravings of nude female forms were discovered a bit later in the same cave. During his visit, Breuil declared: "These are the most remarkable female sculptures of the Magdalenian period. This is a veritable revelation since, before the sixteenth century, we thought there was no sculpture in France that made reference to such artistic canons. Both Madame Recamiers," the Abbé insists she be called this, "come from a simultaneously realistic and idealistic aesthetic. Now, Magdalenian art, at least as we have known it up to now, had revealed nothing like this to prehistorians. What most resembles the Venuses of La Magdeleine, given their craftsmanship, would be certain figures of Cretan art of a nonreligious origin." Vergnes's rather insufficient sketches of the two nudes give the impression that they are distinguished by certain features. Be that as it may, these two prostrated women have languid poses. One of them has "her legs spread open with her sex organs clearly delineated." The very similar position of the other even suggests a voluptuous state. These are apparently erotic figures. But, once again, this does not alter a rather clear, total picture.

27. Breuil, *Four Hundred Centuries of Cave Art*, p. 23.

28. *Ibid.*, p. 23.

29. The site of the rituals was as a rule uninhabited and likely to inspire a sense of the sacred. Breuil noted some exceptions: "If the placing of the painted panels in the depths of deep underground corridors shows a search for true secret places, almost inaccessible to the multitude, other sites such as Cap Blanc, the Roc de Sers, Angles, and so on are open and inhabited places" (*ibid.*, p. 23). In any case, the caves he discusses were painted only during the Magdalenian period (see p. 407).

30. Bataille delivered "Nonknowledge, Laughter, and Tears," the final lecture of his "Lectures on Nonknowledge," at the Collège Philosophique on February 9, 1953, two months before the present essay appeared in *Critique*. During that lecture, which contains perhaps Bataille's most thorough discussion of laughter as a philosophical problem, he claims, "Insofar as I am doing philosophical work, my philosophy is a philosophy of laughter. It is a philosophy founded on the experience of laughter . . . [a philosophy] that doesn't concern itself with problems other than those that have been given to me by this precise experi-

ence" (*The Unfinished System of Nonknowledge*, ed. Stuart Kendall, trans. Michelle Kendall and Stuart Kendall [Minneapolis: University of Minnesota Press, 2001], p. 138). — Trans.

CHAPTER FIVE: A MEETING IN LASCAUX: CIVILIZED MAN REDISCOVERS THE MAN OF DESIRE

"Au rendez-vous de Lascaux, l'homme civilisé se retrouve homme de désir," *Arts*, no. 423 (Aug. 7–13, 1953), pp. 1 and 6; repr. in Bataille, *Oeuvres complètes* (Paris: Gallimard, 1970–88), vol. 12, pp. 289–92.

   1. Two years earlier, Bataille reviewed two books on da Vinci in *Critique*; see "Léonard de Vinci (1452–1519)," *Critique*, no. 46 (March 1951), pp. 261–67; repr. in Bataille, *Oeuvres complètes*, vol. 12, pp. 65–73. In this review of Antonina Vallentin's *Léonard de Vinci* (Paris: Gallimard, 1950) and of *Tout l'oeuvre peint de Léonard de Vinci* (Paris: NRF, 1950), Bataille situates da Vinci's thought and work in relation to the birth of science and, hence, the origins of modernity. In Bataille's reading, however, da Vinci's work was inspired less by the rationally abstract and objective concerns that would characterize modern science than by a passionate love of nature. Da Vinci lived prior to our own era of disciplinary specialization, but, Bataille suggests, his passion for inquiry would have led him beyond such confines had they existed in his day. This passion, too, led da Vinci beyond observation and experimentation into the realm of the imagination, into speculation, into the fantastic. For this reason, among others, da Vinci's machines often fail the test of functionality. In this sense, da Vinci's passionate imagination, in Bataille's reading, contests nature, negates it. As evidence of this essential ambivalence, Bataille cites a story from da Vinci's youth in which da Vinci is both attracted and repulsed by his experience exploring a cave, which in his imagination is linked to the catastrophic and viscous horrors of nature. Da Vinci, then, in Bataille's reading, stands on the cusp of the modern, rationalist sensibility without losing himself in it: his passion for inquiry is fueled by both love and horror, without delivering itself to either specialization or functionalist, objective rationality. — Trans.

   2. "What is lacking" here translates "ce qui lui manque." This phrase might

also be translated as "he who fails himself." The phrase also suggests a sense of someone who fails to *coincide* with himself or herself, who *misses* himself or herself, as in the case of a subjectivity that is not self-possessed. Animals, following this logic, lack self-possession or self-consciousness. This verb may also be used to indicate someone who fails in his or her suicide attempt. — TRANS.

CHAPTER SIX: LECTURE, JANUARY 18, 1955

Bataille delivered this lecture in Orléans on January 18, 1955. The venue and the occasion for the lecture remain unknown, though, as Bataille indicates here, the lecture anticipates by three months the publication of *Prehistoric Painting: Lascaux; or, The Birth of Art*.

1. *Prehistoric Painting: Lascaux; or, The Birth of Art* was published on April 30, 1955. — GALLIMARD NOTE

2. The American anthropologist referenced here is William Howells. Bataille quotes this comparison in *ibid.*, pp. 17ff. See William Howells, *Back of History: The Story of Our Own Origins* (1954). — GALLIMARD NOTE

3. We do not know what film was projected on this occasion. — GALLIMARD NOTE

4. Bataille interrupted his lecture at this point to show the film. — GALLIMARD NOTE

5. He is talking about Picasso. — GALLIMARD NOTE

CHAPTER SEVEN: THE LESPUGUE VENUS

"La Vénus de Lespugue" was not published during Bataille's lifetime. The text can be found in Bataille, *Oeuvres complètes* (Paris: Gallimard, 1970–88), vol. 9, pp. 344–52. Bataille apparently prepared the manuscript — originally titled "The Erotic Image" — in 1958 for inclusion in the abortive journal *Genèse* (Genesis).

Maurice Girodias, the publisher of Olympia Press and the original publisher of *Critique*, approached Bataille following the publication of *Erotism* (1957) with the proposal that Bataille edit an illustrated journal for a general readership on the subject of eroticism. The project foundered in acrimony after a year of vigorous and detailed preparation when it became apparent that Girodias expected

the journal to cater to a clientele whose tastes were more salacious than scholarly. The direction of Bataille's own intentions for the journal can be seen in his heavily illustrated final work, *The Tears of Eros* (1961), a project he began in the year following the abandonment of *Genèse*. Part One of *The Tears of Eros* bears the significant title "The Beginning." It is not surprising, then, that so many of the ideas and images Bataille discusses in the present article should reappear there.

More broadly, in regard to both projects, it should be noted that Bataille considered titling the proposed journal *L'Espèce humaine* (The Human Species), in reference not only to the species in question but also to Robert Antelme's book of that title, published by Gallimard in 1957. Antelme's book records his experiences in Dachau and other Nazi concentration camps during the Second World War (see Bataille, *Choix de lettres,* ed. Michel Surya [Paris: Gallimard, 1997], pp. 484–85; Antelme's book is available in English translation under the somewhat misleading title *The Human Race*).

In volume 9 of Bataille's *Oeuvres complètes*, the Gallimard editors include the following selections from Bataille's notes for this article:

The Erotic Image

Limit ourselves to the female image

The impossibility of defining the erotic image

 Variable across time.

 For us pretty nudity

 But in other times the element of nudity was missing

        prettiness or not

        identical with what it is today

        or even unrelated to what it is today

Whatever the case, seeing an erotic image in

 the celebrated Lespugue Venus

 the most striking the most beautiful female image

 come to us from the earliest times

There is also the Brassempouy Venus

 that of Laussel

 but these are of little importance

We cannot hope to see with true clarity
We cannot experience what was experienced
what the first men and in particular what the creator of the statuette
experienced

But we can reach by means of this image
a certain number of considerations
precise and limited
we can assume that it is an erotic image
    the erotic character in general of ancient human figures
        ithyphallic men
the erotic character of women, if it exists, is not separate from their
fecundity
from the erotic character independent of the elegant nudity of the body
    the obscene nudity
that which appears at a certain stage in clothes

    What is in a way pinpointed
        in the Lespugue Venus
no contradiction between the genitalia and the statuette
    between the reproductive function
        the flower of fat

    There is no accordance between the erotic image and the human image

1. In the margin beside the three preceding sentences, Bataille writes: "Suppress?" — GALLIMARD NOTE

2. She has prominent buttocks, forming a perpendicular ledge beneath her waist. See Luce Passemard, *Les Statuettes féminines paléolithiques dites Vénus stéatopyges* (1938), p. 31, pl. 111.

3. See Salomon Reinach, "Statuette de femme nue découverte dans une des grottes de Menton," *L'Anthropologie* (1898), pp. 26–31. [Images of this figurine are reproduced in *The Tears of Eros*, trans. Peter Connor (San Francisco: City Lights Books, 1989), pp. 32 and 33. — TRANS.]

4. See Raymond Vaufrey, "La Statuette féminine de Savignac sur le Panaro (Prov. de Modène)," *L'Anthropologie* (1926), pp. 429–35.

5. See *L'Anthropologie* (1910), p. 690.

6. See Passemard, *Statuettes féminines*, pp. 47–48, pl. 8. On this figurine, three oblique marks might represent eyes.

7. See Salomon Reinach, "Une Nouvelle Statuette féminine en ivoire de mammouth," *L'Anthropologie* (1924), p. 346; and Marcellin Boule, *Les Hommes fossiles: Eléments de paléontologie humaine*, 3rd ed. (Paris: Massin, 1946), pp. 334–35, fig. 225. The head of this figurine is missing.

8. See E.A. Golomshtok, "Trois Gisements du paléolithique supérieur russe et sibérien," *L'Anthropologie* (1933), pp. 335–36.

9. The most well known of these bas-reliefs has been named the Laussel Venus. See G. Lalanne, "Bas-reliefs à figuration humaine de l'abri sous roche de Laussel (Dordogne)," *L'Anthropologie* (1912), p. 131, fig. 1. One of these, sold by someone who worked on the excavation, can now be found in the Berlin Museum. The others are part of the Lalanne collection in Bordeaux. [One of these bas-reliefs is reprinted in *The Tears of Eros*, p. 22. — TRANS.]

10. A note in the margin of the typescript: "Correspondence between aggression and the breach." — GALLIMARD NOTE

11. See Paolo Graziosi, "Une Nouvelle Statuette préhistorique découverte en Italie," *Bulletin de la Société Préhistorique Française* (1939), pp. 159–62. [Images of this figurine are reproduced in *The Tears of Eros*, p. 24. — TRANS.]

12. J.V. Zeligko insists that certain people in warm regions appreciate the obesity of women (see "Nachtrag zur Frage der Steatopygie des paläolitischen Menschen," *Mitteilungen des anthropologischen Gesellschaft in Wien* 56 [1926], pp. 12–15). Georges-Henri Luquet claims that the sexual characteristics emphasized in some of these statuettes signal an erotic tendency in general among primitive peoples (*L'Art primitif* [1930]). The opinions of Passemard, H. Kleatsch, Moritz Hoernes, and Oswald Menghin similarly side with the sexual signification. Elisabeth Della Santa has summarized the hypotheses sparked by these images in *Les Figures humaines du paléolithique supérieur eurasiatique* (Antwerp: De Sikkel, 1947), pp. 9–21.

13. Thomas Gainsborough (1727–88), *The Honorable Mrs. Graham*. — TRANS.

14. Robert Musil, *The Man Without Qualities*, trans. Sophie Wilkins (New York: Knopf, 1995), vol. 1, p. 108. — TRANS.

CHAPTER EIGHT: PREHISTORIC RELIGION

"La Religion préhistorique," *Critique*, nos. 147–48 (Aug.–Sept. 1959), pp. 765–84; repr. in Bataille, *Oeuvres complètes* (Paris: Gallimard, 1970–88), vol. 12, pp. 494–513.

1. This chapter is a review of Johannes Maringer, *L'Homme préhistorique et ses dieux*, trans. Paul Stéphano (Paris: Arthaud, 1958). This book originally appeared in Dutch as *De godsdienst der praehistorie* (1952). Mary Ilford edited and translated the book into English as *The Gods of Prehistoric Man* (New York: Knopf, 1960). — TRANS.

2. Rudolf Otto, *The Idea of the Holy* (1917), trans. John W. Harvey (Oxford: Oxford University Press, 1923). — TRANS.

3. These comparisons are possible on the condition, formulated by Wilhelm Schmidt, whom Maringer quotes, that they concern "civilizations of the similar nature" (Maringer, *Gods of Prehistoric Man*, p. 40). Thus such a comparison is possible between hunting communities and not between hunters and shepherds or hunters and farmers. Moreover, the compared civilizations must be of comparable stages of development. [Maringer is quoting Wilhelm Schmidt, *The Origin and Growth of Religion: Facts and Theories* (London: Methuen, 1931). — TRANS.]

4. Furthermore, religious texts are inevitably invalidated by the fact that they cannot translate inner experience without connecting it to a positive interpretation. I suggest this at the end of this essay: religions have always contained the negation and the destruction of what they are.

5. Maringer stresses that the oldest customs known through the discovery of bones can otherwise be compared with modern customs, observed in our day, among archaic peoples. The discovery of skulls, Maringer affirms, can be interpreted "in the light of practices observed among modern primitive tribes of a similar level of advancement, these finds show that the prehistoric hunters treated their dead with great reverence. Like their modern counterparts, they probably preserved certain parts of the skeleton, mostly the skull or lower jaw,

in special places, perhaps adorning them with ornaments or painting them with ochre. When the tribe moved, the skulls were probably taken along" (*Gods of Prehistoric Man*, p. 190).

6. This 1936 discovery confirmed a hypothesis asserted in 1926 by A. Irving Hallowell, which sees the bear cult, which would have been, according to him, the origin of the first alpine deposits, as "a specific phenomenon in the history of culture" (*ibid.*, p. 37). [See A. Irving Hallowell, "Bear Ceremonialism in the Northern Hemisphere," *American Anthropologist* 28 (1926). — TRANS.]

7. Maringer, *Gods of Prehistoric Man*, pp. 37–38. Maringer does not take into account the difference between the case in which the bear is *captured* and that in which it is *killed* in the hunt. On one occasion in the above, I had to, for the logic of his explanation, substitute the word "killed" with the word "captured." From other descriptions I have read, I believe I can say that the capture, not the death, of the animal was essentially the goal of the hunt. This consideration is of the utmost importance: the custom of the capture followed by the killing links the origin of sacrifice to hunting rather than to livestock, which, consequently, locates this origin at a very early date, to the Upper Paleolithic, if not to the Middle Paleolithic.

8. *Ibid.*, p. 88; see also p. 79. The author, who several times discusses the model, does not talk about it in his chapter on the bear cult of the Upper Paleolithic. It seems to me that this is because this model was responding to a ritual of magic, whereas he connected a religious meaning to the skull with the filed-down teeth. It seems necessary to grant the model a meaning analogous to the meaning behind the skull. The magical interpretation corresponds to the traditional interpretation of prehistorians. But I think the inevitable comparison I discussed should be cause enough for mistrust with regard to this tradition. The carvings on the walls of Les Trois-Frères, which show bears pierced with spears and bleeding, which Maringer interprets in the religious sense, can at most have had a magical significance; that is, they may have responded to the intention to provoke through bewitchment the animal's death, while in principle the utilization of the model demanded this prior death, since the simulacrum of the death demanded the addition of the animal's actual head. The question, however, demands to be considered together, beginning with the model in the Montespan cave.

9. Eveline Lot-Falck, *Les Rites de chasse chez les peuples sibériens* (Paris: Galli-
mard, 1953). Bataille previously referenced this passage in *Prehistoric Painting:
Lascaux; or, The Birth of Art*, trans. Austryn Wainhouse (Geneva: Skira, 1955), pp.
125–26. *Les Rites de chasse chez les peuples sibériens* appeared as a volume in a
series titled L'Espèce humaine edited by Michel Leiris. Lot-Falck based her book
in part on the extensive research and notes of Anatole Lewitzky, who had lec-
tured on shamanism at the Collège de Sociologie on March 7 and 21, 1939.
Lewitzky, a Russian émigré, was then preparing a thesis on Siberian shamanism
at the Ecole Practique des Hautes Etudes under the direction of Marcel Mauss
and René Grousset. He was shot in 1942 for his Resistance activities. See Denis
Hollier, ed., *The College of Sociology* (Minneapolis: University of Minnesota
Press, 1988), pp. 248–61. — Trans.

10. Herbert Kühn, author of *Kunst und Kultur der Vorzeit Europas: Das
Paläolithikum* (Berlin, 1929), *Das Problem des Urmonotheismus* (Wiesbaden, 1952),
*Die Felsbilder Europas* (Stuttgart, 1952), among other works. Quoted by Marin-
ger, *Gods of Prehistoric Man*, p. 82. — Trans.

11. Maringer, *Gods of Prehistoric Man*, p. xviii. Wilhelm Schmidt is the Vien-
nese ethnographer who supported the thesis of a unique, primitive god, of the
belief in one supreme being, at the origin of religions. Without offering any
apologetic demonstrations of this thesis, I must say that Schmidt's thesis is far
from lacking interest. Furthermore, it is remarkable that it left Maringer
defenseless when faced with the usual magical interpretation. Maringer would
have loved to speak on behalf of the religious spirituality of the Upper Paleolithic
civilization, which he takes with good reason to be one of the most brilliant peri-
ods in human history, but he is limited (following, moreover, Schmidt) to speak-
ing about a virile consciousness that affirms itself, through countless technical
advances. These men would have thought they were able to influence the out-
side world, and would have doubted the effectiveness of a supreme being (p. 81).
Maringer adds that the invention of art must have contributed in large part to
stimulating the hunters' belief in mysterious forces (p. 82). Of course, this goes
hand in hand with Maringer's great honesty.

12. *ibid.*, p. 20.

13. *ibid.*, p. 49; my emphasis. Though it concerns a well-known hypothesis, I do not recall ever having seen it so well put, so precisely and expressively. The "macaroni" lines are not so rare. They do indeed seem to precede the figurative drawings.

14. *Par jeu.* In addition to "fun," *jeu* here also suggests "risk," "gambling," and "play." — TRANS.

CHAPTER NINE: THE CRADLE OF HUMANITY: THE VÉZÈRE VALLEY
Bataille did not publish "Le Berceau de l'humanité: La Vallée de la Vézère." The text appeared for the first time in *Tel quel* 40 (Winter 1970) and is reprinted in Bataille, *Oeuvres complètes* (Paris: Gallimard, 1970–88), vol. 9, pp. 353–76. Notes accompanying the text among Bataille's papers permit us to date the composition of this essay to the summer of 1959. The outline below was among those notes (it appears in *Oeuvres complètes*, vol. 9, p. 485).

Significantly, during the summer of 1959, Bataille was just beginning to work on *The Tears of Eros*, the earliest record of which is a letter to his editor, J.M. Lo Duca, dated July 24, 1959.

*Le Pur Bonheur ou la part du jeu* (Pure Happiness or the Role of Risk), mentioned below, refers to a planned fourth volume of Bataille's *La Somme athéologique* (see Bataille, *The Unfinished System of Nonknowledge*).

The following outline offers a glimpse of the direction Bataille intended to pursue not only in this chapter but in the "Universal History" that was to come.

27-7-59

Begin with the article on the *Vézère*
as basis, the principle being to speak successively about local aspects significant to universal history
raise in this chapter:
what is said in *Prehistoric Religion* (*Critique* Aug.–Sept. 59)
what is said in *Qu'est-ce que l'hist. univ.?* (*Critique* Aug.–Sept. 56) [What Is Universal History?]
what is said in *The Erotic Image*

unpublished article (this in view of treating the question of sexual taboo)

Thereafter

The development of religion and politics

as a whole, as it is sketched in the article on Sovereignty (2nd part of the *Introduction* ["The Schema of Sovereignty," in *The Accursed Share*, vol. 3, trans. Robert Hurley (New York: Zone Books, 1993), pp. 213–23; originally published as "Le Paradoxe de la mort et la pyramide," *Critique* 74 (July 1953).])

II

The war game and royal religion

an article to be written for *Critique* (after the article on Nietzsche) on *The Sacred King* and the work by Cerfaux and Tonnelat

don't forget the article on Caillois['s book *Les Jeux et les hommes* (Gallimard, 1958)], though that article should find its place in the book titled Le Pur Bonheur ou la part du jeu [Bataille left the first portion of this title blank in his notes. — GALLIMARD NOTE]

III

From slavery to equality (measure). Christianity in relation to royal immoderation. Work.

IV

Revolution and Immoderation. France-Russia-China.

The inevitable triumph of immoderation seeking measure of the measurement itself.

Sovereignty.

1. See Pierre Teilhard de Chardin, *The Phenomenon of Man*, trans. Bernard Wall (New York: Harper, 1959). — GALLIMARD NOTE

2. The manuscript indicates that Bataille intended to include an illustration here. — GALLIMARD NOTE

3. The text of the *Oeuvres complètes* contains a typo here. For "art mobilier" (portable art) the text reads "art immobilier" (stationary or immobile art). The context, however, makes Bataille's intended meaning clear. — TRANS.

4. See Chapter Eight, "Prehistoric Religion," note 9, for information on Eveline Lot-Falck and Bataille's repeated use of this quotation. — TRANS.

5. The phrase "turn away from" translates *détourner*, a word meaning "to redirect," "to reroute," "to divert," or "to distort or twist," as well as "to turn one's eyes or head away." — TRANS.

### CHAPTER TEN: UNLIVABLE EARTH?

"Terre invivable?" *United States Lines, Paris Review*, "For a World Festival" (Summer 1960); repr. in Bataille, *Oeuvres complètes* (Paris: Gallimard, 1970–88), vol. 12, pp. 514–17.

1. The word *fête* can reference a holiday, a celebration, a feast, a fair, a festival, a vacation, or a party. These diverse and distinct meanings suggest something of Bataille's point in this short essay. — TRANS.

### APPENDIX: NOTES FOR A FILM

These notes for a film on Lascaux were found among Bataille's papers at the time of his death. They appear in Bataille, *Oeuvres complètes* (Paris: Gallimard, 1970–88), vol. 9, pp. 319–24. The potential producer of the project remains unknown. The project can be dated to the end of 1952 or early 1953, because the notes were found among papers related to Bataille's article "Hemingway à la lumière de Hegel," *Critique* 70 (March 1953), pp. 195–210.

The first page of notes included here appears on the backs of two postcards from Lascaux. Two additional postcards include, on one, an enumeration of civilizations from Stonehenge to the Renaissance and, on the other, a list of Bataille's then-current work in progress. This list reads: "Preface to *Mourir de rire*, Lecture on Laughter, Film on prehistory, Next: 1. Article on Hemingway signed Jean Deluaux, 2. prehistory, 3. notes: press notes 1953 and new publications, See Bandi *Art préhistorique*" (*Oeuvres complètes*, vol. 9, p. 480).

Each of the remaining pages represents a distinct note for this film that was not to be.

Zone Books series design by Bruce Mau
Typesetting by Archetype
Image placement and production by Julie Fry
Printed and bound by Maple-Vail on Sebago acid-free paper